The *Très Riches Heures* of Jean, Duke of Berry

The
Très Riches Heures
of Jean, Duke of Berry

Musée Condé, Chantilly

Introduction and Legends by Jean Longnon,
Honorary Curator, Library, Institut de France
and Raymond Cazelles, Librarian, Musée Condé
Preface by Millard Meiss,
Institute for Advanced Study, Princeton

GEORGE BRAZILLER NEW YORK

Reproduced from the Illuminated Manuscript
Belonging to the Musée Condé, Chantilly, France.

Translated from the French by Victoria Benedict.

Library of Congress Catalog Card Number 70-79776
Photographed and Printed in France by Draeger Frères, *Paris.*

Contents

Preface

There is luck in artistic creation, no less than in scientific discovery. A cycle of full-page illustrations of the calendar was the perfect theme for the Limbourg brothers in their mature years. In the choice the painters no doubt "participated," as Plato would say, together with Fortune. If, as seems likely, the idea of such a novel sequence was theirs, they would still have needed the approval of their patron, and he happened to be an extraordinary one. A series of Seasons was as rich in possibilities for them as the Life of the Virgin for Giotto or the Creation for Michelangelo. The Limbourgs were just then in the midst of great discoveries about the world and the means of representing it. Their contemporaries and successors in Italy, on the other hand, were far less concerned with the face of nature than with ideas and principles, and they never produced a memorable calendar cycle. The principal, and in a sense the only, heir of the Limbourgs was another great Northern master, Peter Bruegel, in his panels of the Seasons painted 150 years later.

The calendar of the Limbourgs and indeed their entire cycle in the *Très Riches Heures* has become in our time one of the most famous of all works of art even though, until now, nearly everyone has known it only in reproductions that blur its subtle light and color or its perfect detail. Such wide popularity is absolutely exceptional for an illuminated manuscript that is closed in a library rather than, like other forms of painting, displayed in a public place. So familiar to us are the miniatures of the Limbourgs that we may be surprised to learn that they disappeared for three centuries without apparently leaving, during that time, any record of appreciation whatsoever. We know that the Duc de Berry and the painters of the day greatly prized the miniatures. The appraisers of the Duke's estate fixed a relatively high price for the manuscript, which had been left only half completed at his death in 1416; and still in the early sixteenth century Flemish illuminators paid tribute to the calendar pictures by imitating figures or entire compositions. Thereafter, like medieval art in general, the

manuscript disappeared from history; in 1856 the perceptive founder of the museum at Chantilly bought it from an Italian family.

Though during the nineteenth century historians and collectors showed increasing enthusiasm for early Italian painting the *"primitifs français"* caught on only a few years before 1904, the year of the first exhibition of French Gothic panels and illumination and also of the publication of the first monograph on the *Très Riches Heures.* French painting of the period came into focus much more slowly than Italian, in part no doubt because of the lack of a comparable critical tradition. There had been no Ghiberti in France to write sympathetically of the masters of the fourteenth century, and no Vasari to devise a systematic story of late medieval and Renaissance art. Thus only in recent years have we recognized the continuity of the French pictorial tradition from Jean Pucelle to Jacquemart de Hesdin, the Boucicaut Master, the Limbourgs, and Jean Fouquet; and only now can we see that it represents a unique and vital phase of European painting, intermediate between the Mediterranean and the North and occasionally capturing the best of both.

The miniatures of the Limbourgs and of their great anonymous contemporary, the Boucicaut Master, prove that about 1400 in France major artists commonly undertook illumination. Indeed their miniatures closely resemble panel paintings, and it has long been known that in the Purification of the Virgin (no. 56) the Limbourgs transferred the composition of a fresco by Taddeo Gaddi to a folio of the *Très Riches Heures.* The series of miniatures in this manuscript is thus like an entire cabinet of small panels. Like it, but yet not like it, for nowhere on earth is there a cycle of panel or mural paintings that still preserves the intact surface and the pristine color of the miniatures of the Limbourgs.

In the eleven representations of the months (November and the lower parts of March and September were painted later by Jean Colombe) the Limbourgs reveal contemporary France to us as it had never been seen before. These images, rich in detail yet marvelously unified, appear at the beginning of a book of prayers for private devotion—a Book of Hours. This kind of personal religious manuscript became popular first in the fourteenth century, especially in France. Like the small diptychs or triptychs that were so common at the same time in Italy, the Books of Hours are striking manifestations of the new individual forms of patronage, of the concern with paintings for private prayer and aesthetic enjoyment. Even among manuscripts of this kind the *Très Riches Heures,* as it was called in the Duke's inventory, was a very personal book. For the first time the patron enters into —even dominates—the previously generalized representations of the calendar. The portrait of the Duke at table in January is followed in the succeeding pictures by equally unprecedented portraits, if we may describe in this way pictorial replicas of fields and castles owned by the Duke or related to him. In the religious cycle, too, and precisely in the illustration for the Mass of Saint Michael (no. 134), the painters held the mirror up to a venerated building, Mont-Saint-Michel, which of course the Duc de Berry had visited.

Thus the Limbourgs, champions of a pictorial Nominalism, developed simultaneously the portraiture of persons and of their environment. By the imaginative selection

8

of subject and setting, and by the sensitive modulation of light and color they give us in the calendar a vivid sense of the world at different seasons of the year. April and May are lush with fresh growth, and the small trees burst into bloom. The hot sun of July beats on the ripe grain and on the castle of Poitiers, giving each of its several walls a slightly different shade of white. Boys dive into the pond in August. The trees in December have turned russet, and fallen leaves litter the ground. In February the land lies covered with snow under a leaden sky. All life is controlled by cold. Outdoors wood is chopped or transported, indoors men and women toast themselves before the fire, raising their skirts for maximum warmth. Smoke winds from the chimney up against the icy sky. The breath of the man in the yard condenses on the frosty air. The snow has settled irregularly into the haystack (what perceptiveness!). The sheep huddle together in the fold, and the birds, caught without natural food, peck at the grain previously scattered by a peasant, whose path from the house is marked by footprints in the snow. Altogether, nothing like this had ever been painted before, and indeed nothing like it would be seen again until Peter Bruegel painted his beautiful *Winter* now in Vienna.

The idea of time and change, so vivid in the calendar of the *Très Riches Heures,* informs the sacred stories also. The tree in the Nativity (no. 40), for instance, is bare and leafless. In the Death of Christ (no. 115) the day, in accordance with the Gospels, darkens, and in Christ in Gethsemane (no. 107) a soft clear night envelops Christ and the soldiers who collapse at the sight of Him. In these moving nocturnal miniatures the painter has been guided by two Gothic pictorial conventions, grisaille or mono-chromatic painting and, for the starry sky, the sparkling diapered background. But these conventions, as well as the earlier approach to the portrayal of night by Taddeo Gaddi, which the Limbourgs knew, merely provided suggestions that were trans-formed by the painters' own visual experiences. A fallen lantern and two torches in Christ in Gethsemane throw a little light in the gloom. The two halos glow, Christ's brightly, Saint Peter's dimly. The still, shadowy masses of two large trees loom above the hill. Christ stands alone in the tangle of fallen soldiers, His eyes lowered. Giving no sign of awareness of His miraculous powers He is as quiet as the night. The twinkling stars in the sky seem distant signs of His mysterious radiance. It is difficult to know what to admire most in this marvelous scene, the artist's astonishing mastery of tone or the unforgettable poetic mood. The miniature is the first in a series of memorable Northern night scenes, painted by a follower of the Van Eycks, by Geertgen tot Sint Jans, Bruegel, and Rembrandt.

In Christ in Gethsemane as well as in other miniatures the Limbourgs obtained beau-tiful effects by adding to the usual pigments gilt emulsion and gold- or silver-leaf glazed in red or green. This sophisticated combination of pigments and metal, devel-oped also by the Boucicaut Master, is one of the glories of the painting of the time. The Limbourgs caught the sheen and transparency of water by the use of silver glazed with green. In Hell (no. 91) scintillating gold sparks shoot skyward in the orange flames that envelop the damned. It is noteworthy that comparatively little gold appears in the naturalistic calendar pictures. As the most precious metal it is associated espe-cially with the supernatural, appearing in halos, around God, and in the court of

heaven. The rays that issue from the Lord in the Nativity move towards the Infant Christ and the shepherds, covering the hills around them with a golden mantle.

In October the penetrating study of light evident in all the miniatures led to discoveries that were momentous for Western painting. People and boats are reflected in the water, and shadows are cast on the ground. These are the earliest representations of such phenomena that we know. The shadows, furthermore, imply a single source of light, whether they fall behind people, the scarecrow, blackbirds and magpies, or the legs of the horse. One man even leaves his momentary imprint on the outer wall of the Louvre, anticipating by many years the famous shadows on the ark in Paolo Uccello's *Flood*.

October is full of innovations of all kinds. The ground, instead of moving irregularly upward as it recedes, stretches straight inwards. Nor does any road or line of trees curl back to measure and symbolize the recession. That is achieved by regular diminution, by overlapping, and by differences of color and tone. Indeed the brightest area is far away. Nowadays all this seems to us a rather simple feat, but no earlier painter, not even the Boucicaut Master, had quite achieved it. The scene, furthermore, has a new informality. Only the scarecrow and a tower suggest a central axis. There are no strong framing forms at the sides, and the two men in the foreground move out of the picture, in opposite directions. Never before had the continuity of space beyond the frames been so vividly conveyed.

Here too, however, as in the portrayal of light, the important new principle seems to emerge from related forms in other miniatures, most of them presumably painted earlier. Thus in both the Death of Christ and Christ Leaving the Praetorium (no. 110) the presence of great crowds is indicated by introducing a small loop in each sideframe and filling it with closely packed heads. Here and elsewhere similar loops in the upper frame provide a distinctive space for supernatural figures and forms.

The linear perspective of the Limbourgs, though not fully systematic, helps to create imposing masses and traversible spaces—witness October with its enormous, four-square Louvre! In the religious stories buildings rise to great heights above the people in the streets. Landscapes stretch back to unusual depths and the celestial choirs are vast. The progressive diminution of the angels falling from heaven (no. 65) or of the bodies of the damned exhaled by Lucifer in Hell gives new scale to these cataclysmic events. Terrifying and at the same time quite grand is the vast geyser of bodies rising from Lucifer's mouth. Despite the monster's superhuman power the raging fire is given mechanical aid: three huge bellows are worked by the devil's colleagues.

Thus the new naturalistic mode of representation transformed the Christian mysteries as well as the contemporary world. When recreating the traditional stories the Limbourgs showed an unusual awareness of ethnic and cultural differences. Negroes appear in several scenes. In the miniature of the Adoration of the Magi (no. 49) the second Magus bends to the ground before Christ, in the Eastern manner of the proskynesis. Leopards and camels are conspicuous, and many men here and in other Near Eastern events wear turbans. To Taddeo Gaddi's temple in the Purification of the Virgin

10

the Limbourgs have added the tablets of the Law displayed on an altar. One miniature consists of a map of the monuments of Rome (no. 106). The world has grown larger and more diversified, just as it bears many more signs of historical and temporal change.

The most memorable naturalistic landscapes in the *Très Riches Heures* are in the calendar, where they lie before a portrait of a particular château. The landscapes in the religious stories are almost always less advanced. The more or less shallow foreground that supports the main figures in these scenes appears before a steeply ascending hill, much in the manner of Italian trecento models. These lambent hills, rather unreal at least in size, are clearly associated with the supernatural. Reaching toward heaven, they serve also to enclose the sacred events and to give them a grander scale. Occasionally, as in the Meeting of the Magi (no. 48), we can see past the fantastic crags to a more normal northern French terrain, and here again it is connected with familiar buildings—in this miniature none less than Notre-Dame de Paris and the Sainte-Chapelle. A similar vista opens in the Adoration of the Magi.

The sacred figures in the *Très Riches Heures* thus do not actually inhabit the free open space, and the same may be said of the courtiers in the calendar. In April and May the nobles are framed by vegetation, somewhat like their religious counterparts. Their place in the foreground conforms perfectly with their nature, tall, thin-limbed manikins in magnificent costumes. Their curling hats and trailing mantles weave enchanting patterns of rhythmical line and color. Only the peasants really move into the countryside. They do so normally for their work; in other words they apply themselves to the modification of the land. The courtiers could not possibly undertake this; neither they nor indeed the religious figures were constructed for it. The ladies in April barely manage to pick flowers. The peasants are much sturdier. Still, we must admit that even they are not quite equal to their tasks. Perhaps this is one of those uncommon instances from which we may infer that an artist cannot do perfectly what he would like to do. The peasants do not easily wield their rakes, scythes, and sickles. Even in the masterful October, though the harrower is firmly seated in his saddle, the sower seems a little unsteady on his legs.

Although the nobility and the peasants are very differently conceived, both of them have been idealized by the Limbourgs. The world is a garden, beautiful and secure, whether one hunts with falcons or mows ripe hay. The latter, it is true, requires physical labor, but in peaceful fields, under a bright sun. When the cold comes, as in February, there is a good fire—of which the unceremonious peasants can take greater advantage than the court in January. And it is country boys who splash in the water in August while the fashionable nobles ride in what must have been uncomfortably warm and confining garb.

It is clear, then, that in these respects the miniatures of the Limbourgs in the *Très Riches Heures* show two main pictorial modes, modes that are related to categories of subjects, agriculture on the one hand, the court and to a degree the religious on the other. Since we know from the entry in the Duke's inventory that the manuscript was painted by "*Pol et ses frères*," and since we can safely assume that the style of

each of these brothers (very probably three) changed during the several years of work on the book, no wonder there is no agreement about the share of the three nor indeed about the problem of authorship in general! Attempts to distinguish artists have of course been made; indeed the dauntless Dr. Waagen, the first scholar to see the manuscript after its discovery in 1856, plunged right into a series of attributions. We owe the most perceptive observations to the remarkable connoisseur Georges Hulin de Loo, who in 1903 divided the miniatures among four masters. However, what Hulin did not notice is that all the calendar pictures showing the court turn out to be by his masters A and B, whereas those showing peasants he gave to his masters C and D. In other words what I have previously described as differences of mode he assumed to be differences of hand. Of course the two kinds of classification need not be exclusive, for certain masters may well have elected to paint certain kinds of subjects. These problems are too complex to be discussed here.

About 1485 Jean Colombe was invited by the Duc de Savoie to complete the calendar and the rest of the manuscript. Colombe was a good illuminator, and since he worked in the style of Fouquet, who in turn had learned much from the Limbourgs, he was not an inappropriate choice for the task. Still, his role does not seem enviable, to us at least. Most of his additions, however, are not seen simultaneously with the work of his great predecessors, so that he enjoyed an advantage over a painter asked to finish another's mural cycle or a composer who had to complete another's polyphonic Mass.

Colombe studied the miniatures of the Limbourgs carefully. His Resurrection (no. 127), for instance, was inspired by their wonderful Christ in Gethsemane. He composed, in the manner of Fouquet, fine placid hazy landscapes. The reflection of the setting sun in the rippled water of the Entombment (no. 118) is spectacular. The rose and blue floor of the Funeral Service (no. 138) darkens as it recedes in the gray, black, and gold church, and David prays in a series of luminous chapels. Hezekiah's Canticle (no. 90), with its anguished soul, strikes us as a little masterpiece. Colombe is usually far more prolix than the Limbourgs. For the greater splendor that he and his contemporaries prized he employed larger amounts of gold, devising especially sumptuous and often dazzling golden frames. The strokes of his brush, particularly when bearing gilt emulsion, play a part in the total effect of the miniatures. The brushwork of the Limbourgs, on the other hand, is fully visible only under magnification, and indeed I suppose that they actually worked with lenses.

Of course no later painter, however gifted, could have matched the smooth perfection of the Limbourgs' surface, their limpid color and complex simplicity. Their art, as the borders show, could capture the delicate, transitory beauty of a newly opened flower. As Emile Mâle said long ago: "*Moment touchant que celui où l'homme trouve enfin le secret de fixer la beauté mobile du monde.*"

Villa I Tatti
April, 1969

Millard Meiss

Introduction

Jean, Duc de Berry

The late fourteenth and early fifteenth centuries were a turbulent time of unrest and strife in France. Yet there lived one of the greatest patrons in the history of art, whose lavish and imaginative support made possible the illustration of two of the most exquisite illuminated manuscripts known today: the *Belles Heures* (New York, The Cloisters) and the *Très Riches Heures* (Chantilly, Musée Condé), both of whose miniatures were painted by the three Limbourg brothers.

Jean, Duc de Berry, the third son of Jean II, le Bon, King of France (r. 1350-64), was born on November 30, 1340, in the Château de Vincennes. His brothers were King Charles V (r. 1364-80), the Duc Louis I d'Anjou, and Philippe le Hardi, Duc de Bourgogne, and his nephews were King Charles VI (r. 1380-1422) and the Duc Louis d'Orléans. In 1360 he received the duchies of Berry and Auvergne in appanage, to which in 1369 Charles V added Poitou, recently recaptured from the English by Jean. He married twice: Jeanne d'Armagnac in 1360 and, after her death, Jeanne de Boulogne in 1389. His position as son, brother, and uncle of the Kings of France forced Jean to become involved in politics in the latter part of his life, especially during the dissension incurred by Charles VI's insanity. He played an essentially conciliatory role, concentrating his efforts on three main aims: negotiating with the English, ending the Great Schism that divided western Christendom, and reestablishing the peace that was constantly disturbed by the rivalry of the Houses of Burgundy and Orléans.

When the murder of Louis d'Orléans in 1407, and the threatening ambitions of Jean sans Peur, Duc de Bourgogne, forced the Duc de Berry to commit himself politically,

he was immediately considered the head of the "Armignacs," an anti-Burgundian faction bitterly hated by the people of Paris. In 1411 his Paris residence, the Hôtel de Nesle, was ransacked, and his Château de Bicêtre, on the outskirts of the capital, was pillaged and burned. The following year he was beseiged in Bourges, the capital of Berry, by the Burgundians, and in 1413 the extremes attained by the *cabochien* movement forced him to take refuge in the cloister of Notre-Dame. He had barely recovered from these dramatic events when the French found themselves involved once more in a war with England, which ended with their disastrous defeat at Agincourt in 1415. The Duke died shortly thereafter, on June 15, 1416, in the Hôtel de Nesle, deeply saddened by this fateful battle in which the majority of the noblemen of France were either killed or taken prisoner, including his favorite grandsons, Charles d'Orléans and the Comte d'Eu.

Although the Duc de Berry owned a large part of central France and governed the Languedoc, he was often unable to meet the enormous expenses of his extraordinarily luxurious life. A great patron and friend of artists and a passionate collector, he commissioned works of all kinds; he loved sumptuous buildings, rare jewels, and richly illuminated books. Accompanied by his servants, chaplain, and artist, he moved constantly between the seventeen or more palaces, châteaus, and *hôtels* or private mansions that he owned, some of which are depicted in the *Très Riches Heures*. Even his tapestries, decorated with historical scenes, were transported to adorn the walls of each residence in which he gave magnificent receptions for his family and retinue, served by his personal cup-bearers, pantlers, and carvers, such as we see in the *Très Riches Heures* in the painting for January (plate no. 2).

A relaxed atmosphere existed between this princely patron and the artists he employed, for he enjoyed their company and often guided them in their work; Jean Froissart describes him deeply engrossed in a discussion of new works with André Beauneveu, his master sculptor and painter. He bestowed favors upon them, and they in turn were generous with their gifts to him. In 1408 the painter Jean d'Orléans presented him with "*une belle pomme de musc*" ("musk in an apple-shaped container") that opened in the middle and was decorated within. In 1410 and 1415 Paul de Limbourg gave him similar gifts. His master architect Guy de Dammartin and his brother Dreux, André Beauneveu and his disciple Jean de Cambrai, who executed the funerary sculpture on the Duke's tomb, the miniaturist Jacquemart de Hesdin, and the three Limbourg brothers were considered friends and protégés of the Duke. The creations of these congenial collaborators were renowned: in 1393 Claus Sluter and the painter Jean de Beaumetz traveled to the Duke's château at Mehun-sur-Yèvre to "*visiter certains ouvrages de peintures et d'images*" ("visit works of art") in view of a project Philippe le Hardi, the Duc de Bourgogne, was planning in Dijon.

An avid builder, Jean de Berry personally supervised his restorations and constructions. The master architect for most of them was Guy de Dammartin, who successfully created in the upper stories a graceful decoration that fit in with the imposing grandeur of the whole. The palace and Sainte-Chapelle in both Bourges and Riom, the renovation of the palace and the Château du Clain in Poitiers, and the completion of the

facade of Bourges Cathedral were accomplishments worthy of the importance of the Duke's three capital cities as well as monuments to his good taste in architecture. By restoring châteaus and by building anew, the Duke provided himself with a series of beautiful homes throughout France: Nonette in Auvergne, Lusignan in Poitou, Genouilly and Concressault in Berry, and Gien, Montargis, Etampes, and Dourdan between the Loire and the Seine. The most famous residences, noted for their beauty and magnificence, were the Hôtel de Nesle on the left bank of the Seine facing the Louvre, the Château de Bicêtre to the south of Paris, and the Château de Mehun-sur-Yèvre, four leagues from Bourges.

A born collector, the Duke was possessed by an insatiable curiosity and the desire to own everything that caught his fancy. As well as buying and receiving, he enjoyed giving objects which he sometimes found himself buying back or asking for if he came to miss them too much. His tastes were broad. He was interested in exotic animals and, since he owned ostriches, dromedaries, chamois, and bears, the representation of camels in the *Très Riches Heures* (nos. 48-49) is not surprising. Each animal, including the Pomeranians that we see on the banquet table in the month of January, had its own keeper, and the bears and their guardian followed the Duke on his travels. Bears and swans were his emblems. The number of outstanding objects mentioned in his inventories is striking: historiated and emblazoned tapestries, Florentine and English embroidery, Luccan gold brocade, silk wall hangings, enamels, porcelains, and plates, forks, and spoons of silver and gold, all of which reveal the unimaginable luxury in which he lived.

Jean de Berry's most passionate interest was in jewels and works of art, which he took the greatest pains to find. The predominantly Italian and Jewish dealers of the period knew his preferences and strove to present him with the rarest gems. His collection of at least twenty exceptional rubies was the most beautiful of his time and perhaps of all time; one stone weighed 240 carats. Breathtaking was the richness of his religious *orfèvrerie* or goldwork, most of which he bequeathed to the Sainte-Chapelle in Bourges: crosses, chalices, retables, and reliquaries in solid gold that fairly glistened with precious stones.

He loved beautiful books which he bought, commissioned, received, and offered as gifts. Although his library was not so big as that assembled in the Louvre by his brother, King Charles V, the remarkable quality of his manuscripts established him as the prince of all French bibliophiles. He lovingly followed the execution of each page of the books he ordered, hardly waiting for the completion of one before commissioning another. In addition to French works, the library also included Italian manuscripts known as "*historiés de l'ouvrage de Lombardie*" or "*de l'ouvrage romain*" (Lombard or Roman illuminations). His librarian was, in fact, a Milanese illuminator, Pietro da Verona, who had come to France to sell his works and had remained in the service of the Duc de Berry. As sumptuous as the books' illuminations were the silk, velvet, or red leather bindings, with their small gold or silver fastenings studded with enamel work, pearls, or precious stones and often adorned with *pipes*—small strips of precious metal that bore the same decoration as the fastenings and held the signatures to the binding.

The Duke's library naturally reflects something of the personality of its founder. The 41 histories that dominate the secular works, followed by 38 chivalric romances, attest to his interest in the mundane, but he was also curious about natural phenomena and had acquired Marco Polo's *Book of Travels,* Gossuin's *Imago Mundi,* Aristotle's *De Coelo, Le Livre de la Sphère* by Nicolas Oresme, *Fleur des histoires de la terre d'Orient,* three *mappe-mondes* or maps of the world in two hemispheres, a book of divination, and an astrological treatise on the seven planets. But even these important works were overshadowed by the extraordinary number and quality of religious works, and in particular, the prayer books: 14 Bibles, 16 psalters, 18 breviaries, 6 missals, and 15 Books of Hours, which included the most beautiful manuscripts.

Books of Hours, generally intended for private use, were the most popular devotional books of the later Middle Ages. They were collections of the text for each liturgical hour of the day, hence their name. However, a typical Book of Hours contained many texts supplementary to these "Little Offices," which were usually preceded by a calendar and followed by the Hours of the Cross, of the Holy Ghost, and of the Passion. These Hours were placed between extracts from the Gospels, various prayers and daily devotions, the Penitential Psalms, the Litany of Saints, and masses for certain holy days.

Although the *Très Riches Heures* can be considered the most beautiful of all of the Duke's Books of Hours, he owned others of exceptional interest. Several had been executed for members of his family, such as the *Heures de Jeanne d'Evreux,* illuminated by Jean Pucelle (1325-28; New York, The Cloisters), or the so-called *Heures de Savoie,* begun in Pucelle's workshop, completed during the reign of Charles V, and destroyed in 1904, leaving only the fragment presently in the Library of the Bishop of Winchester. Not entirely satisfied with any of these manuscripts, whose style was already antiquated, Jean de Berry commissioned the most famous contemporary artists—André Beauneveu, Jacquemart de Hesdin, Paul de Limbourg and his two brothers—to illustrate numerous devotional books, already distinguished from one another in his inventories by their different attributes.

The *Petites Heures* (Bibliothèque Nationale, ms. lat. 18.014) is believed to have been executed before 1388 with the exception of a miniature showing the Duc de Berry leaving on a trip, added by the Limbourgs. Millard Meiss believes that at least five painters collaborated on the illuminations: Jacquemart de Hesdin and four anonymous artists.

The *Grandes Heures* (Bibliothèque Nationale, ms. lat. 919), larger than any of the Duke's other Books of Hours, was probably illuminated mainly by the Pseudo-Jacquemart, one of the unknown artists who worked on the *Petites Heures.* It was completed in 1409 by the Bedford Master and an artist from the workshop of the Boucicaut Master.

Because the Cloisters *Belles Heures* was listed in the Duke's inventory of January, 1413, it is generally agreed that the Limbourgs probably illuminated this manuscript between 1410 and 1412, or just before the *Très Riches Heures.*

The *Très Belles Heures,* now in Brussels (Bibliothèque Royale de Belgique, ms.11060-1), was painted for the Duke under the supervision of Jacquemart de

Hesdin. It disappeared for several centuries, but despite divergent opinions, the manuscript in the Bibliothèque Royale seems to correspond without doubt to that described in the inventory of 1402.

More complicated is the provenance of the *Très Belles Heures de Notre-Dame*. Begun about 1384 by an artist very close to the Parement Master, it was left unfinished, perhaps at his death; between 1405 and 1409 three pages were painted by an illuminator influenced both by André Beauneveu and the Limbourgs. In 1413 the still incomplete manuscript appears in an inventory compiled by the Duke's "registrar," Robinet d'Etampes, who shortly thereafter divided it into two parts. The finished section was kept by Robinet, and the rest was acquired by the House of Bavaria-Holland, which promptly commissioned the Van Eyck brothers, Jan and Hubert, to complete it. This portion of the manuscript was again divided in two, half of which burned with the Royal Library of Turin in 1904 and the rest of which, known as the *Heures de Milan,* is presently in the Museo Civico of Turin. Thus the *Très Belles Heures de Notre-Dame* is presently divided among the Bibliothèque Nationale (ms. nouv. acq. lat. 3093) and the Louvre (RF 2022-2024) in Paris, and the Turin museum. The part that perished is known only through reproductions published in 1902.

Lastly, we cannot omit the beautiful *Psalter* (c. 1386; Bibliothèque Nationale, ms. fr. 13.091), in which the figures of the apostles and prophets are thought to be by André Beauneveu, an attribution which corresponds to the inventory of 1402.

The Limbourg Brothers

The artists chosen by Jean de Berry toward 1413 to illuminate the *Très Riches Heures,* a Book of Hours to surpass all those he had owned until then, were natives of Nimwegen in the Duchy of Guelders between the Meuse and the Rhine. It would be incorrect to call them Flemish; at the time, Paul was vaguely referred to as "*alemant,*" or "*natif du païs d'Allemaigne*" (German or a native of Germany). Their father, Arnold de Limbourg, was a wood sculptor; their mother, Mechteld, was the sister of the painter Jean Malouel, who, trained by his father in the painting of escutcheons and banners at the court of Guelders, came to France to design heraldic materials for Queen Isabeau de Bavière and was retained as a salaried artist in 1397 by the Duc de Bourgogne, Philippe le Hardi. Of Arnold and Mechteld's six known children, Paul was the most famous, followed by Herman and Jean (or Jannequin), who worked with him. All we know of the others is that in 1416 Roger was made canon of the Sainte-Chapelle in Bourges, in 1417 Arnold became the apprentice of a goldsmith in Nimwegen, and in the same year Marguerite married a tradesman from Nimwegen.

After spending their childhood in the midst of this artistic family, Herman and Jean left Nimwegen when still "*jeunes enfants*" ("young adolescents"), possibly just after their father's death, to serve their apprenticeship with a Parisian goldsmith, which was probably arranged for them by their uncle, Jean Malouel. According to the accounts of the Duchy of Burgundy, the goldsmith sent the boys home "*pour cause de la mortalité*" ("because of the plague") raging in Paris in 1399. Unfortunately, their driver set out by way of Brussels, torn at the time by the conflict between Brabant

and Guelders, and as a result the young artists were thrown into prison. After six months, local goldsmiths and painters put up bail of 55 écus for the boys, and, out of consideration for their uncle, the Duc de Bourgogne matched this sum on May 2, 1400 so the prisoners might reimburse their vouchers. The Duke seems to have made this gesture in order to bind the nephews of his *"peintre et valet de chambre"* ("court artist and attaché") and, in fact, accounts for 1402-03 state that Jean and Paul were retained by Philippe le Hardi for four years at the workday rate of 20 *sous parisis* (sous minted in Paris) *"pour faire les ystoires d'une très belle et très notable Bible qu'il avait depuis peu fait commencer"* ("to illustrate a very beautiful and noteworthy Bible which had been undertaken only recently").

Philippe le Hardi died in April, 1404, and there is no way of knowing whether Paul and Jean stayed on in the service of his son, Jean sans Peur, as their uncle did. All trace of the three brothers is lost from 1403 to 1408, in which year it seems to have been for Paul that the Duc de Berry abused his authority and elicited the intervention of the Paris Parlement by kidnapping Gillette le Mercier, an eighteen-year-old girl of a respected middle-class Bourges family, so that she might marry against her mother's wishes *"un paintre alemant qui besognoit pour lui en son hostel de Vincestre lés Paris"* ("a German painter who worked for him in his mansion in Vincestre [Bicêtre] lés Paris"). Since a deed dated February 1, 1434, concerning Paul de Limbourg's house in Bourges at the death of his widow refers to him in the same terms, *"paintre nommé Pol, natif du païs d'Allemaigne,"* one and the same person seems to be involved. We can conclude that Paul de Limbourg was already employed by Jean de Berry in 1408 for the decoration of the Château de Bicêtre, in compensation for which the Duke gave him, in the following year, the *hostel* in Bourges in front of the church of Notre-Dame de l'Afflichault—a gesture that indicates how anxious he was to maintain the artist's goodwill.

In 1410 the three brothers definitely installed themselves with the Duke. On June 29, Herman and Jean gave their houses and furnishings in Nimwegen to their mother, and at the end of the year they joined Paul in the presentation of a facetious New Year's gift to the Duke, indicative of the familiar relationship they already enjoyed with their protector. In spite of the jocular nature of their present, the brothers lavished all their artistic skill on this *"livre contrefait d'une pièce de bois en semblance d'un livre, où il n'a nuls feuillets ne riens escript"* ("a counterfeit book made of wood, with no pages and nothing written within"). It was covered with white velvet and adorned with a vermeil clasp enamelled with the Duc de Berry's arms. The Prince carefully preserved the inventory listing it: *"lequel livre Pol de Limbourc et ses deux frères donnèrent à mondit Seigneur ausdites estrainnes (le 1er Janvier 1411)"* ("which book, Paul de Limbourg and his two brothers gave to His Lordship as a New Year's gift on January 1, 1411").

Many other references to the three brothers were to follow this one in the Duke's inventories and accounts. On January 15, 1412, Jean de Berry gave Paul de Limbourg (*"Paulo de Limbourc"*) a diamond mounted on a gold ring; this was followed by another golden ring *"où il a un ours d'esmeraude sur une terrace de mesmes"* ("on which an emerald bear lies on a bed of emeralds"). At about the same time, probably when the *Très Riches Heures* was begun, the Duke gave *"Paulo et duobus fratribus suis illuminatoribus"*

("to Paul and to his two illuminator brothers") nine *"pièces de monnoie d'or de diverses manières"* ("different types of gold coin"), probably medals, including the ones of Constantine and Heraclius which served as models for the tympani of the calendar months and the figures of the Magi (nos. 2-13, 48-49). The Duke also made numerous cash payments to the artists. On August 22, 1415, he gave as guaranty of the payment of 1,000 gold écus to *"Paulo de Limbourc et Hermando et Jehannequino, ipsius fratribus et varletis camere dicti domini ducis"* ("to Paul de Limbourg, to Herman and Jannequin, his brothers, attachés of the aforementioned Lordship, the Duke"), a small ruby, *"fait en façon d'un grain d'orge, assis en un annel d'or"* ("in the form of a barley grain set on a gold ring"), which he had purchased for 3,000 gold écus two years before. For his part, Paul had given the Duke a New Year's present of a little agate saltcellar, encrusted with gold, *"dont le couvercle est d'or, et au dessus a un petit fertelet, garny d'un saphir et de quatre perles"* ("with a gold cover topped with a little knob adorned with a sapphire and four pearls").

This active exchange of gifts shows to what extent the Limbourgs, especially Paul, enjoyed the intimacy and esteem of the Duc de Berry, who bestowed upon them the title of *valet de chambre*. The hypothesis that Paul held the privileged position as head of the workshop is substantiated by the following extract from an inventory compiled after the Duke's death which also confirms the attribution of the *Très Riches Heures:* *"Item en une layette plusieurs cayers d'une très Riches Heures, que faisoit Pol et ses frères, très richement historiez et enluminez"* ("also in a small box several signatures of a very rich Hours richly illustrated and decorated by Paul and his brothers"). This inscription was made after the three brothers' death, which might have occurred even before that of the Duke. Two documents in the Nimwegen Archives deal with their estate: one, dated March 9, 1416, mentions the death of Jean, known as Jannequin *("Jenneken"),* and the second, dated September-October of the same year, mentions Herman, Paul, and Jean. The fact that the three brothers are cited together leads us to believe they died at about the same time, perhaps victims of an epidemic; since Jean's death was recorded in Nimwegen by March 9, it must have occurred toward the end of February at the very latest. In 1400 Herman and Jean had been described as young adolescents, so the eldest could hardly have reached the age of thirty when they died. The order in which the three are listed in the second document might indicate that Herman was the oldest; this would mean that Paul had earned the Duc de Berry's favor solely on his own merit. Although all three brothers were famous in their time, (describing Paris, Guillebert de Metz named *"les trois frères enlumineurs"),* a century later, Jean Pèlerin, known as *le Viateur,* cited in his *De Artificiali perspectiva* only one of the three—"Paoul"—as among the great painters of the past.

Beside the *Belles Heures* and the *Très Riches Heures* little is known of the Limbourgs' work. The *"très belle et très notable Bible"* illuminated by Paul and Jean about 1402-03 for the Duc de Bourgogne is not preserved. The paintings that we presume Paul executed in the Château de Bicêtre in 1408 perished in the fire of 1411. This leaves a few scattered miniatures painted between 1409 and 1412: three illustrations in the *Très Belles Heures de Notre-Dame,* a painting added to the *Petites Heures,* and a series of pictures at the beginning of a *Bible historiée* (Bibliothèque Nationale, ms. fr. 166),

with a drawing that was added to it. There exist two further Books of Hours that appear to have come from the Limbourg workshop. One, belonging to the Earl of Seilern in London, has been described by Jean Porcher as almost a copy of the *Belles Heures* with resemblances to the *Très Riches Heures: "une reproduction presque littérale des* Belles Heures, *avec certains souvenirs des Heures de Chantilly."* The other, presently in the Musée Condé (ms. 66, ex 1383), is of an inferior quality, but its Nativity, Annunciation to the Shepherds, and Presentation in the Temple show extraordinary similarities with the *Très Riches Heures* and the *Belles Heures*. If these two manuscripts are correctly attributed to the Limbourgs, it would prove that although the brothers devoted the greater part of their energies to works commissioned by the Duc de Berry, they were not above executing less important works for other collectors.

The Très Riches Heures

Upon the death of Jacquemart de Hesdin in about 1409, the Limbourg brothers—Herman, Paul, and Jean—seem to have succeeded him as Jean de Berry's miniaturists. The consecutive execution of the *Belles Heures* and the *Très Riches Heures* (the first between about 1409 and 1412 and the second between 1413 and 1416) reveals the Duke's insatiable desire, as soon as he had the latest book in hand, for another more beautiful, more sumptuous Book of Hours that would surpass all his others. The two manuscripts reveal similarities of style: there are the same beautiful colors and graceful figures, the same kind of bearded Christ with long curly hair, and the same kind of female nude, with a high bosom, thin waist, and protruding stomach (thus Eve in the *Très Riches Heures* resembles Saint Catherine in the *Belles Heures*). Similar also are the conventional architectural settings, the conical mountains, and the indistinct background monuments.

But what great differences there are between the two books! The liturgy and the subjects (notably illustrations of the devotions to saints) of the miniatures, probably chosen by the Duc de Berry, differ. In the *Très Riches Heures* the conventional borders of foliage and small vine leaves have given way to charming and imaginative motifs scattered throughout the margins; its calendar contains large scenes of each month, apparently also suggested by the Duke, which replace the traditional two medallions; the theme of each miniature is approached afresh so that repetition is scrupulously avoided. Most important of all, however, the more balanced and harmonious composition, the relationships of color, the bolder execution, and the extraordinary innovative landscapes reveal a maturity, skill, and knowledge that make the Limbourgs' earlier work seem youthful by comparison.

We are led to believe that one of the three Limbourgs renewed their art by introducing these new qualities. One, probably Paul as master of the workshop, must have worked in Italy, almost certainly in Milan and Siena, and this experience left its most obvious imprint on the Hours of the Passion (nos. 107 ff.). Jean Porcher has dated this fruitful trip between 1412 and 1413, which would explain the rapid evolution between the *Belles Heures* and the *Très Riches Heures*. But even the influence of Italian art does not clarify the mystery of how and why the Limbourgs introduced landscapes in

what was to be their last work. For suddenly they included sites and châteaus dear to the Duc de Berry: Lusignan, Dourdan, the Palais de la Cité, the Château du Clain in Poitiers, Etampes, Saumur, the Louvre, Vincennes, Mehun-sur-Yèvre and the astonishing winterscape for the month of February (no. 3), whose white starkness is so strikingly realistic. Although the Sienese were accomplished landscape artists (and perhaps Paul saw Ambrogio Lorenzetti's charming rural scenes in the *Buono Governo* fresco cycle in the Palazzo Publico), they still used oblique, extremely foreshortened settings and constructions, such as the Limbourgs had used in the *Belles Heures*. How, then, did the artists discover the linear and proportional art of the landscape that we see in the *Très Riches Heures?* Could their work have been achieved by means of some optical device, a dark room, a "light room," or a frame strung with vertical, horizontal, and transversal strings through which they observed nature ?

The Limbourgs' new and original collective work combines elements which could be considered contradictory: an extraordinary feeling for the countryside along with an affinity for the luxury of court life, a charming elegance with a sometimes crude realism, classical nudes similar to those of antiquity with fashionably shaped female figures. The architecture was painted with two different methods: either distance or aerial perspective rendered buildings indistinct, as in the case of the châteaus of Dourdan and Etampes (nos. 5 and 9); or, as in the most beautiful miniatures, an exceptionally talented draftsman precisely recorded the most minute details of the Palais de la Cité (nos. 6-7), Saumur (no. 10), the Louvre (no. 11), and Mehun-sur-Yèvre (no. 121), without upsetting the harmony of the whole. Several eminent scholars have tried to use this distinction to identify the work of each brother, but without success, because insufficient evidence of the artists' individual characteristics exists, and the manuscript has an overall unity despite differences among the Hours of the Passion, scenes from the life of Christ (nos. 124, 125), the Meeting and Adoration of the Magi (nos. 48-49), and the calendar (nos. 2-13).

The *Très Riches Heures* was unified under the guidance of the head of the workshop by a skillful use of luminous colors and tones and the artful composition of figures in varied settings. Due to their exceptional gifts of observation and execution, nurtured by the milieu in which they grew up, the Limbourgs were able to blend Northern and Italian influences with the French pictorial tradition, to create an original work that remains the highest expression of what is known as the International Style. Its mastery cannot be overemphasized, especially when one considers the youthfulness of its creators who attained the height of their art in such expressions of their personal vision as the brilliant images of the Garden of Eden (no. 20) and the Coronation of the Virgin (no. 59) and the extraordinary scenes of the Fall of the Rebel Angels (no. 65) or Christ in Gethsemane (no. 107). One can imagine the Duc de Berry's joy upon seeing the results of his artists' inspiration, for none of these subjects were usually included in a Book of Hours and these in fact were added to the *Très Riches Heures* in the form of inset pages. What might these gifted artists have produced had they lived longer ? The *Très Riches Heures* is constantly referred to as *"le roi des manuscrits enluminés"* or the "king of illuminated manuscripts," but more than that it is a pinnacle in the entire history of painting.

Upon the deaths of the Duc de Berry and the Limbourgs, the *Très Riches Heures* was left unfinished, to be completed at a later date by another artist in a completely different style. The Man of Sorrows (no. 75) shows us the second patrons of the manuscript, the Duc Charles I de Savoie and his wife, Blanche de Montferrat. Since Charles I married Blanche in 1485 and died four years later, in 1489, the *Très Riches Heures* must have been completed between these two dates. It is no surprise that the manuscript had passed into the hands of the ducal couple of Savoie, since Bonne, one of the Duc de Berry's two daughters, had married Amedée VII de Savoie, and as Amedée's direct descendent the Duc Charles I inherited the *Très Riches Heures*.

Paul Durrieu's extensive research led him to decide that the illustrator or *"historieur"* of the manuscript's second series of paintings had special ties with the town of Bourges and that he had completed an *Apocalypse figurée* for Charles I de Savoie. Because an *Apocalypse* in the Escorial, containing miniatures similar to those in the *Très Riches Heures,* was known to be completed about 1482 by a certain Jean Colombe then living in Bourges, Durrieu concluded that the *"historieur"* and Colombe were identical. Almost nothing was known of Jean Colombe until the recent and still unpublished discoveries of Jean-Yves Ribault, Archivist for the Department of the Cher, who has kindly authorized us to summarize the additions he has made to the research of his predecessors, Paul Chenu, Alfred Gandilhon, and Maurice de Laugardière.

Born about 1430-35 of Philippe Colombe and a certain Guillemette, Jean was probably the elder brother of Michel Colombe, the sculptor. The Colombe family was perhaps originally from Sens and moved to Bourges only toward the end of the twelfth century. In 1463 Jean Colombe finished his apprenticeship with Clement Thibault, *"écrivain de forme"* ("calligrapher of manuscripts"), and married the following year, establishing himself in a house opposite his mother's. In 1467 he undertook the construction of a house elsewhere in Bourges, on the site of a building that had burned down, where he lived with his wife, Colette, until his death in about 1493. We know that Jean Colombe traveled at least once to Savoie and to the Piedmont, from acts dated June 3, 1486 and signed by Charles I in Turin in the presence of the artist, which retain as his illuminator, *"maître Jean Collumbe,"* whose services were declared satisfactory. However, Jean-Yves Ribault believes this stay lasted no more than a few months or a year at most since the artist's continuous presence in Bourges is proven by the almost complete accounts of the chapter house of Saint-Pierre-le-Puellier. Furthermore, a document from the archives of Charles I's treasurer fixes the payment of 25 gold écus to Jean Colombe, *"in villa de Bourges, pro illuminatura et historiatione certarum horarum canonicarum"* ("in the town of Bourges, for the illustration and decoration of some canonical Hours") for August 31, 1485, a date which agrees perfectly with the completion of the *Très Riches Heures* and establishes the presence of the artist in this provincial capital that same year.

Besides the *Très Riches Heures* and the *Apocalypse figurée* there exist several other manuscripts illuminated by Jean Colombe. *Le Livre des douze périls d'Enfer* (Bibliothèque Nationale, ms. fr. 449) was executed in a similar style for Queen Charlotte de Savoie, wife of Louis XI and the artist's protectress. Between 1469 and 1479 she requested that *"ung povre enlumineur à Bourges nommé Jehan Coulombe"* might

be exempted from the tax and from watch duty, and it was probably she who recommended the painter to the court of Savoie. Jean Colombe also illustrated Sébastien Mamerot's *Romuléon* (Bibliothèque Nationale, ms. fr. 364), which bears the artist's signature, for Admiral Louis Malet de Graville, and Mamerot's *Passages d'outre mer* (Bibliothèque Nationale, ms. fr. 5594) probably for Louis de Laval. He illuminated a *Vie de Christ* in three volumes (Bibliothèque Nationale, ms. fr. 177-179) for the bastard Louis de Bourbon, Comte de Roussillon. Henry Joly credits him with the *Missel de Lyon* (Bibliothèque de Lyon, ms. 514), which is closely related to his other works, particularly the second series of miniatures in the *Très Riches Heures*.

Faced with the problem of finishing what the Limbourgs had begun, Jean Colombe apparently decided to work in the spirit of his time rather than try to imitate the past. In seventy years, tastes and fashions had changed considerably: the arched brow had become stylish for women, clothes were different, the interest in orientalism had waned. Colombe rendered modeling with small parallel lines, visible to the naked eye; his colors became almost violently bright, dominated by deep blues, much gold heightening, and currant red. The deliberate boldness of his figures and foregrounds was undoubtedly a reaction against the former style of frailty, which had outworn its popularity. Architectural decor was constructed with knowledge but, here again, in a style quite different from the Limbourgs'. Colombe's landscapes receded into vaporous horizons of diminishing blues, which contrasted with the severity of the foregrounds and perhaps helped furnish the public with the escape it craved. Whether painting the landscapes of Berry or of Savoie, Jean Colombe seemed to excell in rendering these château-covered hills and mountains among which wind bodies of water flecked with boats.

The *Très Riches Heures,* as we know it, consists of 206 bound sheets of extremely well-prepared, fine vellum. Each sheet now measures 29 cm. by 21 cm., but originally they must have been larger since the binder obviously cut into some of Jean Colombe's miniatures (the Man of Sorrows [no. 75], the Ascension [no. 128]). Each signature theoretically consists of four sheets of parchment folded in two, or eight folios, but re-collations have sometimes altered the number of folios in a signature. At the foot of the last page of each signature was placed a catchword corresponding to the first word of the following signature, to avoid errors in assembling the book.

The pages were ruled in red, and the beginning of each office and hour was cursorily indicated in the margin to provide the layout for the calligrapher, who nevertheless was often obliged to adapt the size of his writing to the space alloted him. The name of the scribe responsible for the *Très Riches Heures* remains unknown, and we can only note that in 1413, the Duc de Berry had in his employ an *"escripvain de forme"* named Yvonnet Leduc. As in all the most beautiful manuscripts of this period, initial capital letters and line endings are decorated; their calligraphy and that of the text is in the same style throughout the manuscript with a few exceptions necessitated by the Duc de Savoie's re-collations. This is the case with no. 50 and folio 54 (not reproduced in this volume), in which the ink and style unfortunately differ from that in the rest of the manuscript. The exquisite little self-contained scenes and portraits

within the initial captial letters constitute an important part of the manuscript's illustration. Like the miniatures, they were executed partly for the Duc de Berry and partly for the Duc de Savoie, with marked differences between the two styles as well as between the accompanying foliage in the margins and center columns.

A layout artist indicated the placing of each illustration. Small miniatures were inserted in the text, which, up to the Last Judgment (no. 29), contained legends in blue and gold related to the subject represented; larger miniatures occupied an entire page, in which case the text was reduced to two columns of four lines each at the foot, as in the Coronation of the Virgin (no. 59). When confronted with these larger spaces, Jean Colombe either retained two columns of text while violating the frame indicated at the time of the Duc de Berry (Paradise [no. 102]) or deleted the established text and re-inscribed it only in part on the miniature itself (as in no. 85). From the outset, the Limbourgs used entire pages with no text at all for some illustrations, as in the calendar months and several miniatures in the Passion cycle (nos. 107 ff.). Furthermore, the *Très Riches Heures* includes several large paintings, some of which are most unusual for a Book of Hours: Anatomical Man (no. 14), the Garden of Eden (no. 20), the Fall of the Rebel Angels (no. 65), a Plan of Rome (no. 106), and others of a more conventional theme such as the Adoration of the Magi (no. 49) and Hell (no. 91). These miniatures were not originally planned for the manuscript and were executed on inset pages; the artists' or the Duke's reasons for adding them as afterthoughts remain unexplained.

The painters' illustration of the prepared pages began with a light pen and ink sketch, one of which is still visible in the marginal decoration of the Annunciation (no. 21), left incomplete at the time of the Limbourgs' death. In the painting itself, the sky and landscape or architectural background was executed first, followed by the foreground and figures, and last of all the heads and faces. This sequence of steps is most obvious in miniatures left incomplete by the Limbourgs; the month of September (no. 10) was begun by the brothers, who started with the upper two-thirds—the sky and the Château de Saumur—and was completed by Jean Colombe, who filled in the harvest scene with its different figures; the Procession of Saint Gregory (nos. 73-74) was almost entirely executed by the Limbourgs except for the heads (the last stage) on the right-hand folio by Jean Colombe.

The colors used by the miniaturists were prepared in their workshop, ground with a muller on a slab of marble and then moistened with water thickened with either arabic or tragacanth gum, which served as a binder and ensured their adherence to the vellum and their preservation. Besides black and white, there were approximately ten shades of blue, green, red, yellow, and violet, obtained from minerals, plants, or chemicals, whose composition is described in various treatises on painting, and notably a fourteenth-century *Art d'Illuminer*. Of the two blues, the most beautiful, called *azur d'outremer,* was an ultramarine made from costly Oriental lapis-lazuli *(pierre d'azur),* which was considered so precious that two leather bags containing the mineral were mentioned in the Duc de Berry's inventory: "*deux sacs de cuir où il y a dedans de l'azur.*" It is with this deep and yet transparent blue that the Limbourgs created their luminous skies. The second blue, *azur d'Allemagne,* or

cobalt blue, was made from Saxony cobalt ore and was less transparent than the ultramarine. Jean Colombe seems to have used it for the gradation of his background landscapes.

The beautiful tones of the young women's robes in the month of May (no. 6) were painted in one of the two greens used at the time, *vert de Hongrie,* or malachite green, which was made from the green crystal of the same name, a carbonate of copper. The other green, *vert de flambe,* was obtained, according to the *Art d'Illuminer,* from wild irises by mixing newly crushed flowers with massicot, while a seventeenth-century book of formulas explains that it was actually the leaves of the iris that were used. Vermilion, the brightest of the reds, was made from cinnabar, or mercuric sulfide, obtained by heating one part quicksilver with two parts sulphur. The other chemical red, *mine,* consisted of red oxide of lead produced by heating white lead. The third, darker red was made from an earthy substance, red ocher, a kind of red mineral. Pink, or *rose de Paris,* was extracted from the decoction of red dyewood. The two yellows were obtained from minerals: massicot from a monoxide of lead, and orpiment from arsenic trisulfide. Violet was a vegetable color extracted from the sunflower. White was made with white lead ore, which the *Art d'Illuminer* describes as the "*seule espèce de blanc pour l'enluminure*" ("the only kind of white suitable for illumination"). Black was obtained either from soot or from ground charcoal. There were two kinds of gold: gold leaf, applied on an "*assiette*" (gold sizing) and held in place with a paste called "*cerbura*" in the *Art d'Illuminer,* and ormolu, a gold powder applied with a brush.

The microscopic work characteristic of the Limbourgs required extremely fine brushes and, probably, lenses. Jean Colombe's brushwork was slightly less delicate, as we can see in his part of the month of September.

Charles I, Duc de Savoie, was not destined to enjoy the *Très Riches Heures* for long since he died childless in 1491, leaving all his possessions to his first cousin, the Duc Philibert le Beau. The latter also passed away without progeny, and the manuscript was left to his widow, Margaret of Austria, the daughter of the Emperor Maximilian and at that time responsible for the government of the Netherlands. Paul Durrieu demonstrated the probability of the inclusion of the *Très Riches Heures* in a group of manuscripts belonging to the House of Savoie which the Princess had transferred to the Netherlands; he identified it with "*une grande heure escripte à la main*" ("a large Book of Hours written by hand") mentioned in the Princess' chapel in Mechlin in 1523. Upon Margaret's death in 1530, this Book of Hours went to Jean Ruffaut, chief treasurer and paymaster of Charles V of Germany and one of the executors of the Princess' will.

The history of the manuscript would be totally unknown for three centuries thereafter, if it had not been bound during the eighteenth century in red morocco leather decorated with the Spinola arms. How this famous Genoese family acquired the manuscript remains a mystery, but it is not unreasonable to explain it by the military activity of the family members, especially Ambrosio Spinola, in the Spanish Netherlands in the seventeenth century. The *Très Riches Heures* eventually passed into the

hands of the Serra family, whose escutcheon was applied to the front cover over the Spinola arms, and then to the Baron Félix de Margherita, who lived in Turin. Toward the middle of the nineteenth century, the Duc d'Aumale learned of the manuscript's availability and saw it during a trip he made in 1855 to Genoa. He immediately recognized it as a work executed for the Duc de Berry, by the Duke's portrait in the month of January, the numerous bears and wounded swans, the mysterious initials "VE" (no. 14), and the fleurs-de-lys escutcheons engrailed in gules.

But it still remained to identify the manuscript among Jean de Berry's numerous Books of Hours. On February 14, 1881, the eminent scholar Léopold Delisle wrote to the Duc d'Aumale: "*Monseigneur, je ne doute pas que vos Heures du Duc de Berry ne répondent à l'article suivant du procès-verbal d'inventaire et prisée dressé après la mort du prince et conservé à la Bibliothèque Sainte-Geneviève: 'En une layette plusieurs cayers d'unes très riches heures que faisoient Pol et ses frères, très richement historiez et enluminez. — 500 livres.'*" ("Sir, I have no doubt that your Hours of the Duc de Berry correspond to the following article in the official report of the inventory and appraisal made after the Duke's death and preserved in the Bibliothèque Sainte-Geneviève: 'in a box several signatures of a very rich Hours undertaken by Paul and his brothers, richly illustrated and decorated—500 livres'"). Delisle's opinion was based on three factors: the inventory's high evaluation of an unfinished manuscript, the absence of any other incomplete Book of Hours in the Duc de Berry's inventories, and the collaboration of three artists, which would explain "*les différences de main remarquées par Votre Altesse dans les peintures de la partie ancienne du livre*" ("the different hands recognized by your Highness in the earlier parts of the book").

Returned at last to France after passing through Savoie, the Netherlands, and Italy, the *Très Riches Heures* recovered its correct attribution thanks to Léopold Delisle and was included in the Duc d'Aumale's generous donation of all his collections and his estate of Chantilly to the Institut de France. It has belonged to this learned body since 1897 and constitutes one of the most precious treasures of the Musée Condé.

Selective Bibliography

BASTARD, A. comte de. *Librairie de Jean de France, duc de Berri*, Paris, 1834. 24 plates. Text never published.

BOBER, H. "The Zodiacal Miniature of the 'Tres riches Heures' of the Duke of Berry—Its Sources and Meaning," *Journal of the Warburg and Courtauld Institutes*, XI (1948), 1-34.

Bourges. Musées. *Chefs-d'œuvre des peintres-enlumineurs de Jean de Berry et de l'école de Bourges* [Bourges, 1951].

CHENU, P. "Note sur un manuscrit dont les illustrations sont attribuées à Jean Colombe," *Mémoires de la Société des Antiquaires du Centre*, XL, XLI.

DELISLE, L. "Les *Livres d'heures* du duc de Berry," *Gazette des Beaux-Arts*, XXIX (1884), 97-110, 281-92, 391-405.

DIMIER, L. *L'art d'enluminure, traité du XIVe siècle, en latin*. Translation. Paris, 1927.

DURRIEU, P. *Les Très riches Heures de Jean de France, duc de Berry*, Paris, 1904.

——. "Les Très riches Heures du duc de Berry conservées à Chantilly, au Musée Condé, et le Bréviaire Grimani," *Bibliothèque de l'École des Chartes*, LXIV (1903), 321-28.

——. "Les petits chiens du duc Jean de Berry," *Académie des Inscriptions et Belles-Lettres. Comptes rendus*. Paris, 1909, pp. 866-75.

FRY, R.E. "On Two Miniatures by de Limburg," *Burlington Magazine*, VII (1905), 435-45.

GORISSEN, F. "Jan Maelwael und die Bruder Limburg," *Gelre*, LIV (1954), 153-221.

GUIFFREY, J. *Inventaires de Jean, duc de Berry* (1401-1416). 2 vols, Paris, 1894-96.

—— "Médailles de Constantin et d'Heraclius acquises par Jean, duc de Berry," *Revue numismatique*, 1890.

HULIN DE LOO, G. "Les Très riches Heures de Jean de France, duc de Berry, par Pol de Limbourg et ses frères," *Bulletin de Gand*, XI (1903), 178 ff.

JOLY, H. "Un missel franciscain attribué à Jean Colombe," *Bibliothèque de la ville de Lyon. Documents manuscrits, typographiques, iconographiques*. Fas. V., Lyon, 1925.

LECOY DE LA MARCHE, A. *L'art d'enluminer, manuel technique du XIVe siècle*. Paris, 1887.

LEHOUX, F. *Jean de France, duc de Berri. Sa vie. Son action politique. 1340-1416*. 4 vols. Paris, 1966-68.

LONGNON, J. "L'enlumineur Paul de Limbourg et sa famille," *Journal des Savants*, 1956, pp. 175-88.

MALO, H. *Les Très riches Heures du duc de Berry*. Paris, 1933.

MARINESCO, C. "Deux empereurs byzantins en Occident: Manuel II et Jean VIII Paleologue," *Académie des Inscriptions et Belles-Lettres. Comptes rendus*. Paris, 1958, pp. 23-35.

MEISS, M. *French Painting in the Time of Jean de Berry.* 3 vols. pub. to date. London and New York, 1967-68.

———. "The Exhibition of French Manuscripts of the XIII-XVI Centuries at the Bibliothèque nationale," *Art Bulletin,* XXXVIII (1957), 187-96.

———. "A Lost Portrait of Jean de Berry by the Limburgs," *Burlington Magazine,* CV (1963), 51-53.

MELY, F. de. "Les Très riches Heures du duc de Berry et les 'Trois Grâces' de Sienne," *Gazette des Beaux-Arts,* CVIII (1912), 195-201.

MEURGEY, J. *Les principaux manuscrits à peintures du Musée Condé à Chantilly.* 2 vols. Paris, 1930.

MORAND, E. "La ville de Riom et la fête de Mai dans les Très riches Heures du duc de Berry," *Bulletin de l'Académie des Sciences, Belles-Lettres et Arts de Clermont-Ferrand,* 1954, pp. 1-5.

PÄCHT, O. "The Limburgs and Pisanello," *Gazette des Beaux-Arts,* LXII (1963), 109-22.

PORCHER, J. *Les Très riches Heures du duc de Berry.* Paris, 1950.

———. *Les Belles Heures de Jean de France, duc de Berry.* Paris, 1953.

———. *Les manuscrits à peintures en France du XIIIᵉ au XVIᵉ siècle.* Paris, 1955.

———. "Jean Colombe," *Médecine de France,* XXV (1951), 29-32.

PRADEL, P. *Michel Colombe, le dernier imagier gothique.* Paris, 1953.

RORIMER, J. J. and Freeman, M. B. eds. *The Belles Heures of Jean, Duke of Berry, Prince of France.* New York and Paris, 1958.

SCHILLING, R. "A Book of Hours from the Limbourg Atelier," *Burlington Magazine,* LXXXI (1942), 194-197.

"Les Très riches Heures du duc de Berry—Le calendrier, par Pol de Limbourg et Jean Colombe," *Verve,* 1940, no. 7.

"Les Très riches Heures du duc de Berry—Images de la vie de Jésus," *Verve,* 1943-44, no. 10.

WINKLER, F. "Ein neues Werk aus der Werkstatt Pauls von Limburg," *Reportorium für Kunstwissenschaft,* XXXIV (1911), 536-43.

———. "Paul de Limbourg in Florence," *Burlington Magazine,* LVI (1930), 95 f.

Note to the Plates

The unusual disposition of many of the miniatures on left-hand pages is in accordance with the sequence of pages in the manuscript, with the exception of nos. 16 and 17. Every miniature and a selection of the decorated text pages have been reproduced to size, without plate or page numbers. The bracketed number following each legend refers to the folio number of the page described. All biblical passages are from the Douay version, the English translation of the Latin Vulgate, which was the Bible used at the time of the manuscript's execution.

The Plates with Commentaries

J

Jauuier a .xxi. iour
Et la lune .xxx.

					La quntite des iours lxxuiz. apt		Nôbre dor nouel
vj.	A	KL			viij	xxvij	xix.
	b	iiij ñ	Octaues saint esticnne		viij	xxix	
xi.	c	iij ñ	Oct. s. iehan se genucuueuc.		viij	xxxi	vuj
	d	ij. ñ.	Octaues des innocens		viij	xxxij	rvi.
xix.	e	nonas	saint symeon		viij	xxxb	v
vuij	f	viij id			viij	xxxbij	
	g	vij id	saint fiambourt		viij	xxxix	vij
xbj	A	vi. id	saint lucien		viij	xli	
x	b	v. id	saint pol. puimer hermite		viij	xliij	ij
	c	iiij id	saint guillaume		viij	xlv	x
xuj	d	iij. id	saint sauuieur		viij	xlvj	
ij	e	ij. id	saint satir		viij	xlix	rbuj
	f	idus	saint hylaire		viij	lij	
x	g	xix kl	saint felix		viij	lb	vij
	A	xviij kl	saint mor		viij	lbiij	xiv
xbuj	b	xvij kl	saint mauvel		ix	o	
vij	c	xvi. kl	saint anthoine		ix	ij	iiij
	d	xv. kl	saint prisce		ix	v	xij
xb	e	xiiij kl	saint lomer		ix	vij	j
iiij	f	xiij kl	saint sebastien		ix	x	
	g	xij. kl	sainte agnes		ix	iiij	ix
xij	A	xi. kl			ix	xbi	rbuj
i.	b	x. kl	sainte emeranciene		ix	xix	
	c	ix. kl	saint babile		ix	xxiij	vij
xx	d	viij kl			ix	xbiij	
	e	vij. kl	saint policarpe		ix	xx	xxuj
xbij	f	vi. kl	saint iulien		ix	xxiij	
vj	g	v. kl	sainte agnes		ix	xxbj	iiij
	A	iiij kl	sainte paule		ix	xxxiv	ij
xiiij	b	iij. kl	sainte baudour		ix	xlij	
iij	c	ij. kl	Saint metran		ix	xlb	xx

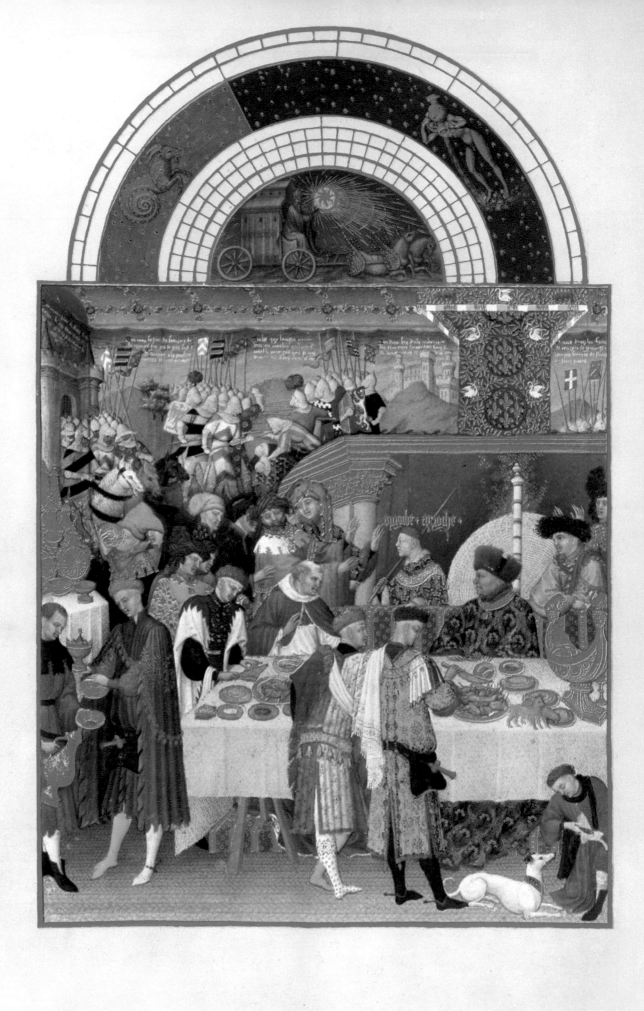

1. Calendar

In the *Très Riches Heures,* each representation of a month is accompanied by the corresponding calendar. We have reproduced only the calendar page for January.

<div align="right">[F. 1v]</div>

2. January

We see here the day chosen for exchanging gifts. Jean de Berry enjoyed giving and receiving; Paul de Limbourg and his brothers used to participate in the festivities, presenting the prince with an object worthy of their artistry. The Duke sits at his table, surrounded by friends. Behind him the blaze of a large fire in the monumental fireplace is guarded by a wickerwork screen. Above the fireplace rises a red silk canopy bearing the Duke's heraldic motifs: golden fleurs-de-lys, strewn on a blue ground. Wounded swans and bears symbolize the Duke's love for a lady called Ursine *(ours:* bear; *cygne:* swan). Tapestries hanging behind the canopy depict knights emerging from a fortified castle to confront the enemy; the few decipherable words of the poetry inscribed at the top of the tapestries seem to indicate a representation of the Trojan War as imagined in medieval France.

The table is covered with a damask cloth and laid with platters, plates, and a beautiful gold saltcellar in the shape of a ship, which is referred to in the inventories as the *"salière du pavillon."* The Duke's little dogs wander freely among the dishes. Behind the Duke stand two young men whose coiffures and dress suggest figures from the scenes of April, May, or August. One of them casually leans on the back of the Duke's chair. They might be close family members or princes of his retinue.

A prelate with sparse white hair and a purple coat sits on the Duke's right, thanking him for this honor. He is probably a close friend, Martin Gouge, Bishop of Chartres, who shared the Duke's love of beautiful books. Behind him several figures are seen entering and stretching their hands toward the fire; the chamberlain encourages them, saying *"Approche approche!"* "Come in, come in!" Other figures follow, including a man with an angular, willful face, who wears a cap folded over one ear. Paul Durrieu *(Les Très riches Heures de Jean de France, duc de Berry, p. 131)* believes Paul de Limbourg intended this figure to be a self-portrait, a hypothesis which appears all the more credible since the coifed head reappears in two other books of hours by the Limbourgs: the *Petites Heures* (Bibliothèque Nationale, Paris) and the *Belles Heures* (The Cloisters, New York). If the hypothesis were carried even further, we could identify a hooded figure greedily drinking from a cup as one of the brothers, and the woman behind him, whose face is partially hidden, as Paul de Limbourg's wife, Gillette le Mercier, the daughter of a Bourges burgher. A cup-bearer, a pantler, and a carver, busy waiting on table in front of the officers of the ducal court, complete this lively tableau which recreates a familiar scene from the life at the court of Jean de Berry.

For a description of the figures in the tympanum above, see the month of November (no. 12).

<div align="right">[F. 2r]</div>

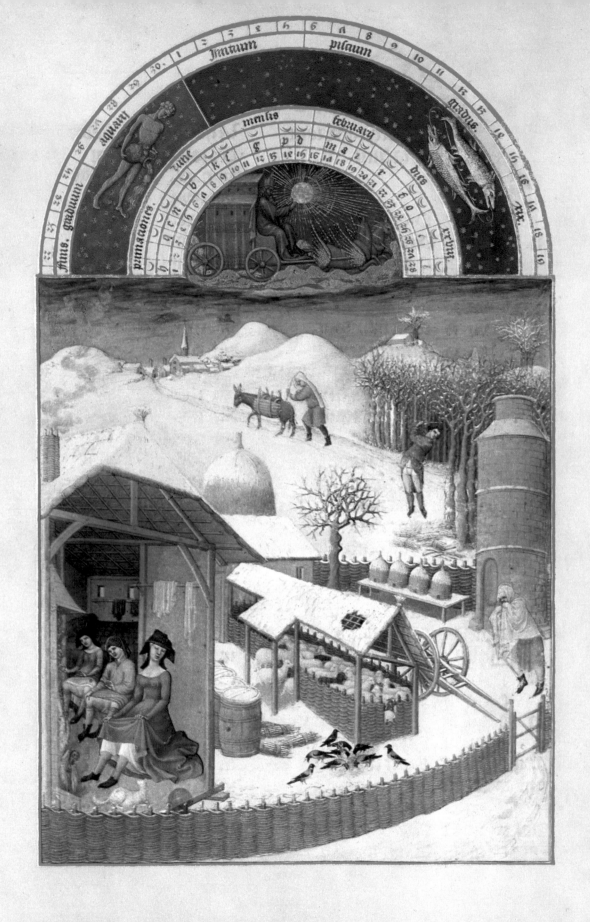

3. February

The Limbourgs chose a winter scene to represent this month, often the coldest of the year. They have painted it with extraordinary veracity, rendering details with a realism that captures the atmosphere of this harsh season. Pale light from a wan sky falls onto the whitened countryside. The starkness of the snow underlines planes and accentuates details, giving the landscape a particular sharpness. In the distance a village hides its snow-covered roofs between two hills. A peasant on the road approaches the town, driving his donkey laden with the goods he intends to sell there.

In the foreground a farm is represented, its every element executed with meticulous care: the dovecote, beehives, cart, casks, sheepfold, a bare tree, the house and the wattled enclosure.

Near the farm a young man cuts wood; in front of the dovecote a benumbed figure clutching a wool coat over his head and shoulders hurries home. A large fire shines from the wooden house in which two peasants immodestly warm their legs while the mistress of the house, elegant in a lovely blue dress, warms herself with more decorum. Linen has been hung to dry on rods along the walls, and smoke curls from the chimney. The severity of winter is further emphasized by the birds huddled near the house, scratching for food which the snow makes it impossible to find elsewhere. Everything in this picture of winter is noted with care and rendered with skill, attesting to the painters' power of observation and the perfection of their art.

[F. 2v]

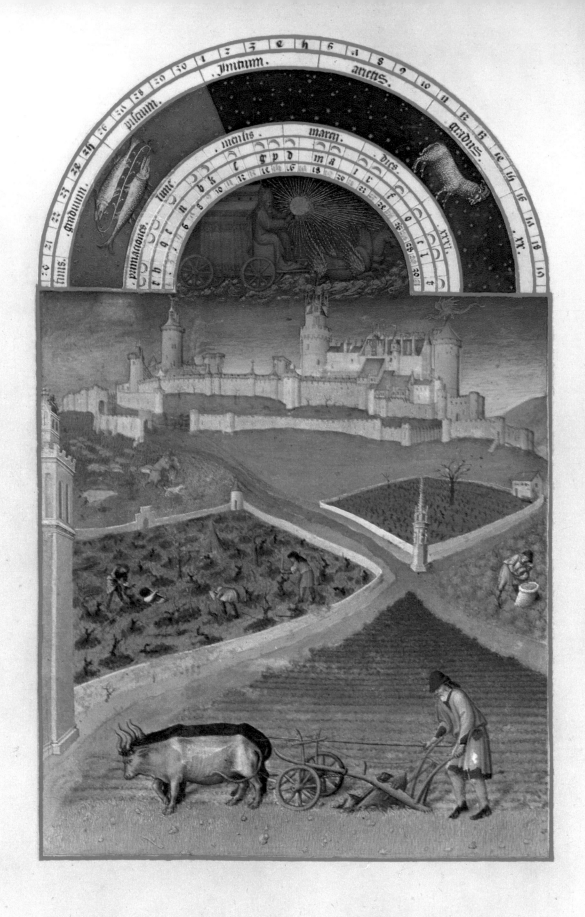

4. March

The Limbourgs present here the year's first farm work, in a broad landscape at the foot of the Château de Lusignan. Several scenes of country life are juxtaposed. On the upper left, a shepherd and his dog watch a flock of sheep; below them, three peasants trim vines within an enclosure; on the right, another enclosure, with a house, seems to surround more vineyards; below that, a peasant leans over an open bag. A small monument known as a *Montjoie* rises at the intersection of paths separating the different plots; a customary sign or milestone, it resembles one on a subsequent page representing the Meeting of the Magi (no. 48).

A beautiful picture of plowing occupies the foreground. A white-bearded peasant wearing a surcoat over a blue tunic holds the plow handle with his left hand and goads the oxen with his right. The two oxen are differently colored; the fine reddish hide of the near one stands out in relief against the other, black, animal. Every detail of the plow is carefully recorded. The plowshare penetrates earth covered with faded winter grass, churning it into furrows that are distinctly marked by already dried blades of grass.

These rustic scenes are dominated by the powerful Château de Lusignan, above which hovers the fairy Mélusine, protectress of the château who turned into a winged dragon on Saturdays, recalling the legend of its construction. (Mélusine promised to make Raimondin, son of the king of the Bretons, the first nobleman of the realm if he married her, on condition that he never see her on Saturday, the day of her metamorphosis. Raimondin's curiosity got the better of him, and Mélusine flew away from the château in the form of a winged dragon.) The artists have meticulously depicted the château's different parts: the Tour Poitevine below the fairy, the queen's quarters, the Tour Mélusine, the Tour de l'Horloge, the Barbacane, and the two enceintes. This was one of the Duc de Berry's favorite residences; the improvements he made on it are evident in the high windows of the royal quarters and the Tour Mélusine.

The month of March is the first of the great landscapes favored by the Limbourgs in the *Très Riches Heures*. It is rendered with such veracity that one wonders if they had access to some optical device, a dark room, or rather a "light room," which would have lent such linear and proportional exactitude to their work. Furthermore, with the delicacy of their brush they have achieved an extraordinary precision of detail without detracting from the overall effect of grandeur imparted by Mélusine's château forcefully standing out against the blue sky.

[F. 3v]

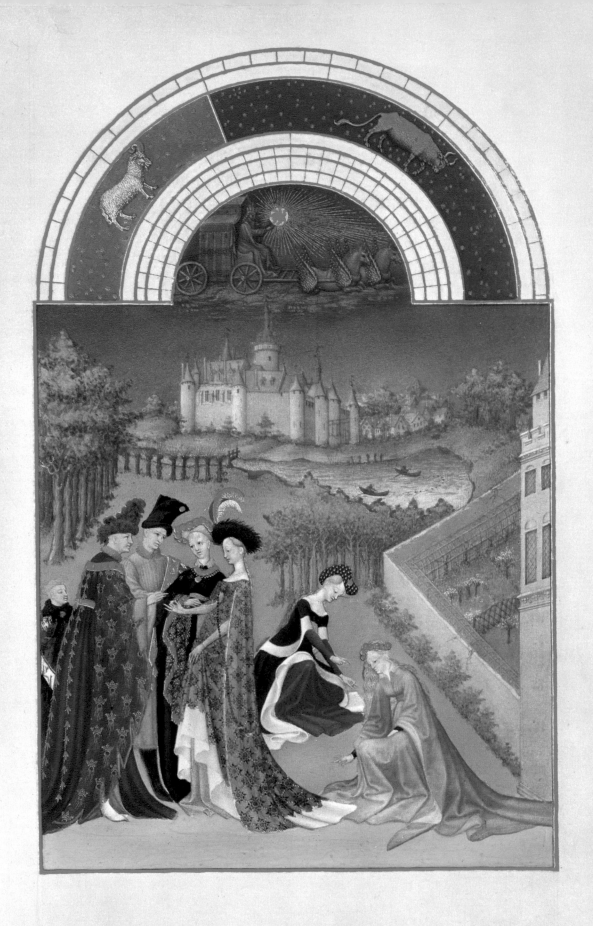

5. April

Le temps a laissé son manteau
De vent, de froidure et de pluie,
Et s'est vestu de broderie,
De soleil rayant, cler et beau.

"Time has shed its cloak / of wind, rain and cold, / to assume the embroidery of the sun, shining bright and beautiful." So sang the prince and poet, Charles d'Orléans, at this time. Nature revives. Fields and woods turn green once more; flowers spring from the fresh grass. One and all celebrate this rejuvenation and become a part of it.

The scene is at Dourdan, the property of the Duc de Berry from 1400, improved and fortified by him. The towers and dungeon of the château, whose ruins are visible to this day, rise at the top of a hill. Crowded nearby is the village. At its foot flows the Orge upon which two boats are seen. Figures in chatoyant robes are grouped against the green background of fields, meadows, and woods. Two maidens bend to pick violets while a betrothed couple exchange rings before their parents. The composition is admirable: the figure groups make up a rounded pyramid. Contrast emphasizes the colors of the sumptuous garments: the fiancée's pale blue stands out against the mother's black, the beautiful pink of the maiden kneeling in the foreground opposes the dark blue of the other girl. The fiancé wears princely apparel strewn with golden crowns. Expressions are rendered with subtlety: the fiancé searches the face of his betrothed while presenting her with the ring toward which she extends her finger and lowers her eyes. The mother is visibly moved; the father turns to look affectionately at his daughter. The Limbourgs have created a harmony of color, composition, and emotion that is perfectly attuned to the scene represented and to the charm of the new season.

The artists seem to have attempted to represent a real event, about which several hypotheses are feasible; we suggest the following one. In April, 1410, at the time the illustrations for the *Très Riches Heures* were begun, the Duc de Berry's eleven-year-old granddaughter, Bonne, daughter of Bonne de Berry and the Comte Bernard d'Armagnac, became engaged to Charles d'Orléans, who was then sixteen. An agreement was reached at Gien and the wedding was celebrated four months later at Riom. The couple might have met at Dourdan since the Duke had put the château at the disposal of his future grandson. Thus the miniature could recall the family gathering when Charles was bound to the one of whom he was later to say, *"Ah! qu'il fait bon regarder, la gracieuse, bonne et belle!"* "Ah! how good it is to watch her, graceful, kind, and beautiful!" Although this is only a hypothesis, it is a fairly likely one, which would well befit the charm of the painting.

[F. 4v]

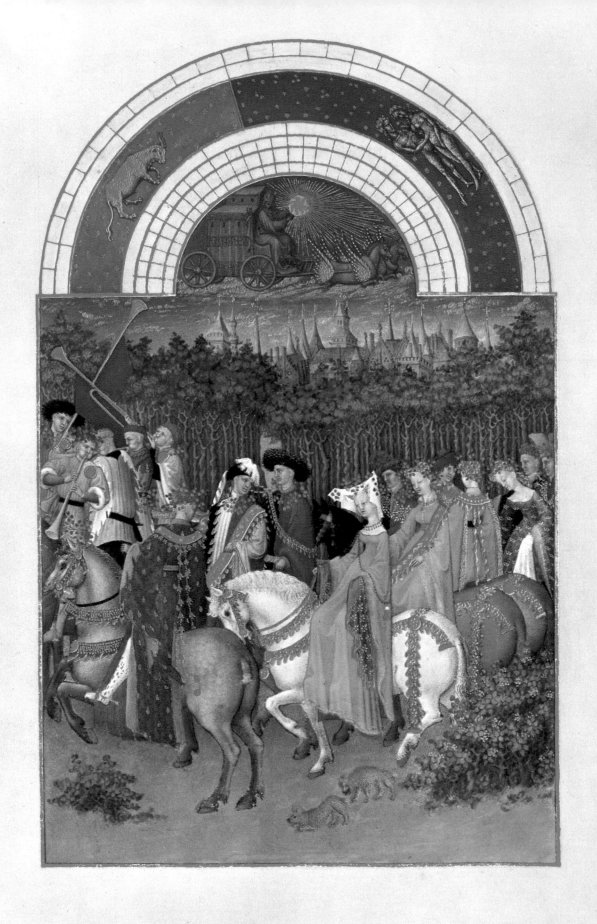

6. May

"*C'est le mai, c'est le mai, c'est le joli mois de mai!*" ("It's May, it's May, the beautiful month of May!") As the song of old went, so the figures of this merry pageant seem to be saying to one another. On the first of May, following a tradition derived from the *floralia* of antiquity, young men used to make a light-hearted jaunt through the country and bring back branches. On that day one had to wear green at the risk of being ridiculed. This is the origin of the expression "*Je vous prends sans vert*" ("I've caught you napping"). In his youth the Duc de Berry liked to take part in this festivity, and at court the King would distribute garments made of cloth *vert gai* in color and known as *livrée de mai*.

This garb is worn by the three girls riding horses caparisoned in a refined soft green, a color obtained from the crushed crystalline stone, malachite. The sumptuous dress lined with blue and ornamented with gold flower-work identifies the girls as princesses. One, wearing a white headdress decorated with green leaves, dominates the middle of the scene. Turning to contemplate her is a rider dressed half in red, half in black and white, the royal livery of France at that time; he is probably a prince of the blood. At the girl's left rides a man dressed in a rich blue brocaded coat strewn with golden flowers: could it be the Duc de Berry? In front, musicians lead the gay group of amiable riders to the sound of their trumpet, flute, and trombone. They are accompanied by the Duke's small dogs which frisk about the horse's hoofs.

Roofs, towers, and the tops of tall buildings appear behind the wooded background. The architecture at times has been identified as the Château de Riom, capital of Auvergne and part of the Duke's appanage; however, it bears little resemblance to old representations of this château. On the contrary, it is undoubtedly similar to the Palais de la Cité in Paris (included in the month of June). Such precise details as the gables, chimneys, battlements, and weathervanes obviously form the roofs of the Palais. On the left, the square tower with a bartizan would be the Châtelet on the right bank of the Seine. Then, after a gap and behind the turret of a corner building, are the top of a corner tower, the two towers of the Conciergerie, and the Tour de l'Horloge, all four of which still exist on the Ile de la Cité. Farther on stand the twin towers of the Grand Salle of the Parlement, and at the extreme right the Tour Montgomery, seen from the rear. Therefore this pretty scene must have been set in the woods bordering the rue du Pré-aux-Clercs, near what is now the rue de Bellechasse.

[F. 5v]

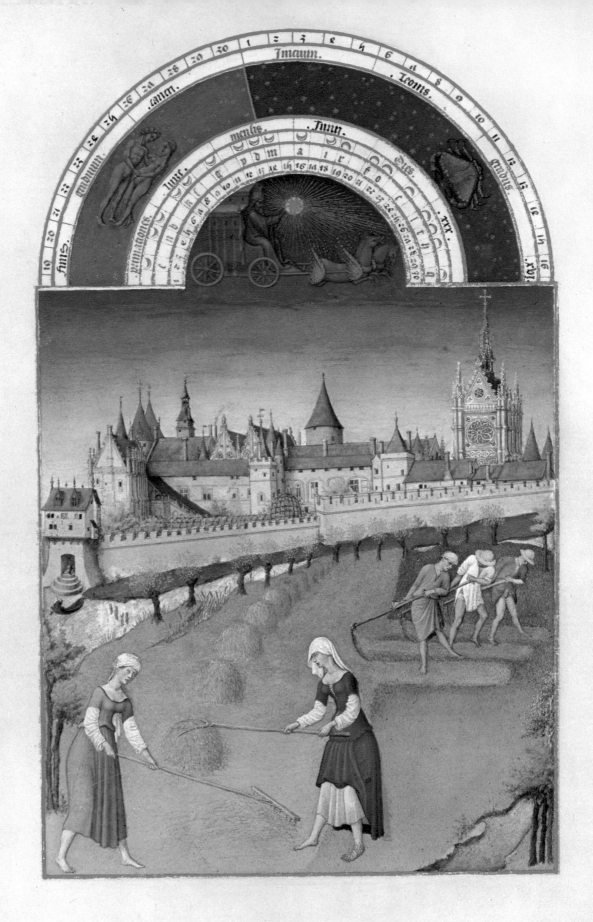

7. June

It is harvest time; scantily-clad peasants wearing hats mow the wide meadow in unison. Every detail of the operation is carefully observed and rendered. The freshly mown area stands out brightly against the untouched grass, and the already fading shocked hay is still different in color. In the foreground two women rake and stack the hay. The grace, one might even say the elegance, imparted by the fragility and flexibility of these simply-dressed reapers is typical of the mixture of perception and charm that characterizes the Limbourgs' genius.

The view, from the Hôtel de Nesle (the Duc de Berry's Paris residence and the present site of the right wing of the Institut de France which now houses the Bibliothèque Mazarine) encompasses the fields on either side of the Seine and the inner facade of the Palais de la Cité. The slate roofs of the Palais rise against a blue sky, providing a large dignified background for this rustic scene; the minutely recorded details of this interior facade are particularly precious. We find ourselves before the buildings whose roofs were represented in the month of May: the corner pavilion, the Conciergerie towers, the Tour de l'Horloge, the double nave of the Grand Salle, the Tour Montgomery, and the Sainte-Chapelle in all its refined splendor. Before this facade, we glimpse trees in a garden partially hidden by the enceinte. These walls terminate at the left in a curious door opening onto the Seine. A boat on the river bank completes this scene of the month of June, to which the artists imparted both rustic grace and grandeur.

[F. 6v]

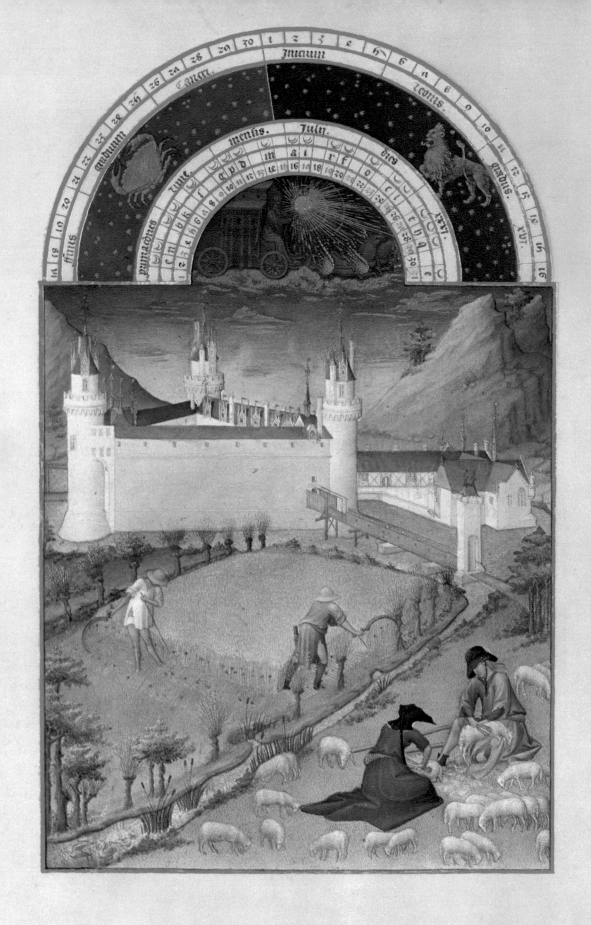

8. July

The Limbourgs represent here the rustic activities of the month of July, the harvest and sheep shearing, in the vicinity of the Château du Clain in Poitiers. Poitiers was, in fact, one of the Duc de Berry's habitual homes, a part of his appanage like Berry and Auvergne.

Two peasants reap, not with scythes as in the haymaking, but with sickles. One, closely resembling a harvester in the month of June, wears a straw hat and a simple shirt under which appear his drawers or *petits draps* as they were then called. Every detail of the wheat is minutely rendered. The heads are more golden than the stalks and both are speckled with flowers; on the ground lies the mown wheat, not yet bound in sheaves but already drier than the rest. At lower right a man and and woman proceed with the sheep shearing. Each holding an animal on one knee, they cut the wool with a kind of shears called *forces;* the shorn wool accumulates at their feet.

This miniature is a precious document of a château that no longer exists. The Duke had reconstructed the triangular building thirty or forty years before. This view is from the right bank of the Clain. A wooden footbridge leads to the right tower, resting on three stonework piers that still stand in the riverbed; at one end a moveable bridge leads to a rectangular entrance tower, and at the other a drawbridge is attached to the château. We glimpse a chapel to the right of the château amid buildings separated from it by an arm of the river. The towers are constructed in the style favored by the Duke and evident in his various châteaus: corbelled with machicolations and crenatures, and decorated in the interior courtyard with high windows. In the background the artists have painted conventionally shaped mountains, the asymmetrical cones often found in their works.

[F. 7v]

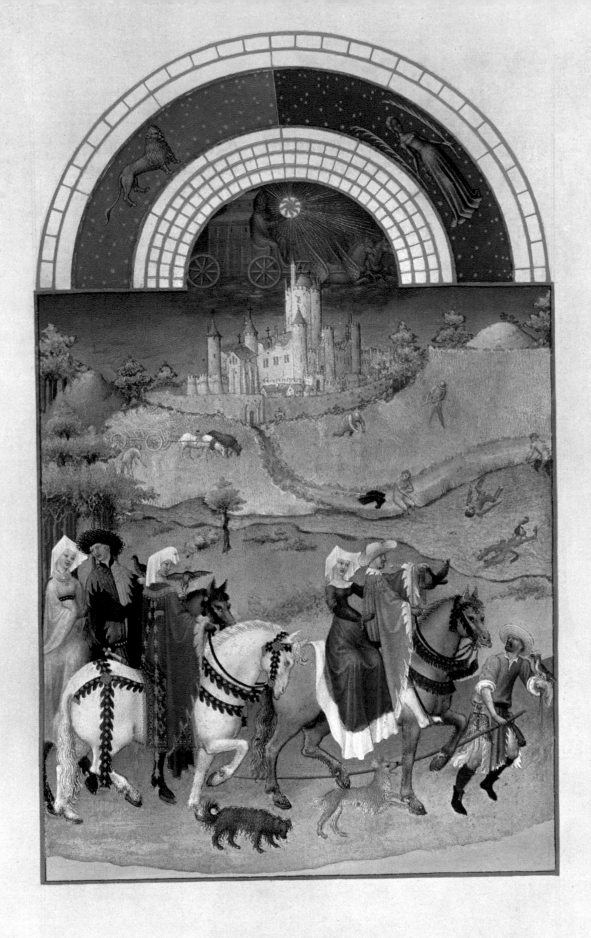

9. August

This scene is at Etampes which, like nearby Dourdan, belonged to the Duc de Berry and which he put also at the disposal of Charles d'Orléans. A richly dressed horseman, wearing a white hood and bearing a falcon on his fist, leads two couples hawking. Leading on foot, a falconer holds two birds on his left fist and drags a long pole in his right hand. He is followed by a rider wearing a hat with upturned brims and an ultramarine cloak, carrying behind his saddle a maiden dressed in a gray frock trimmed with a white flounce; the rider releases a falcon from his right hand. Another couple appears, perhaps more concerned with an amorous conversation than with the hunt. And, as in the month of May, small dogs accompany the riders.

The Château d'Etampes commands the scene. We can distinguish towers, the chapel, and buildings covered with tiles. In the midst rises the quadrangular twelfth-century dungeon, the Tour Guinette, flanked by corner towers which still exist. The inventories made upon the death of the Duc de Berry attest to the pleasure he derived from his stays here.

On the hills, peasants bind into sheaves the newly mown wheat and pile the harvest onto an overloaded cart. Swimmers frolic in the Juine. A figure, obviously female, has just undressed and is preparing to enter the water; another is emerging; two more are already swimming. The deformation of the figures' appearance by the water's refraction has been carefully observed and curiously rendered.

All of this varied scene recalls the diversions of court life amid the seasonal work of the country. Thus we review, from one month to the next, the daily life of the court of the Duc de Berry.

[F. 8v]

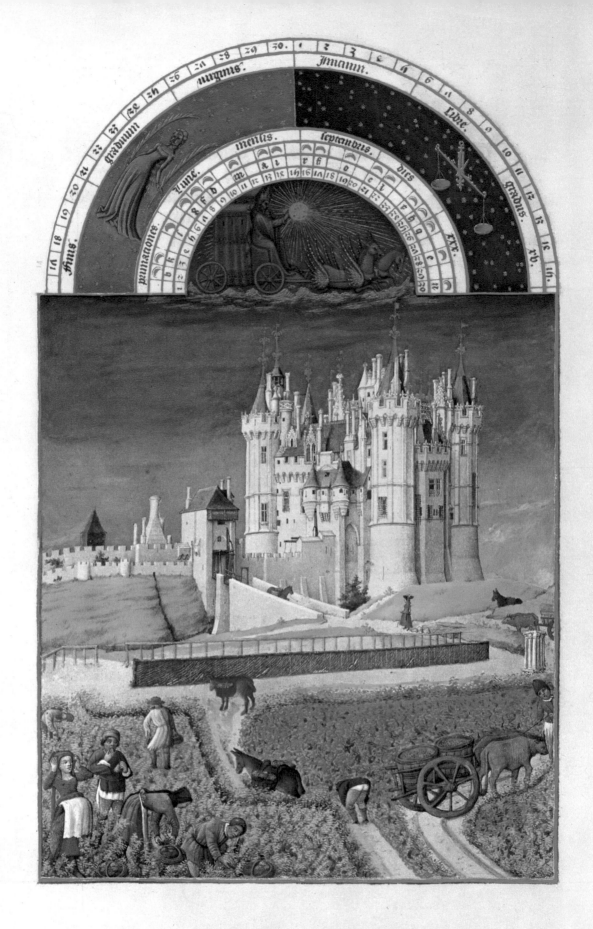

10. September

This representation of the grape harvest at the foot of the Château de Saumur is distinctive because it was begun by Paul de Limbourg and his brothers, and completed seventy years later by Jean Colombe. The different styles are evident in the tonalities of color, delicacy of techniques, and nature of the figures. The Limbourgs executed the upper two-thirds. Traditionally, the background was, in fact, the first part of a miniature to be executed; sky, landscape and architectural decor were then followed by the foreground, figures, and last of all the faces, as we shall see later in the Procession of Saint Gregory (nos. 73-74).

The Château de Saumur, near Angers, belonged to a nephew of the Duc de Berry, Duc Louis II d'Anjou, who had completed its construction at the end of the fourteenth century. It appears here in all its fresh newness: chimneys, pinnacles and weathervanes crowned with golden fleurs-de-lys thrust skyward. It is drawn in a firm bold line that includes every detail and reveals the sure hand of that one of the three brothers attracted to architectural representations and responsible also for the Palais de la Cité in June and the Louvre in October. The château stands to this day, although the crowning crenelations have disappeared, and is easily recognizable in this miniature by the buttressed towers, battlements, glacis, and general arrangement of the buildings.

On the left we glimpse a belfry that might belong to the church of Saint-Pierre; next is a monumental chimney with secondary stacks undoubtedly belonging to the kitchen and comparable to those at the nearby abbey of Fontevrault; and last, a drawbridge entrance from which a horse walks while a woman with a basket on her head approaches.

The harvest scene itself was executed by Jean Colombe. He probably worked over a sketch by the Limbourgs since miniatures were completely and lightly drawn before being painted. We can see the gathering of the grapes in the famous Angevin vineyard. Aproned women and young men pick the purple-colored clusters of grapes and fill baskets to be loaded into hampers hanging from the mules or into vats on the wagons. One of the mules burdened with baskets is in the section painted by the Limbourgs and was probably executed by them. Compared to that of his predecessors, Jean Colombe's work is less refined: the touch is less delicate, the color more blurred and dull, the figures shorter and less elegant. Although Jean Colombe was a good miniaturist, his work does not bear close comparison with Paul de Limbourg's; especially here in the same painting where the difference in methods stands out obviously. Nevertheless, this harvest scene is one of the most picturesque and beautiful in the calendar.

[F. 9v]

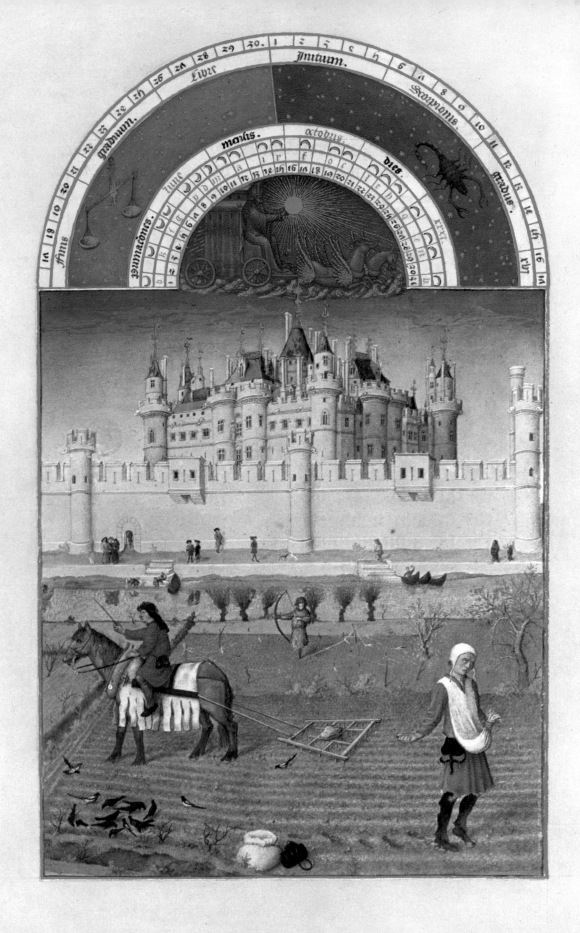

11. October

October, the month of tilling and sowing, is represented along the left bank of the Seine. The view is from the vicinity of the Hôtel de Nesle, the Duc de Berry's Paris residence, from approximately the same vantage point as in the month of June. In June the Limbourgs looked east, while here they turn toward the north; in June they painted the Palais de la Cité, former residence of the kings of France, while here they show the Louvre, the royal residence since the time of Philippe Auguste (reigned 1180-1223). Before us is the imposing mass of the Louvre of Charles V, the Duc de Berry's brother, as seen from the windows of the Duke's hôtel; it is rendered so scrupulously that we can make out its every detail. In the middle rises a big tower, the dungeon built by Philippe Auguste, whose outline is traced in the paving of the château's *cour carrée* (square courtyard). This dungeon, commonly called the Tour du Louvre, symbolized the royal prerogative; from here appanages were granted, and here the royal treasure was housed. In the miniature the dungeon hides the northwest tower, known as the Tour de la Fauconnerie, where Charles V kept the precious manuscripts of his "library." But we can see the three other corner towers: to the right is the Tour de la Taillerie; then the eastern facade protected by twin towers whose outline is also visible on the courtyard paving; farther to the left is the Tour de la Grande Chapelle, followed by the southern facade, also with double towers. Every detail is so precise that even today, several centuries after this Louvre's destruction, a model of it was made possible thanks largely to the Limbourgs' painting. An enceinte marked by towers and machicolated balconies stretches along the Seine in front of the château. At left is a postern. Tiny figures stroll on the quai from which steps lead to the river, giving access to the boats.

In the foreground, in the fields bordering the left bank, a peasant wearing a blue tunic sows seeds that he carries in a white cloth pouch. A bag of grain lies on the ground behind him, beyond which birds peck at the newly sown seeds. At the left, another peasant on horseback draws a harrow on which a heavy stone has been placed to make it penetrate more deeply into the earth. A scarecrow dressed as an archer and strings drawn between stakes both help discourage birds from eating the seeds. This scene of country life in the shadow of the royal residence gives us a vivid image of the outskirts of Paris at the beginning of the fifteenth century.

[F. 10v]

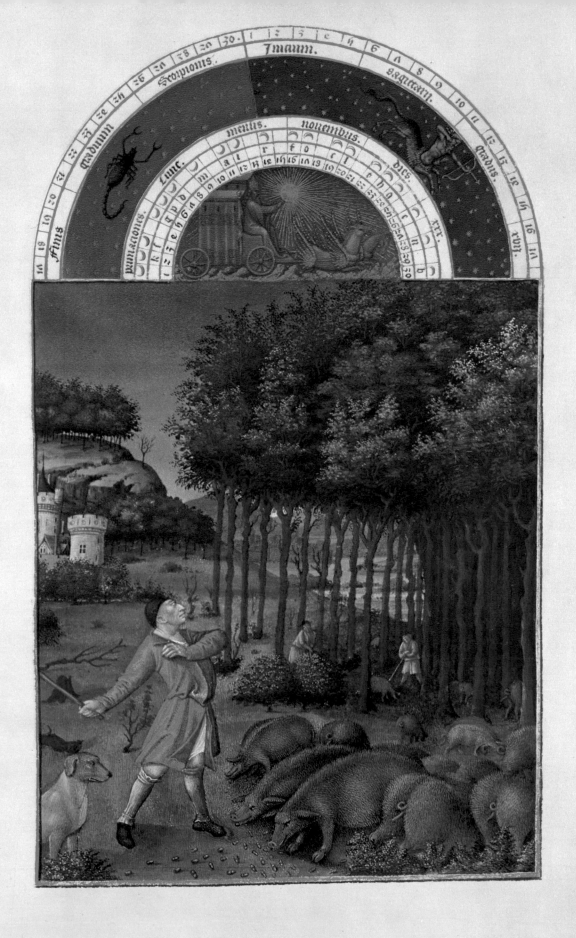

12. November

The scene of November showing the acorn harvest, a traditional theme for this month, was executed entirely by Jean Colombe. The Limbourgs painted only the tympanum, which—as in the other eleven months—crowns the scene with signs centered around a semicircle painted in blue *camaïeu* (monochrome), in which a man carrying a brilliant sun, as one might present a monstrance, is enthroned on a chariot drawn by two horses. (This image of the sun chariot is taken from a medal, now in the Bibliothèque Nationale, representing the Emperor Heraclius returning the True Cross to Jerusalem. A copy of this coin belonged to the renowned collection of Jean de Berry). Above are astronomical signs and the signs of the zodiac for the month of November in blue *camaïeu* on a background of golden stars: Scorpio at left, Sagittarius at right. The Limbourgs probably painted the tympani for the various months all at one time.

Unlike the other scenes, this does not take place on a famous site that the artists were proud to evoke. The setting, painted with some talent, seems to be a figment of Jean Colombe's imagination, although it might have been inspired by the countryside of Savoie, where the artist completed the *Très Riches Heures* for the Duc de Savoie. The different planes are picturesquely spaced, blending into the blue of the horizon where a sinuous river twists between the mountains. Nearer, the towers of a château and a village cling to the rocks. In front, a peasant dressed in a tunic with golden highlights draws back his arm and prepares to hurl a stick into an oak tree. At his feet, pigs greedily eat the fallen acorns under the watchful eyes of a dog. We see other peasants with their pigs under the trees. The scene is painted in muted tones that at first glance differentiate it from the other months but do not detract from it. It has an agreeable quality; only the animals do not have the muscular vigor that the Limbourgs were able to impart to their creatures on the following page.

[F. 11v]

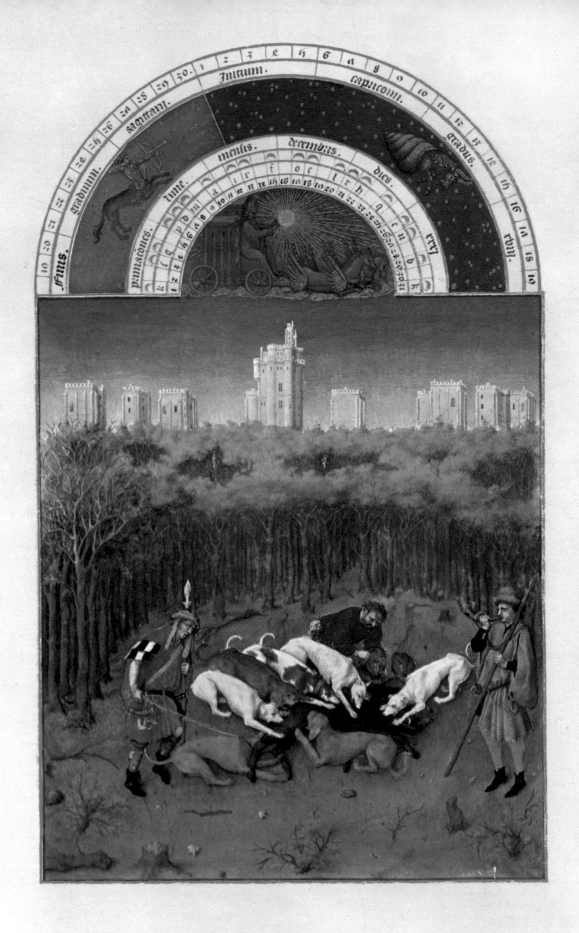

13. December

With the month of December, representing the end of a wild boar hunt in the forest of Vincennes, we return to the Limbourgs and the Duc de Berry. The dungeon and square towers rising above the trees are those of the home in which the Duke was born on the eve of December: November 30, 1340. At that time the Château de Vincennes had not reached the proportions shown here, and the dungeon, begun three years before, consisted only of its foundations.

The enormous rectangular enclosure flanked by the nine towers seen in the miniature was undertaken only in 1364 by Charles V, *"sage artiste, savant architecteur"* ("wise artist, learned architect") in the words of his biographer Christine de Pisan (c. 1365-after 1430), to make the château *"la demeure de plusieurs seigneurs, chevaliers et autres ses mieux aimés"* ("the home of several lords, knights and other beloved ones"). He subsequently deposited part of his art treasures, precious manuscripts, and fortune here. Several towers of the ensemble were partially razed during the course of the centuries. Still standing in their entirety, however, are the main tower which served as entrance and the magnificent dungeon that Jean Fouquet (born c. 1420), some time after the Limbourgs, painted in a miniature in the *Heures d'Etienne Chevalier*.

The forest of Vincennes attracted many kings of France. Louis VII built a hunting lodge there; Philippe Auguste undertook the construction of a small château enlarged by Saint Louis, who, as we know, liked to dispense popular justice under one of its oaks. This is the wood we see represented here in the russet tones of a waning autumn. The boar has been run down and speared by the huntsman on the left, and hounds are tearing it apart. At the right a hunter blows the mort on his small horn. The dogs' desperate eagerness is rendered with astonishing realism: their positions, the gestures of their paws, their greedy expressions, all have been observed and noted with care. These are bloodhounds, boarhounds, hounds whose breeding an expert would recognize immediately. This scene is perhaps the liveliest in a calendar full of lively images; it completes the year in an appropriate setting and time, recalling the birth of the Duc de Berry.

[F. 12v]

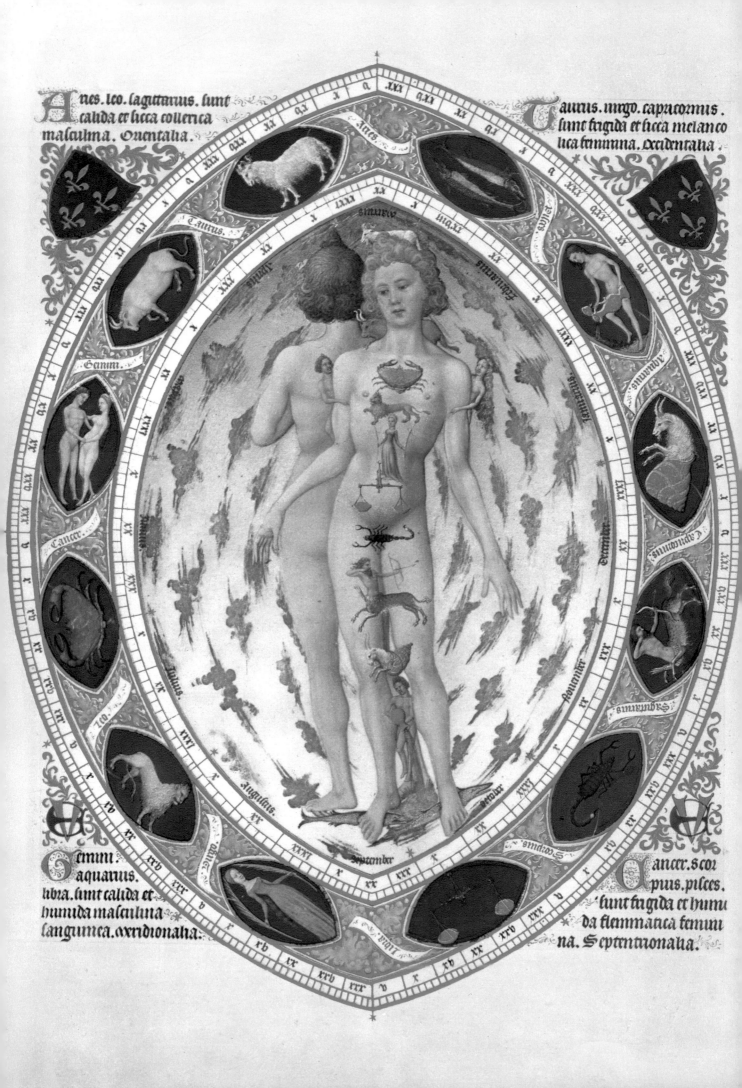

14. Anatomical Man

This symbolic picture, of a type found in calendars of the late fifteenth century and known as an "anatomical man" ("astrological man" would be a better appelation), exists in no other illuminated manuscript. An extension of the calendar, to which it was added in the form of an inset page, the present example is a remarkable exception explained by Charles V's passionate interest in astrology, shared by his brothers and satisfied by his astrologer, Thomas Pisani, father of the celebrated Christine de Pisan.

The miniature claims to show the influence of the zodiacal stars on the human body. According to the comments inscribed in the corners, humanity can be divided into several different categories. First, temperaments are based on one of the four traditional humors: sanguinous or full-blooded, phlegmatic or lymphatic, choleric or bilious, and melancholic or acrimonious. Man may be further categorized according to his degree of heat or dryness, according to the proportion of masculinity or femininity of his character, and finally, what is more obscure, in relationship to the cardinal points. Combinations of these categories result in four main groupings of the signs of the zodiac: Aries, Leo, and Sagittarius are hot and dry, choleric, masculine, and oriental; Taurus, Virgo, and Capricorn are cold and dry, melancholy, feminine, and occidental; Gemini, Aquarius, and Libra are hot and wet, masculine, sanguinous, and meridional; Cancer, Scorpio, and Pisces are cold and wet, phlegmatic, feminine, and nordic. Such categories and connections were held dear in the Middle Ages.

Two figures standing back to back illustrate these categories. The frontal figure is slenderer and obviously represents the feminine character; the figure seen from the back and only in part is more vigorous, representing the masculine character. One is blonde, the other dark in contrast. The Limbourgs succeeded in making a graceful image of these figures. Fernand de Mély has noted that the female figure seems to be inspired from an ancient group of the Three Graces, now in the Museo dell'Opera del Duomo, Siena. The signs of the zodiac are shown on the figure at the points where they influence the human body: Aries the ram is at the head, Taurus the bull at the neck, and so on to Pisces at the feet.

In an almond-shaped band around both figures the signs of the zodiac are repeated, a little differently from those in the calendar months but not without grace. Above, just under the inscriptions in the upper corners, are painted the arms of the Duc de Berry, while in the lower corners are the mysterious initials, VE, inexplicably adopted by him.

[F. 14v]

15. Saint John on Patmos

Following the calendar, the text of a Book of Hours began with extracts from the four Gospels, starting with Saint John: "In the beginning was the Word. ..." The Limbourgs illustrated this first excerpt with a large miniature representing John on Patmos, the island to which, according to tradition, he was exiled by the Emperor Domitian, and where he received the revelation recorded in the Apocalypse.

Patmos, an island of the Dodecanese or Sporádhes, is shown here as a desert isle. The boat which has brought the apostle pulls away toward a distant shore where the buildings of an unknown city appear indistinctly. John is young and beardless; beside him stands his principal attribute, an eagle, shown here with spread wings and a portable inkstand in his beak.

Three mysterious trumpets ring in John's ears, figuring the verse from the Apocalypse: "I ... heard behind me a great voice, as of a trumpet. ..." (Apocalypse I: 10) In the clouds above appears the vision John is about to describe in his book: "I saw... one like to the Son of man. ..." (Apocalypse I: 13) On the Lord's knees are the Lamb and the scroll with seven seals mentioned later in the Apocalypse; seated around His throne are twenty-four elders in white robes and golden crowns.

In the lower border decorative initials from which delicately painted foliage falls, ending in frail violets, give us a first glimpse of the rich and varied ornamentation of the *Très Riches Heures*.

[F. 17r]

16. Saint Matthew

Between the large miniatures of Saints John and Mark, the Limbourgs represented the other two Evangelists in small illuminations the width of one written column. An illustrated extract from Luke is followed by Saint Matthew's description of the Adoration of the Magi, beginning: "When Jesus therefore was born in Bethlehem of Juda, in the days of king Herod, behold, there came wise men from the East to Jerusalem. ..." (Matthew II: 1) We suppose the Limbourgs illustrated this text with the appropriate Evangelist, although the ox above the miniature is usually an attribute of Saint Luke.

Matthew is shown against an archaic background of blue *camaïeu*. He is characterized by a flowing white beard and hair. Inspired by the Holy Ghost, in the form of a dove, he sits on a high-backed chair in the arm of which is an inkstand into which he dips his pen to write on a desk. Before him a small table is crowned by a statue of a prophet similar to that of Moses in the Annunciation from the *Belles Heures* (folio 30r). On the right we see a château atop a hill, which stands out against the blue background of foliage.

[F. 18v]

17. Saint Luke

The extract from Saint Luke is related to the Annunciation: "And in the sixth month, the angel Gabriel was sent from God into a city of Galilee, called Nazareth." (Luke I: 26) By the same error which led the Limbourgs to represent an ox, the attribute of Luke, above Matthew, the angel traditionally attributed to Matthew appears over the miniature of Luke.

The Evangelist is shown against an archaic blue background with gold foliage which, along with the squared, lozenged, or floral ground favored in the fourteenth century, appears in many of the small miniatures in the *Très Riches Heures* but rarely in the large ones.

Luke sits on a high-backed chair and writes on a kind of desk. The beloved Greek physician who accompanied Saint Paul on all his journeys is inspired by the Holy Ghost again shown as a dove, and a ray of light falls on him from heaven.

Above, the angel sits on a magnificent branch and unrolls a scroll. In the left margin blooms more foliage, on which a bird seems to peck at a flower bud.

[F. 18r]

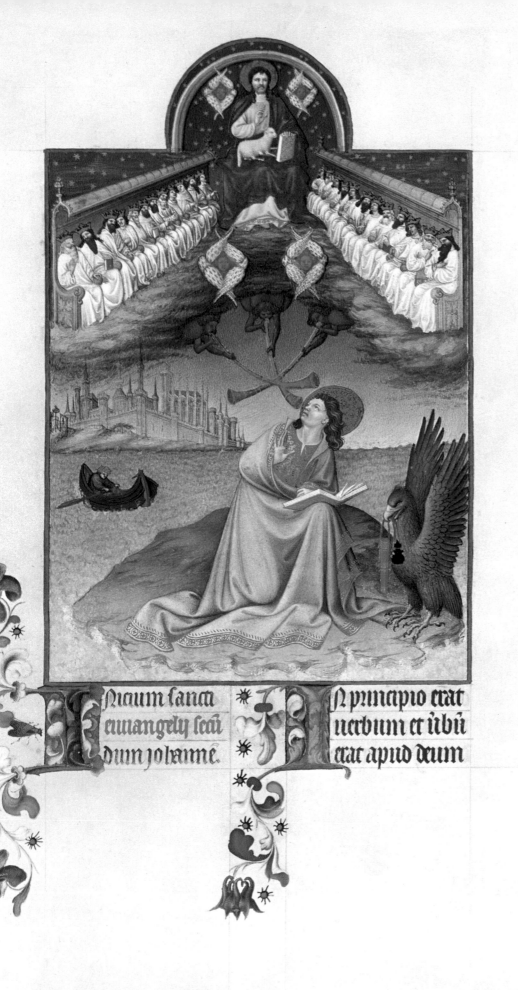

Incipit sancti
euuangely secū
dum Johannē.

In principio erat
uerbum et ūbū
erat apud deum

gelum. Quo modo fieri
istud quoniam uirum
non cognosco. Et respon
dens angelus: dixit ei.
Spiritus sanctus super
ueniet in te et uirtus al
tissimi obumbrabit ti
bi. Ideoq; et quod nascet
ex te sanctum uocabitur
filius dei. Et ecce elizabeth
cognata tua: et ipsa con
cepit filium in senectu
te sua. Et hic mensis e
sextus illi: que uocatur
sterilis. Quia non erit
impossibile apud deu
omne uerbum: dixit
autem maria. Ecce a
cilla domini: fiat mi
chi secundum uerbum
tuum. Deo gracias.
Secundum matheum.

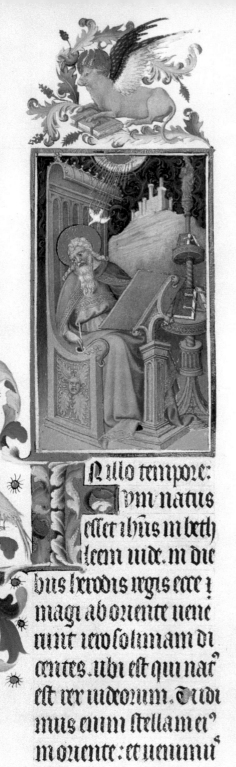

IN illo tempore:
Cum natus
esset ibus in beth
leem iude. in die
bus herodis regis ecce i
magi ab oriente uene
runt ierosolimam di
centes. ubi est qui nat
est rex iudeorum. Uidi
mus enim stellam ei[us]
oriente: et uenimu[s]

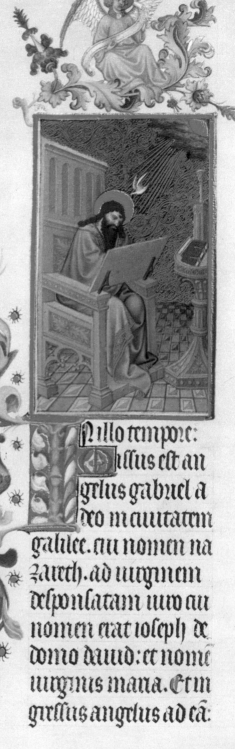

dixit. Aue gracia plena
dominus tecum: bene
dicta tu in mulieribus.
Que cum audisset tur
bata est in sermone eius.
et cogitabat qualis eet
ista salutacio. Et ait
angelus ei. Ne timeas
maria: inuenisti enim
graciam apud deum.
Ecce concipies in utero
et paries filium: et uo
cabis nomen eius ihe
sum. Hic erit magnus
et filius altissimi uo
cabitur. Et dabit illi
dominus deus. sedem
dauid patris eius et re
gnabit in domo iacob
ineternum. Et regni
eius non erit finis. Di
rit autem maria ad an

In illo tempore:
Missus est an
gelus gabriel a
deo in ciuitatem
galilee. cui nomen na
zareth. ad urginem
desponsatam uiro cui
nomen erat ioseph de
domo dauid: et nomen
uirginis maria. Et in
gressus angelus ad eam:

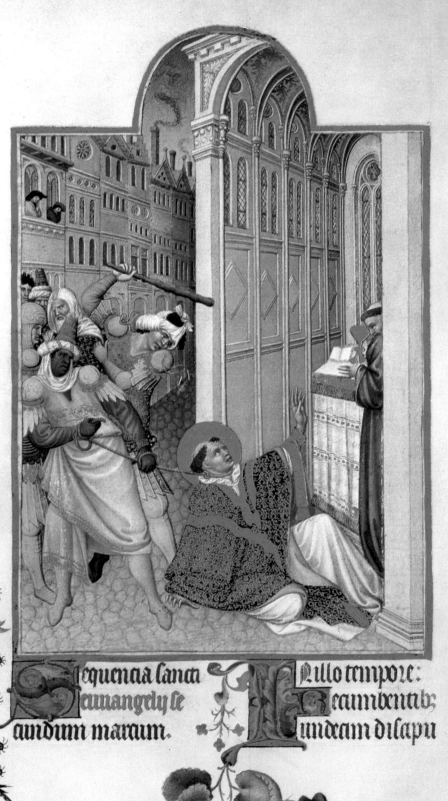

18. The Martyrdom of Saint Mark

The Acts of the Apostles tell of a John Mark, a disciple of Paul and Peter, who is traditionally identified as the author of the Gospel of Saint Mark. He journeyed with Paul and Barnabas on their first mission (Acts XII-XIII) and later was with Paul in Rome (Colossians IV: 10), where he probably wrote his Gospel. According to *The Golden Legend* of Jacopo da Voragine, Peter asked Mark to go to Alexandria to spread the word of God. While Mark was celebrating Easter service, heathens slipped a noose around his neck, screaming, "Let us drag this cowherd to the garbage heap." He was dragged through the streets of the town to prison, where Christ appeared to comfort him, saying, "Peace be with you, Mark, my evangelist!"

The Limbourgs have represented the suffering and martyrdom of Mark at the head of an extract from his Gospel relating the apparition of the Resurrected Christ to His disciples. The Negro who has pushed the vestmented saint from the altar at which he was officiating, tightens the noose; the movements of both tormenter and tormented, for example, Mark's right hand, have been rendered with great naturalism. Behind them another pagan raises a club to strike Mark, while the deacon in the church, horrified by the scene, appears to try to save the chalice. A crowd has gathered in the street, and people lean out of their windows to see what is happening.

The architectural setting resembles that in the Hours of the Passion (nos. 107-111). On the right, we see the interior of the church and the altar; the walls, decorated with pilasters, ribs, and lozenges, are painted in the grayish-green frequently used by the Limbourgs for interiors. On the left, tall narrow houses of various colors line a street and recede beyond the church in linear perspective.

As in the miniature of Saint John on Patmos (no. 15), several lines of the Evangelist's text appear beneath the scene, decorated with two capital letters from which foliage extends into the borders. The simple details of two violets and leaves, painted with extraordinary delicacy and realism, reveal the consummate skill of the Limbourgs.

[F. 19v]

19. The Virgin, the Sibyl, and the Emperor Augustus

The composition of a Book of Hours called for two prayers to the Virgin to follow the passages from the Gospel. Here the first of these prayers, *O intermerata,* is illustrated by three small interdependent miniatures that form an ensemble.

In the upper part the Virgin appears on the moon's crescent, surrounded by flames and radiant light. The figure seems to have been inspired by a miniature in the *Boucicaut Hours* in which a Virgin in Majesty is shown in a similar pose and surroundings.

On the lower left, a crowned and haloed sibyl points to the Virgin. In the Middle Ages Virgil's line from the *Eclogues,* "*iam redit et virgo,*" was interpreted as "already the Virgin returns," and medieval artists often represented a sibyl announcing the birth of Christ to the pagans. In the opposite scene the Limbourgs have shown the Emperor Augustus kneeling to praise the Virgin and Child in a position similar to that adopted at a later date by Rogier van der Weyden in the right wing of the *Bladelin Altarpiece* in Berlin. The Emperor's large white beard, strange diademed hat, voluminous blue robe, and curved sword at his side all recall the representation of the oldest of the three kings in the Meeting of the Magi (no. 48). The unusual diadem seems to indicate the inspiration given the artists by Manuel II Paleologus, Emperor of Constantinople, who spent two years in France at the beginning of the fifteenth century. It is, in fact, exactly like the diadem the Emperor John VIII Paleologus, his son, wears in a medal executed by Pisanello (Paris, Bibliothèque Nationale).

The Limbourgs were the first artists outside of Italy to treat the legend alluded to here, which had originated in Rome. According to it, Augustus, whom the Senate wished to defy for having restored peace to the world, happened to consult the Tiburian Sibyl on the day of Christ's birth. The prophetess saw a circle of gold appearing around the sun, from the middle of which radiated a virgin holding a child, and heard a voice saying, "Here is the altar of the Son of God." Showing the apparition to the Emperor, the sibyl said to him, "Today a king is born who will be more powerful than you." Upon hearing this, Augustus renounced all divine honors and fell upon his knees to worship the Son of God.

[F. 22r]

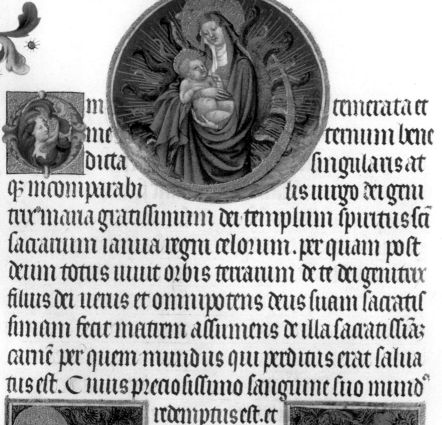

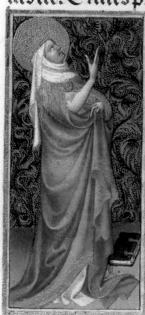

O m uenerata et
 me ternum bene
 dicta singularis at
q̃ incomparabi lis uirgo dei geni
trix maria gratissimum dei templum spiritus sā
sacrarium ianua regni celorum. per quam post
deum totus uiuit orbis terrarum de te dei genitrix
filius dei uerus et omnipotens deus suam sacratis
simam fecit matrem assumens de illa sacratissima;
carnē per quem mundus qui perditus erat salua
tus est. Cuius preciosissimo sanguine suo mundꝰ
redemptus est. et
omnia peccata
et remissa sunt
formans eam ĩ
preciosissimo sā
guine tuo inuest
eam eterne et in
commutabili
diuinitatis sue
a quo bona cūc
ta procedunt p

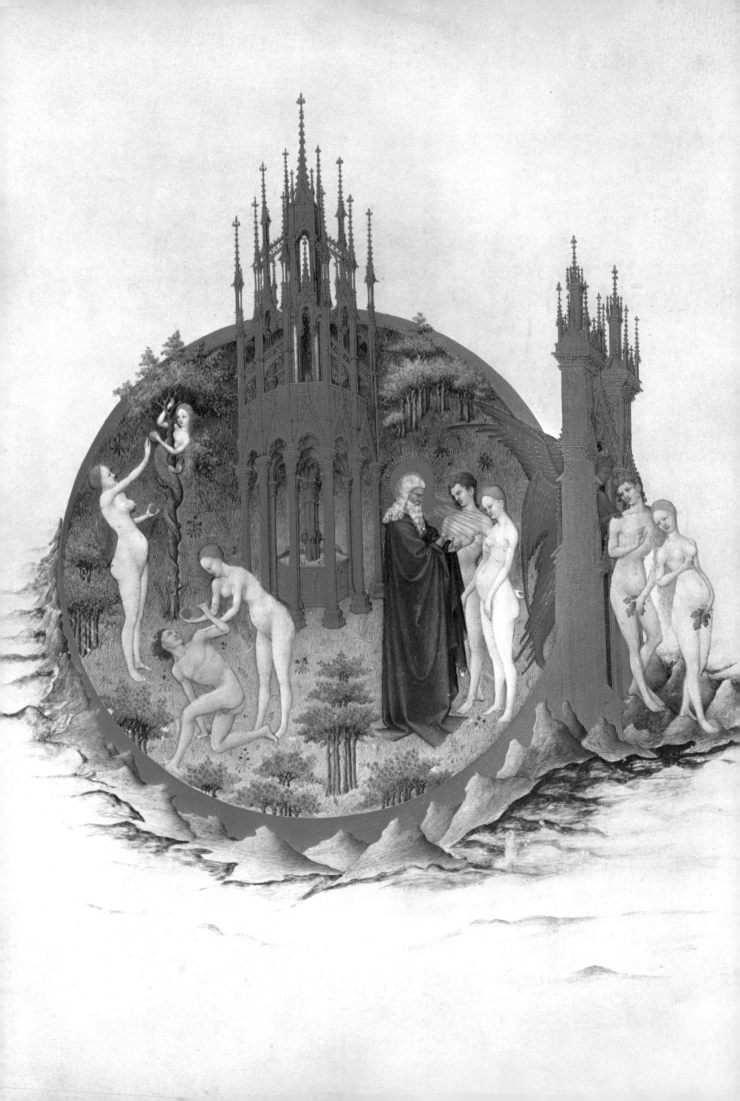

20. The Garden of Eden

As this subject did not usually figure in a Book of Hours, this miniature, so original in conception, composition, and execution, was not planned for the *Très Riches Heures*. It is an inset page, painted separately and added to the manuscript later. Its place here just before the Annunciation was probably determined by the medieval belief that the fall of Adam had brought about the coming of the Messiah; in the words of Emile Mâle, "a new Adam come to erase the sin of the old one" (*L'art religieux du XIII^e siècle en France*, p. 223).

In an unusual yet harmonious arrangement, this painting presents four stages in the fall of Adam and Eve. On the left, Eve reaches toward the forbidden tree to take the apple from the hand of the serpent who has assumed the upper part of a female body to become more enticing. Delightedly she brings the fruit to Adam who, half-kneeling in the grass amid the flowers, turns to her with a lovely movement of his body. After eating the forbidden fruit "they perceived themselves to be naked" (Genesis III: 7), and we see God telling them of the punishment for their disobedience. The sequence ends on the right, where a flaming angel drives Adam and Eve from the Garden of Eden. In the center a fountain of delicate openwork separates the scenes of punishment from the first two, which the Limbourgs endowed with a particular grace and poetry inspired by the feelings of innocence, ease, and freedom usually associated with paradise.

The Limbourgs painted Eve after the type of female fashionable at the time, with a high bosom, thin waist, and slightly protruding stomach. Her elegant slenderness was already evident in the brothers' *Belles Heures*, in the figure of Saint Catherine, but here it has firmer, more determined brush strokes and a purer contour. Adam's kneeling body has the nobility of a classical statue; as Paul Durrieu pointed out, "his pose presents many similarities with the School of Pergamon, of which an example is presently in the museum in Aix-en-Provence (*Les Très riches Heures de Jean de France, duc de Berry*, pp. 38-39). Within the miniature's general harmony of colors, the bodies of Adam and Eve contrast with the background of greenery, and the vivid blue robe of the Lord stands out against the gold of the fountain and of the gates of paradise.

[F. 25v]

21. The Annunciation

In the usual sequence of a Book of Hours, the cycle of hours proper followed the extracts from the Gospel and the two prayers to the Virgin. Eight hours of the day supplemented the regular offices of the church: matins, lauds, prime, terce, sext, nones, vespers, and compline. The *Très Riches Heures* includes several series of hours grouped by the object of their devotion: Hours of the Virgin, Hours of the Cross, Hours of the Holy Ghost, and Hours of the Passion. The Hours of the Virgin was traditionally illustrated by scenes representing the main episodes in the mystical life of Mary, each corresponding to a canonical hour: the Annunciation, the Visitation, the Nativity, the Annunciation to the Shepherds, the Adoration of the Magi, the Presentation in the Temple, the Flight into Egypt, and the Coronation of the Virgin.

Here Mary is shown kneeling at a prie-dieu in a delicately decorated chapel, in which we notice small statues of the prophets on the left. Upon hearing the angel's greeting, she half-turns with a gesture of surprise and modesty. The angel kneels before her, presenting in one hand a green stem with three lilies and in the other a scroll inscribed with the Biblical text of the Annunciation, "*Ave gratia plena.*" In a kind of cantoria at the very top of the chapel other angels lean forward to see the scene in which they join with music and song.

Around this traditional representation, which is painted on an archaic blue background brocaded with foliage, the Limbourgs used all their inventiveness to create an original and fanciful setting. In the upper left God the Father, surrounded by a heavenly choir, contemplates and blesses the scene, while all around the page angels on foliage celebrate the Annunciation with their varied instruments. Below, the symbolic bear and swan, placed on either side of three angels, hold the arms of the Duc de Berry. Each one of these decorative elements is treated with exquisite delicacy, subtlety, and infallible taste both in design and in the use of light and harmonious colors.

[F. 26r]

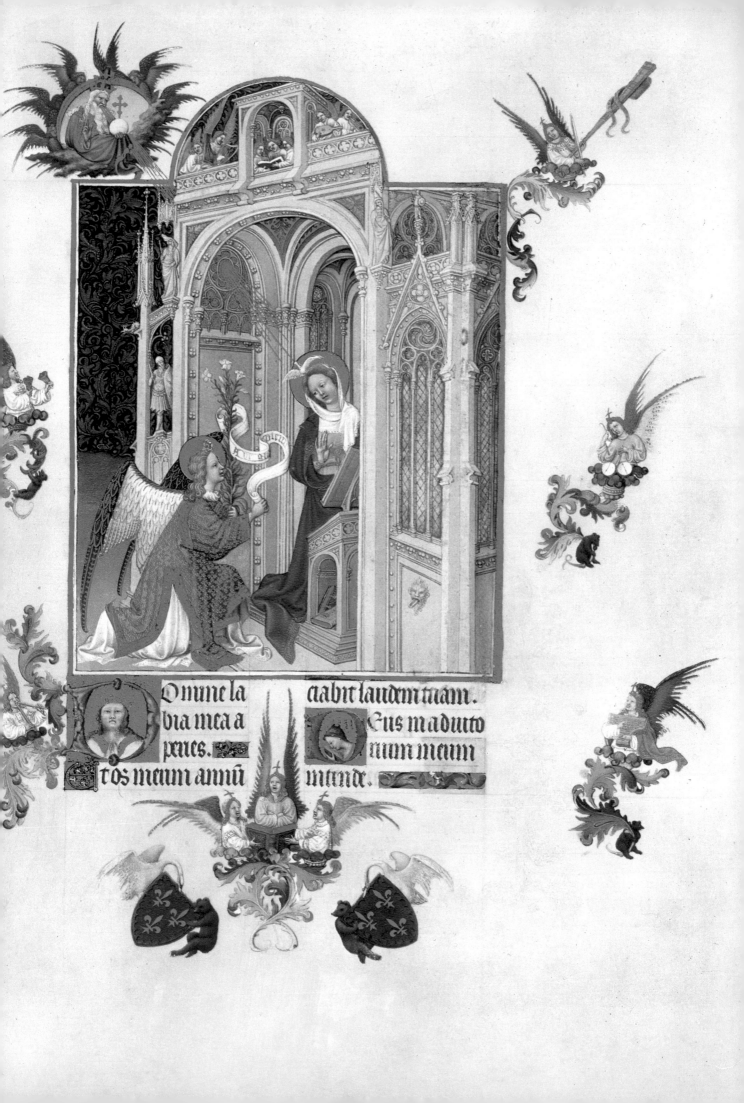

omine ad adiuua
dum me festina.
loria patri et filio
et spiritui sancto.
Sicut erat in princi
pio et nunc et semper
et in secula seculorum.
Amen.
ue maria gratia ple
na dominus tecum.

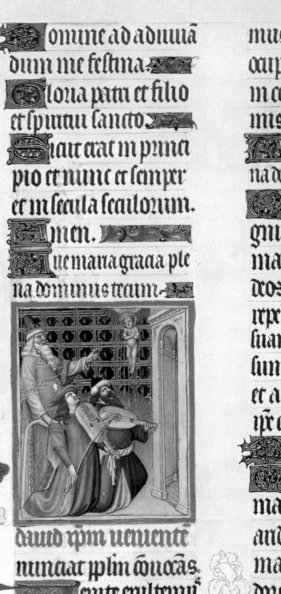

dauid xpm uenientē
nunciat ipsum concas.
enite exultemus
domino iubile

mus deo salutari nostro p
ocupemus faciem eius
in confessione et in psal
mis iubilemus ei.
ue maria gratia ple
na dominus tecum.
Quoniam deus ma
gnus dominus et rex
magnus super omnē
deos: quoniam non
repellet dominus plebē
suam quia in manu ei
sunt omnes fines terre
et altitudines moncaū
ipse conspiat.
Dominus tecum.
Quoniam ipsius est
mare et ipse fecit illud et
aridam fundauerunt
manus eius uenite a
doremus et procidam
ante deum ploremus

22. David Foresees the Coming of Christ

The medieval mind interpreted the Old Testament, and especially David's prayers, as a prefiguration of the coming of Christ. Here the Limbourgs have represented David as an oriental sovereign with a full white beard, long hair, and a tall cap within a crown. Leaning on his harp, he points to the Child which appears in the air. Two musicians, clad and coiffed in an Eastern manner, kneel at his feet; one plays the viol, the other the lute. Below the miniature we can read, *"David Christum renientem nunciat populum convocans"* ("David summons the people and announces the coming of Christ").

This folio is particularly important because of the marginal decoration, which is at different stages of completion and demonstrates the illuminators' method of work. The Limbourgs first executed the miniature in its entirety. They then turned to the marginal decoration, which they proceeded to sketch lightly, as exemplified by the bird perched on the foliage and the vase and iris at the bottom of the page. Over this sketch they sparingly applied the first pure colors, creating an initial relief through which the drawn lines remain visible.

Another clue to the way in which work progressed is the ornamental U which begins the text. Within this capital letter appears a head, such as those often seen in Italian manuscripts. It was executed not by the Limbourgs but by Jean Colombe, seventy years later.

[F. 26 v]

23. David Imagines Christ Elevated Above All Other Beings

At the left David stands facing black Africans, who are probably symbolic of all mankind. Above hovers Christ, hands clasped before His chest, amid clouds that stand out against a background of gold and blue squares. The ornamented initial and foliage were, like the picture, executed at the time of the Duc de Berry.

Under the miniature the text of Psalm VIII praises the majesty of all creation. The picture perfectly illustrates the opening verse: " O Lord our Lord, how admirable is thy name in the whole earth! For thy magnificence is elevated above the heavens. "

[F. 27v]

24. David Foresees the Preaching of the Apostles

David has a vision of the apostles going forth into the world after the Ascension to preach the gospel. Two of them—both haloed, one tonsured, the other with a mane of hair and a beard—proclaim the "good news" to the people of the world who are represented by Africans on the left and Caucasians on the right. Neither group seems overly interested in the teaching.

The Duc de Berry's bear gambols in the foliage of the marginal decoration, which is contemporaneous with the Limbourgs' miniature. Under the picture begins Psalm XVIII, the fifth verse of which was interpreted as a proclamation of the future preaching of the apostles: "Their sound hath gone forth into all the earth: and their words unto the ends of the world."

[F. 28 r]

mater honore angelo
rum domino pectoris
aulam sacris insceub;
casta parasti natus hic
deus est corpore xpus.
Quem cunctus ue
nerans orbis adorat
au nunc ine genu flec
titur omne a quo nos
petimus te ueniente ab
iectis tenebris gaudia
lucis.
Ec largue pater lu
minis omnus natum
per proprium flamie
sacro qui tecum nitida
uunt in etrera regnas
ac moderans seaila cuc
ta. X. In primo noct. au.
xaltata es.
Dauid in spu uider xpm
mmorem angelis super

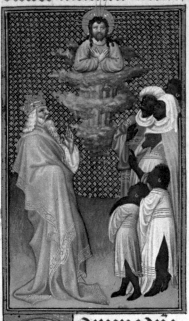

omne craturam ascende

Omine dns
nr quam ad
mirabile est nomen tu
um in muuersa terra.
Quoniam eleuata
est magnificencia tua
super celos.
Exore mfancuum
et lactancium perfecisti
laudem propter inimu

los tuos ut destruas ini
micum et ultorem.

Quoniam videbo ce
los tuos opera digitorum
tuorum lunam et stellas
que tu fundasti.

Quid est homo quod
memor es eius aut filius
hominis quoniam vi
sitas eum.

Minuisti eum paulo
minus ab angelis glo
ria et honore coronasti
eum et constituisti eum
super opera manuum
tuarum.

Omnia subiecisti sub
pedibus eius oues et bo
ues uniuersas insuper
et pecora campi.

Volucres celi et pisces
maris qui perambulat

semittas maris.

Domine dominus
nr quam admirabile
est nomen tuum in uni
uersa terra.

Gloria pn et filio et.

Sicut erat in prina.

Dauid in spu nunciat
aplos p ascensione p u
niuersu pmulgare euang.

Eli enarrant
gloriam dei et

25. The Ark of God Carried into the Temple

The miniature by the Limbourgs illustrates a verse from Psalm XXIII: "Lift up your gates, O ye princes, and be ye lifted up, O eternal gates: and the King of Glory shall enter in."

Four men, Zadok, Abiathat, Ahimaaz, and Jonathan, carry the Ark of God, symbol of the Divine Presence, which David had ordered returned to Jerusalem at the time of Absalom's rebellion, when he withdrew to the desert (II Samuel xv: 24-29).

The Ark is represented as a goldwork reliquary, similar to those found in medieval churches. Exotic coiffures and flowing beards accentuate the figures' oriental appearance. The building's flying buttresses and rose window, of which only the lower part is visible, recall contemporaneous French architecture; the entranceway itself is from a different period, recognizable in many of the other miniatures. The paving reappears in other illuminations such as the Visitation (no. 33), or the Entry into Jerusalem (no. 126). The blue and gold background ornamentation resembles that in nos. 42, 124, and 125.

[F. 29r]

Etenim seruus tuus
custodit ca meustodic
dis illis retribucio multa

Delicta quis intelli
git ab ocultis meis mu
da me domine: et ab a
lienis parce seruo tuo.

Si mei non fuerint
dominati tunc immacu
latus ero et emunda
bo a delicto maximo.

Et erunt ut compla
ceant eloquia oris mei
et meditacio cordis mei
in conspectu tuo semp.

Domine adiutor
meus et redemptor me
us.

Gloria patri et filio.

Dauid in spu uidet porta
templi cu archa portaret
dauid clamat attollite por

Domini est ter
ra et plenitudo
cius orbis terrarum et
uniuersi qui habitant
in eo.

Quia ipse super ma
ria fundauit eum sup
flumina preparauit
eum.

Quis ascendet in
montem domini aut

26. David Foresees the Mystic Marriage of Christ and the Church

This miniature introduces Psalm XLIV, a psalm for the sons of Core, a song of love interpreted as anticipating the union of Christ and the Church: "Hearken, O daughter, and see, and incline thy ear: and forget thy people and thy father's house. And the king shall greatly desire thy beauty. ... All the glory of the king's daughter is within in golden borders, 15 clothed round about with varieties."

Christ holds a red book, leans slightly toward the woman who personifies the Church, and draws her toward Himself. A retinue of saintly figures, halos shining against a delicately squared background, participate in the spiritual betrothal.

Below the miniature the initial is decorated with Jean de Berry's wounded swan. The entire page was illustrated by the Limbourgs.

[F. 31r]

deus in eternum.

Accingere gladio tu
o super femur tuum po
tentissime.

Specie tua et pulcritu
dine tua intende prospe
procede et regna.

Propter veritatem
et mansuetudinem et
iustitiam et deducet te
mirabiliter dextera tua.

Sagitte tue acute
populi sub te cadent in
corda inimicorum regi

Sedes tua deus in se
culum seculi virga di
rectionis virga regni
tui.

Dilexisti iustiaam
et odisti iniquitatem
propterea unxit te de
deus tuus oleo leticie pre

Eructauit cor me
meum verbum
bonum: dico ego opera
mea regi.

Lingua mea cala
mus: scribe veloater scri
bentis.

Speciosus forma pre
filiis hominum: diffu
sa est gratia in labiis tu
is propterea benedixit te

27. The Sons of Core Thank God for Their Salvation

Core, the Levite, with Dathan and Abiram led two hundred and fifty of the people of Israel in a rebellion against Moses and Aaron (Numbers XVI: 3). Upon Moses' invocation, the earth split asunder and swallowed Core and his followers. God showed His mercy to the sons of Core by lifting them up. The miniature represents the salvation of Core's sons, whose father disappears into the gaping earth while a tree splits. It introduces Psalm XLV, one of those referred to in the psalter as "A Psalm for the Sons of Core:" "Therefore we will not fear, when the earth shall be troubled. …"

This and the two following miniatures are by the Limbourgs.

[F. 32r]

28. The Church Militant and the Church Triumphant

This miniature, illustrating another psalm for the sons of Core, shows David before a crowned female figure, symbol of the Church Militant and then Triumphant. She holds in her right hand a bannered cross-staff and in her left a golden chalice and the Eucharist. The triumph of Christ's Church is anticipated in Psalm LXXXVI: "Glorious things are said of thee, O city of God." The initial F contains a sleeping bear.

[F. 32v]

29. The Last Judgment

Psalm XCV praises the Lord with a canticle which anticipates the Last Judgment: "Then shall all the trees of the woods rejoice before the face of the Lord, because he cometh: because he cometh to judge the earth. He shall judge the world with justice, and the people with his truth."

The Lord Christ is seated upon clouds; His feet, showing their wounds, rest on a globe symbolizing the earth. The Virgin and a kneeling figure, probably John the Baptist, beg Him to be merciful. Below, the elect adore on the Lord's right, while the damned plunge into the jaws of hell on His left.

[F. 34r]

Regraciantur filij chozc
qr saluati sūt in aetr cū
tia degluture patrem.

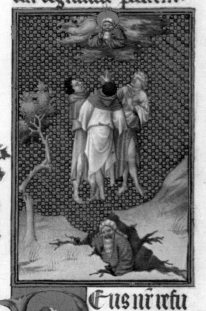

Eus nr refu
gium et virt'
adiutoz m tribulacio
nibus que inuenerunt
nos nimis.

Propterca non time
bimus dum turbabit
terra transferentur mō
tes m coz maris.

Onuerunt et turba
te sunt aque eorum cō
turbati sunt montes
m fortitudine eius.

Fluminis impetus
letificat ciuitatem dei
sanctificauit tabernac
culum suum altissim'

Deus m medio eius
non commonebitur
adiuuabit eam deus
mane diluculo.

Conturbate sunt
gentes et inclinata sūt
regna dedit uocem suā
mota est terra.

Dominus virtutū
nobiscum susceptoz nr
deus iacob.

Uenite et uidete opera
domini que posuit pro
digia super terram.

Auferens bella usq;
ad finem terre arcum
conteret et confringet
arma et scuta 2buret ig.
Uacate et uidete qm
ego sum deus exaltabor
in gentibz; et exaltabor
in terra.

Dominus uirtutu
nobiscum susceptor
noster deus iacob.

Osetiz ãt fily chore mi
litante et triumphãtem
eccliam in monte syon.

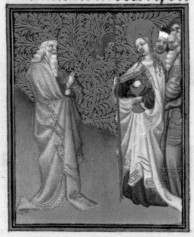

Undamenta
eius in monti
bus sanctis diligit do
minus portas syon sup
omnia tabernacula
iacob.

Glonosa dicta sunt
de te ciuitas dei.

Memor ero raab: et ba
bilonis sacencium me.

Ecce alienigene et ty
rus et populus ethyopu
hij fuerunt illic.

Nunquid syon di
cet homo et homo natus
est in ea: et ipse fundauit
eam altissimus.

Dominus narra
bit in scripturis popu
lorum: et principum
horum qui fuerunt in
ea.

processit ad ortum. In tercio
nocturno antiphona.
Gaude maria.

anunciate de die in die
salutare eius.
Anunciate inter
gentes gloriam eius in
omnibus populis mi
rabilia eius.
Quoniam magnus
dominus et laudabilis
nimis: terribilis est su
per omnes deos.
Quoniam omnes
dij gentium demonia
dominus autem celos
fecit.
Confessio et pulcri
tudo in conspectu eius
sanctimonia et magni
ficencia in sanctificacio
ne eius.
Afferte domino patrie
gentium afferte dño
gloriam et honorem af

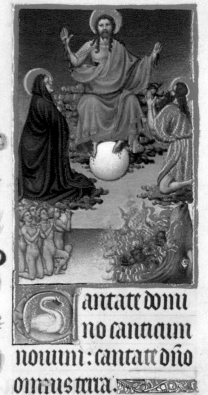

Cantate domi
no canticum
nouum: cantate dño
omnis terra.
Cantate domino et
benedicite nomini eius

ferte domino gloriam
nomini eius. ～～～
Tollite hostias et in
troite in atria eius ado
rate dominium in atri
o sancto eius. ～～～
Commoueatur a
facie eius uniuersa ter
ra dicite in gentibus
quia dominus regnauit.
Et enim correxit
orbem terre qui non
commonebitur iudi
cabit populos in equi
tate. ～～～～
Letentur celi et exul
tet terra commoueatur
mare et plenitudo eius
gaudebunt campi et
omnia que in eis sunt.
Tunc exultabunt
omnia ligna siluarum

um a facie domini
quia uenit quoniam
uenit iudicare terram.
Iudicabit orbem
terre in equitate et po
pulos in ueritate sua.
Gloria patri et filio.

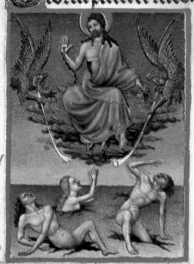

Dominus regna
uit exultet ter
ra letentur insule multe.

30. Christ in Glory

This miniature illustrates Psalm XCVI which announces the reign of the Lord and the downfall of all worshippers of idols: " The heavens declared his justice: and all people saw his glory. " Enthroned on clouds, Christ shows His wounds and raises His right hand in a gesture of command. Two angels, possibly personifications of Justice and Equity, blow long white trumpets.

The prostrate supplicant figures below are the idolaters:

" Let them be all confounded that adore graven things, and that glory in their idols. "

" His lightnings have shown forth to the world: the earth saw and trembled. The mountains melted like wax, at the presence of the Lord: at the presence of the Lord of all the earth. "

Besides the miniature, the Limbourgs also executed the initial letter decorated with a blue flower on a golden background and the foliage graced by two magnificent birds.

[F. 34v]

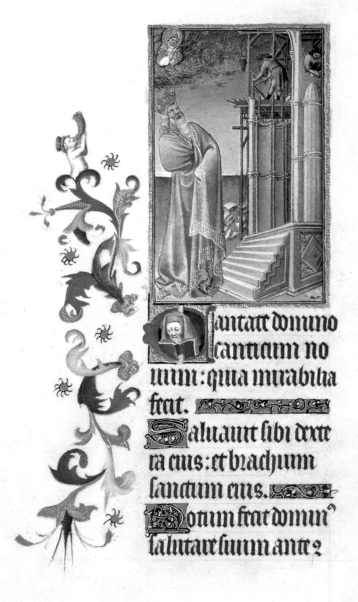

spectum gentium reue
laut iusticiam eius.

Recordatus est mise
sue et ueritati sue domui
i israel.

Uiderunt omnes fi
nes terre salutare dei
nostri.

Iubilate deo omnis
terra cantate et exalta
te et psallite.

Psallite domino in
cythara et uoce psalmi
in tubis ductilibus
et uoce tube cornee.

Iubilate in conspe
ctu regis domini moue
atur mare et plenitu
do eius orbis terrarum
et uniuersi qui habitant
in eo.

Flumina plaudent

antate domino
canticum no
uum: quia mirabilia
fecit.

Saluauit sibi dexte
ra eius: et brachium
sanctum eius.

Notum fecit dominus
salutare suum ante 2

31. The Building of the Jerusalem Temple

David, wearing a crown, looks heavenward at God the Father appearing amid clouds. He is perhaps also interested in the site of a religious building on which two workmen busy themselves. One lays the stones which the other raises with a rope and pulley. It is difficult to determine the relationship between the Limbourgs' illustration and Psalm XCVII below it, which begins: "Sing ye to the Lord a new canticle: because he hath done wonderful things. ..."

Is the chapel under construction one of these "wonderful things"? Or does it represent the "house of Israel" toward which God "hath remembered his mercy and truth"?

[F. 35v]

E deum lau
damus te
dominum confitemur.
Te eternum pa
trem omnis
terra venera
tur.
Tibi om
nes angeli
tibi celi et u
niuerse pote
states.
Tibi cheru
bin et serap
hin: in cessa
bili uoce pro
clamant.
Sanctus
Sanctus. sanctus
dominus deus sabaoth
Pleni sunt celi et ter
ra maiestatis glie tue.

Te gloriosus apo
stolorum chorus.
Te prophetaru
laudabilis numer
Te mar
tirum can
didatus lau
dat exercitus.
Te per or
bem terrarū
sancta confi
tetur ecclia.
Patrem
inmensema
iestatis.
Veneran
dum tuum
nerum et u
nicum filium.
Sanctum quoqz pa
raclitum spiritum.
Tu rex glorie xpe.

32. The Baptism of Saint Augustine

This painting, of medium size, occupies an unusual place in the middle of the *Te Deum,* which it illustrates. Men of the Middle Ages saw a close relationship between the baptism of Saint Augustine and the origins of this magnificent rich song whose verses in praise of God alternate like a noble dialogue. According to Jacopo da Voragine's *The Golden Legend,* on Easter day Augustine received baptism with his son, Adeodatus, born to him while he was still a pagan philosopher, and his friend Alypius, converted like Augustine by the words of Saint Ambrose. After public confession and baptism Saint Ambrose cried " *Te Deum laudamus,* " to which Augustine replied " *Te Dominum confitemur* "; their alternate words of praise continued on to make up the whole hymn.

The Limbourgs represented the scene in a hexagonal baptistery with red vaults. Immersed to his waist in the baptismal font, Augustine wears a miter that symbolizes his future office of bishop of Hippo in Africa. Dressed in priestly vestments and wearing the miter of the archbishop of Milan, Saint Ambrose pours the baptismal water over Augustine's head. Various figures complete the scene, including one wearing a pointed turban, one contemplating the baptism, and others commenting on it.

Inside the initial letter, from which colored foliage spreads, we see painted with a fine, light brush, a praying figure, perhaps meant to represent Saint Augustine.

[F. 37v]

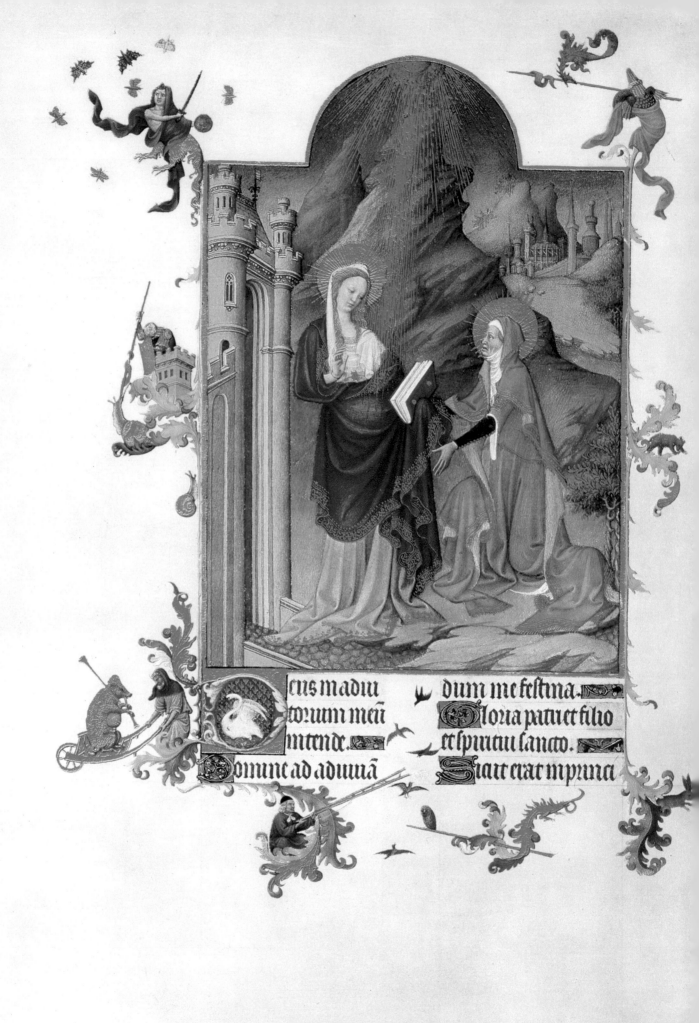

33. The Visitation

Placed before the lauds in the Hours of the Virgin, this miniature represents Mary's traditional visit to her cousin, Elizabeth, who had been advised by the archangel Gabriel that she would give birth to John the Baptist (see also no. 58). The figures are larger than usual in this manuscript; their attitudes and the harmony of the colors are remarkable. Mary came from Galilee to see Elizabeth who, when her baby leaped in her womb upon hearing Mary's greeting, was moved to exclaim, "Blessed art thou among women, and blessed is the fruit of thy womb." (Luke 1: 42)

The Limbourgs have represented Elizabeth bowed in respect and gratitude before the Virgin, an attitude that reflects the words attributed to her by Saint Luke: "And whence is this to me, that the mother of my Lord should come to me?" (Luke 1: 43) Her robe and cloak are painted in two light, harmonious colors which contrast with the deep blue of the Virgin's cloak. Mary stands in a noble, contemplative pose, her body swaying slightly in the manner of French fourteenth-century representations of the Virgin. She answers,

"My soul doth magnify the Lord. And my spirit hath rejoiced in God my Saviour." (Luke 1: 46–47) Rays of light fall from the sky like gold dust to illuminate her face.

At the left is Elizabeth's house, and in the background rise the strange, deformed, domical hills found so often in works by the Limbourgs that they serve almost as the artists' signature. Farther to the right, we glimpse the buildings of a city, which vaguely recalls Bourges, the capital of Berry.

This page is also remarkable for the lighthearted drolleries surrounding the serious scene. A woman defends herself with a sword against butterflies; a warrior in a tower repulses the attack of a snail; an old man pushes a bear playing bagpipes in a wheelbarrow; a cleric chases birds with a ladder. With these small motifs, painted with imagination, a light touch, and subtle coloration, the Limbourgs renewed the tradition of using grotesques for miniature borderwork by liberating them from the conventional matrix of marginal decoration. In the initial, the whiteness of the Duc de Berry's symbolic wounded swan stands out against the fleurs-de-lys of France.

[F. 38v]

34. God Reigns Over All the Earth

Seated in majesty, wearing a tiara, and holding a globe on His knee, the Lord receives the homage rendered by the sovereigns of the world who kneel before Him. Psalm XCII, written in its entirety on this page, is a hymn to royalty and divine omnipotence: " The Lord hath reigned, he is clothed with beauty: the Lord is clothed with strength. ... " The miniature is by the Limbourgs.

[F. 39r]

pio et nunc et semper et
in secula seculorum. X.
ant. Bndicta tu.

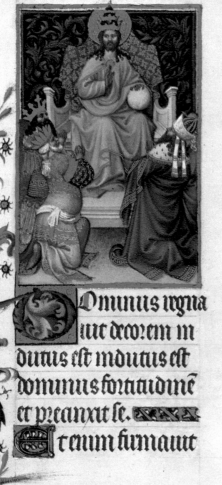

Omninus regna
uit decorem in
dutus est indutus est
dominus fortitudine
et precinxit se.
tenim firmauit

orbem terre qui non co
mouebitur.
Parata sedes tua deus
ex tunc a seculo tu es.
Eleuauerunt flu
mina domine eleua
uerunt flumina uo
cem suam.
Eleuauerunt fluc
tus suos a uocibus a
quarum multarum.
Mirabiles elaciones
maris: mirabilis in
altis dominus.
Testimonia tua
credibilia facta sunt
nimis domum tuam
decet sanctitudo domi
ne in longitudinem
dierum meorum.

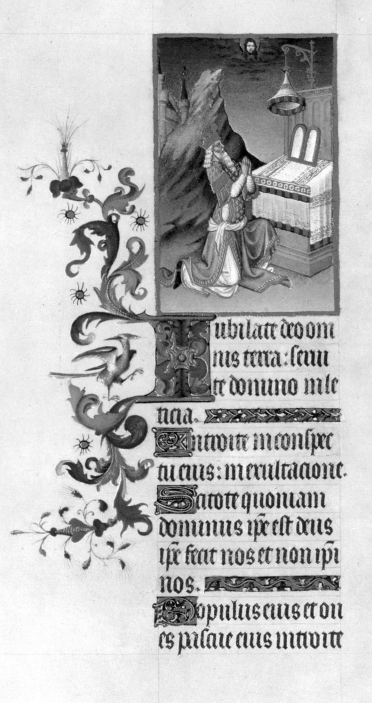

portas eius: in confes
sione atria eius, in hym
nis confitemini illi.
Laudate nomen eū
quoniam suauis est
dominus in eternum
misericordia et usq in
generatione et genera
tionem ueritas eius.
Gloria pri et filio et.

Iubilate deo om
nis terra: serui
te domino in le
titia.
Introite in conspec
tu eius: in exultatione.
Scitote quoniam
dominus ipse est deus
ipse fecit nos et non ipi
nos.
Populus eius et oū
es pasue eius introite

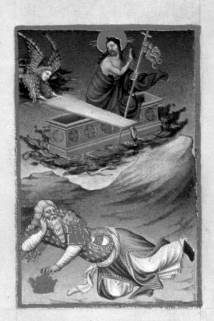

35. Psalms XCIX and LXII

Above, David kneels before an altar and intones Psalm XCIX, a hymn of praise composed for the offering of thanksgiving. Christ's face appears in the sky. On the altar, the Tables of the Law are illuminated by a strange lantern suspended above them. In the background a castle is partially hidden by an abrupt mountain, the type commonly found in works by the Limbourgs. The scene seems to illustrate specifically the first verse which enjoins all the world to rejoice in the Lord: " Sing joyfully to God, all the earth: serve ye the Lord with gladness. "

The miniature below appears at the beginning of Psalm LXII, composed by David while he was in the wilderness of Judah. The Psalmist lies asleep on the ground, with his crown before him and his head resting on his right arm. In his sleep he sees the resurrected Christ leaving the tomb, which is opened by an angel. The illustration is inspired by the verse following David's invocation of God, whom he seeks and thirsts for: " If I have remembered thee upon my bed, I will meditate on thee in the morning. ... "

Like this and the previous miniatures, the large illuminated I integrated with the border decoration was executed in the workshop of the Limbourgs.

[F. 39v]

Eus miseratur nostri et benedicat nobis illuminet vultum suum super nos et misereatur nostri. Ut cognoscamus in terra viam tuam in omnibus gentibus salutare tuum. Confiteantur tibi populi deus: confiteantur tibi populi omnes. Letentur et exultet gentes quoniam iudicas populos in equitate et gentes in terra dirigis. Confiteantur tibi populi deus: confiteantur tibi populi omnes terra dedit fructum suum. Benedicat nos deus

deus noster benedicat nos deus et metuant eum omnes fines terre. Gloria patri et filio.

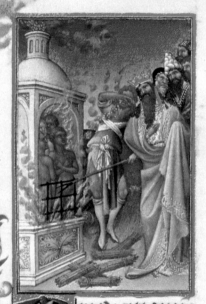

Benedicite omnia opera domini domino: laudate et superexaltate eum in secula.

36. The Three Hebrews Cast into the Fiery Furnace

Because three Hebrews, Shadrach, Meshach, and Abednego, refused to obey King Nebuchadnezzar's order to fall down and worship the golden image he had set up, they were thrown into a blazing furnace (Daniel III). They emerged miraculously untouched. Nebuchadnezzar, henceforth convinced of the strength of the Hebrew God, commanded respect for Him and for those who worshipped Him.

The miniature shows the crowned Nebuchadnezzar witnessing the miracle while the man in charge of stoking the fire shields his face. There are four, not three, Hebrews, and, in fact, the Book of Daniel relates the surprise of the King of Babylon when, instead of the three young men he had thrown into the fire, four appear. "And the form of the fourth is like the Son of God." By his interpretation of this passage, the translator of the Vulgate gave medieval thought claim to a prefiguration of the Messiah.

The Limbourgs imaginatively allowed the smoke of the furnace to escape into the center column of the page from the preestablished frame.

Below the miniature is text from the Canticle of Three Hebrews in the Fiery Furnace, as it appears in the Book of Daniel.

[F. 40v]

benedicite filij hominum
domino.

Benedicat israel do
minum: laudet et super
exaltet eum in secula.

Benedicite sacerdotes
domini domino: bene
dicite servi domini do
mino.

Benedicite spiritus
et anime iustorum
domino: benedicite sancti
et humiles corde domino.

Benedicite anania
azaria misael domino
laudate et superexaltate
eum in secula.

Benedicamus pa
trem et filium cum sancto
spiritu laudemus et su
perexaltemus eum se
cula.

Benedictus es domine
in firmamento celi et
laudabilis et gloriosus
et superexaltatus eum
in secula. Amen.

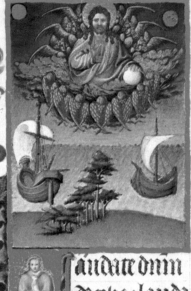

Laudate dominum
de celis: laudi
te eum in excelsis.

Laudate eum om
nes angeli eius: lauda

37. God in Majesty

Christ, with His hand on a globe, hovers in the sky, surrounded by angels with spread and folded wings. The earth and its seas are symbolized by a small wood and a body of water with two ships. Psalm CXLVIII, a hymn of universal praise of the Divine Power, begins just below the illumination: "Praise ye the Lord from the heavens: praise ye him in the high places. Praise ye him, all his angels: praise ye him, all his hosts. Praise ye him, O sun and moon. ..." The sun and moon are placed in the upper part on either side of the Lord. This miniature was painted by the Limbourg brothers.

[F. 41v]

38. The Archangel Gabriel Appears to Zachary

The archangel Gabriel appeared to Zachary and told him that his wife Elizabeth would bear him a son despite her great age. Faced with Zachary's scepticism, the angel struck him dumb until the birth of the child, who was to become John the Baptist (Luke 1: 5-20).

In the Limbourgs' miniature Gabriel stands to the right of the altar. Zachary, in the midst of fulfilling his priestly duties, is deeply surprised by the annunciation of the angel, toward whom he turns his head. Zachary's hymn according to Saint Luke begins beneath the illustration. The storklike bird in the border, emerging from a blue flower to snap up a snake, illustrates the admirable imagination of the Duc de Berry's artists.

[F. 43v]

39. One Page of Text

This page of text is taken from the Hours of the Virgin. It was written and decorated at the time of the Limbourgs.

[F. 44r]

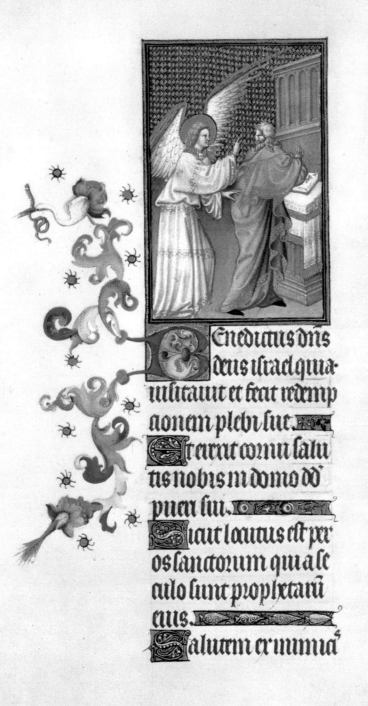

Enedictus dñs
deus iſrael quia
uiſitauit et fecit redemp
tionem plebi ſue.
Et erexit cornu ſalu
tis nobis in domo dd
pueri ſui.
Sicut locutus eſt per
os ſanctorum qui a ſe
culo ſunt prophetarũ
eius.
Salutem ex inimicuˢ

nꝰis et de manu omniũ
qui oderunt nos.
Ad faciendam mi
ſericordiam cum pa
tribus nꝰis et memorari
teſtamenti ſui ſancti.
Iuſiurandum qd
iurauit ad abraham
patrem nꝰm daturum
ſe nobis
Ut ſine timore de ma
nu inimicorum nꝰor
ti liberati ſeruiamus illi.
In ſanctitate et iuſ
ticia coram ipſo omni
bus diebus nꝰis
Et tu puer ꝓpheta
altiſſimi uocaberis pre
ibis enim ante faciẽ
domini parare uias
eius.
Ad dandum ſcientiã

salutis plebi eius in re
missionem peccato
conum

Per viscera mie dei
nri inquibus visita
uit nos oriens ex alto

Illuminare hijs
qui in tenebris et in
umbra mortis sedent
ad dirigendos pedes n
nros in viam pacis.

Gloria pri et filio et.

Hec est regina vir ant.
ginum que genuit regem
regum velut rosa decora ir
go dei genitrix per quam re
perimus deum et hominem
alma virgo virginum in
tercede pnobis ad dnm.

Deus qui corda fidelium
sancti spus illustracio

ne docuisti da nobis in
eodem spu recta sapere z
de eius semper sancta
consolacione gaudere.

Concede nos oro.
famulos tuos
qs dne deus perpetua
mentis et corporis sani
tate gaudere: et glorio
sa beate marie semper
virginis intercessione
a presenti liberari tristi
cia et etina perfrui leticia.

Ecclesiam tua or.
quesumus dne
benignus illustra ut be
ati iohannis apli tui
et euuangeliste illuiia
ta doctrinis ad dona p
uenuat sempiterna. P
xpm dominium nrm.
Amen. Ad primam

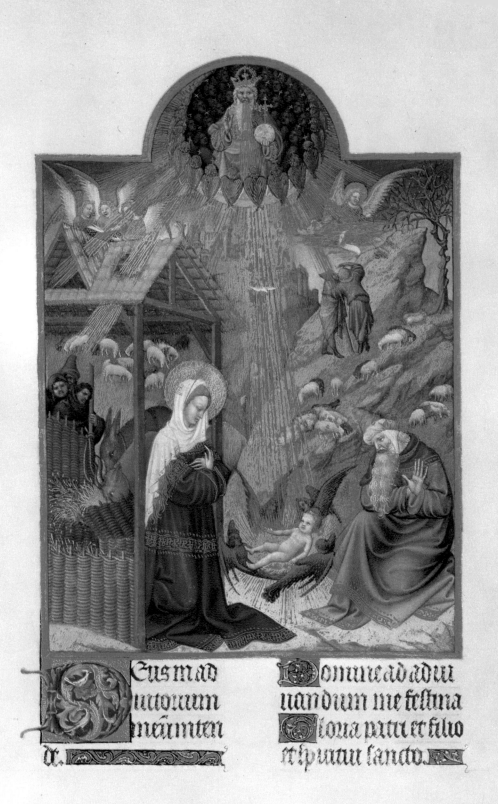

40. The Nativity

This scene occupies its traditional position in a Book of Hours, at the head of the third part of the Hours of the Virgin, known as prime, the service for the first hour of the day. The Limbourgs had already represented the Nativity in the *Belles Heures* (folio 48v), in which the Virgin lies with her infant in her arms; here they have imaginatively renewed the same subject. The Virgin kneels in prayer before her Holy Son, who lies on a bed of straw, surrounded by cherubim.

The scene takes place at the threshold of the stable, whose doorway frames Mary and through whose damaged roof golden beams of light pass. Joseph, with white hair and a flowing beard, kneels at the other side of the Child, struck with admiration before the miracle. To emphasize the oriental setting, the Limbourgs have given Joseph a peaked turban and have painted Arabic letters on the Virgin's mantle.

Anecdotal details embellish the picture: the traditional ox and ass mentioned in the apocryphal gospel, *De Nativitate Mariae et Infantia Salvatoris* (The Birth of Mary and the Childhood of the Savior), shepherds leaning on the wicker fence to stare at the mysterious scene, and shepherds searching the skies for the celestial singers who proclaim the glory of God and peace on earth. Beyond, we glimpse the gates of a city with large buildings along a hillside.

At the top of the miniature, in the semicircle formed by the frame, is God the Eternal Father in heaven, surrounded by flaming seraphim. He holds a globe in His left hand and makes a sign of benediction with His right. A golden shaft of light connecting His mouth with the Child below is symbolic of the Incarnation of the Word. With the dove flying in the rays, the miniature becomes a representation of the Trinity as well.

[F. 44v]

41. David Plays the Harp

Psalm 1, " Blessed is the man who hath not walked in the counsel of the ungodly, " is introduced by a harmonious miniature in which the Limbourgs have represented King David kneeling before an altar, caressing the strings of a harp, and looking heavenward while he sings. Two of the faithful, seated on benches behind him, follow the text in their books. The scene is set in a flamboyant Gothic chapel in which very thin colonettes support a delicately trefoiled arcade.

[F. 45r]

Sicut erat in prin
cipio et nunc et semper
et in secula seculorum.
Amen. alleluya. allã.
Eni creator
spiritus men
tes tuorum visita im
ple superna gratia que
tu crasti pectora.
Memento salutis
auctor quod nostri quon
dam corporis exilli bea
ta virgine nascendo
formam sumpsere.
Maria mater gratie
mater misericordie tu
nos ab hoste protege
et hora mortis suscipe.
Gloria tibi domine
qui natus es de virgi
ne cum patre sancto spi
ritu in sempiterna secla.

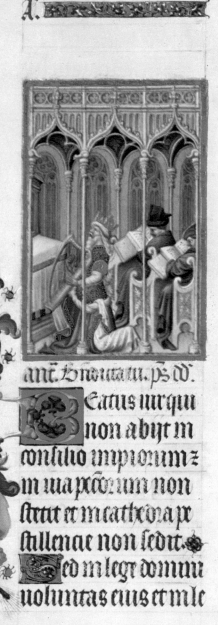

ant. Beati oma tu. ps. oo.
Beatus vir qui
non abyt in
consilio impiorum et
in via peccatorum non
stetit et in cathedra pe
stilentie non sedit. Sed
sed in lege domini
uoluntas eius et in le

gre eius meditabitur die
ac nocte.
Et erit tanquam lig
num quod plantatu
est secus decursus aqua
rum quod fructum su
um dabit in tempore
suo.
Et folium eius non
defluet omnia quecū
qz faciet semper prospe
rabuntur.
Non sic impij non
sic sed tanquam pul
uis quem proicit uen
tus a facie terre.
Ideo non resurgiunt
impij in iudicio neqz
peccatores in consilio
iustorum.
Qm nouit dominus
uiam iustorum : et iter

impiorum peribit.
Gloria p̄ri et filio

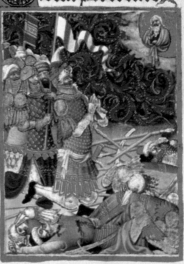

Et iate fremue
runt gentes et
populi meditati sunt
inania.
Astiterunt reges ter
re et principes conuene
runt in unum aduer
sus dominum et ad

42. The Messiah's Dominions

The Limbourgs chose to illustrate Psalm II with a scene showing the annihilation of those who tried to rise up against their Lord: "The kings of the earth stood up, and the princes met together, against the Lord and against his Christ." (Psalm II: 2) But the Lord "troubles them in his anger," strewing the ground with the bloody corpses and arms of the rebellious.

God the Father appears in the upper right, while the armored ranks of the faithful kneel to pray, pennants and banners flying in the wind. The figure in front wearing a helmet adorned with a cross is probably David, identified by the pink tunic and yellow belt that he wears in other small miniatures in the manuscript. Blue foliage decorates the background of the illumination; the center column is ornamented with birds and plants.

[F. 45v]

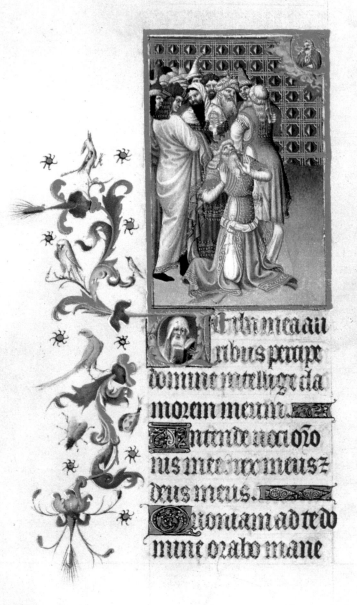

exaudies vocem meam.
Mane astabo tibi
et videbo quoniam
non deus volens iui
quitatem tues.
Neq; habitabit iu
xta te malignus neq;
permanebunt iniusti
ante oculos tuos.
Odisti omnes qui
operantur iniquita
tem perdes omnes qui
loquuntur mendacium.
Virum sanguinu
et dolosum abhomia
bitur dominus ego
autem in multitudi
ne misericordie tue.
Introibo in domu
tuam adoralo ad tem
plum sanctum tuum
in timore tuo.

ibin mea au
ribus percipe
domine intellige cla
morem meum.
Intende voci oio
nis mee rex meus z
deus meus.
Quoniam ad te do
mine orabo mane

43. David Beseeches God Against Evildoers

Dressed in his habitual royal garb, the crowned David on his knees begs God to protect him against the evil, the boastful, the lying, the bloodthirsty, and the deceitful. Wearing long robes and varied coiffures, these enemies are grouped behind the praying King. Some watch him with pity and condescension, and others plot their rebellion.

Psalm v, transcribed below this miniature, begins: " Give ear O Lord, to my words understand my cry. " Birds, a fly, and a butterfly appear in the marginal decoration. The initial letter contains the head of a bearded man holding an open book. These elements together with the miniature were executed by the Limbourgs.

[F. 46v]

44. The Annunciation to the Shepherds

In this miniature at the head of terce, we recognize the carefully observed, naturalistic shepherd that appeared in the Nativity (no. 40): with head thrown back and a hand raised to his forehead he scans the sky for the angels who announce the birth of the Holy Child. Here, the Limbourgs have shown him as one of three shepherds—an old man, a youth, and a woman, who points to the angels in the sky.

The ethereal, luminous angels appear in three groups: on the right, two make music on a trumpet and viol, on the left, two play a lute and drum, and in the center, three sing in chorus from a scroll on which the artists have painstakingly noted staves, notes, and capital letters in red.

The landscape includes, on the right, a hill with grazing sheep and a black and white dog lying at the shepherds' feet, and, on the left, one of the sugarloaf hills dear to the Limbourgs, stratified from right to left. Along its side runs a stream whose flow is caught in a basin that probably serves the animals as a watering trough. Behind the mountain we see more shepherds with their flocks and the buildings of a town supposed to be Bethlehem, "the city of David," where the angel announced that a Savior had been born. Actually, the miniaturists have tried to suggest here, as elsewhere, certain buildings preferred by the Duc de Berry. Paul Durrieu believed that these were in Poitiers: "The central edifice, shown at an angle, could be the Tour Maubergeon. The large belfry on the right might represent the belfry of the collegiate church of Saint-Hilaire, which no longer exists" (*Les Très riches Heures de Jean de France, duc de Berry*, p. 201).

[F. 48r]

45. Psalm CXIX

David, kneeling without his crown and covered with a long blue garment, prays to the Lord, whose face appears to him amid clouds. This miniature introduces one of the gradual canticles, psalms sung by pilgrims climbing toward the holy city: "In my trouble I cried to the Lord: and he heard me." A castle, which is perhaps the King's, rises on the right. The golden foliage on a blue background reappears in other miniatures by the Limbourgs. A white bird decorates one of the two capital letters, and the Duc de Berry's bear the other.

[F. 48v]

46. David Releases Prisoners

In this miniature by the Limbourgs, David, wearing his crown and a full pink cloak with golden borders, stands making a gesture of encouragement to the prisoners emerging from the château in which they were confined. The first bears a striking resemblance to Christ as the Limbourgs depicted Him (c.f. the Hours of the Passion, nos. 107ff.); medieval handcuffs bind his wrists to a metal bar.

Psalm cxx, which begins below, would seem to call for a different interpretation: "... he shall neither slumber nor sleep, that keepeth Israel." However, the Lord is the keeper and He needs no prisons: "The Lord keepeth thee from all evil. ..."

[F. 49r]

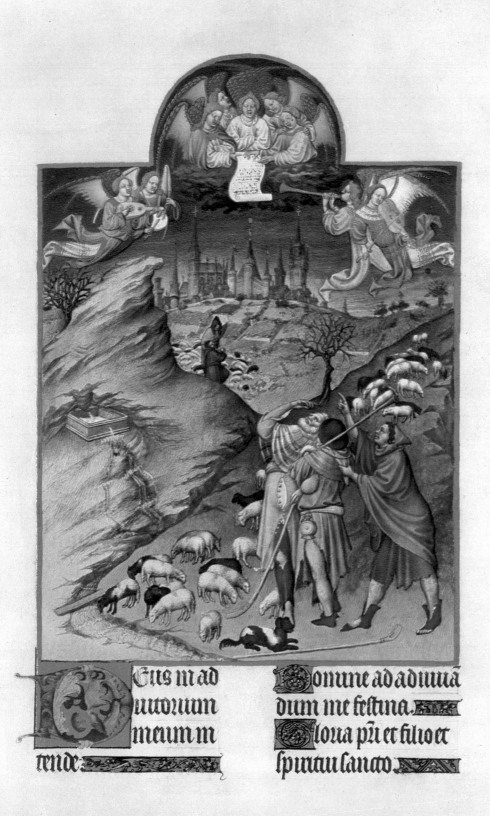

Eus m ad
utonum
meum m
tende:

Oomme ad adıuuā
dum me festına.
Glona pri et filio et
spırituı sancto.

Sicut erat in princi
pio et nunc et semper
et in secula seculorum
Amen alleluya allia.

Eni creator
spiritus men
tes tuorum visita im
ple superna gracia q̃
tu creasti pectora.

Memento salutis
auctor quod nũ quon
dam corpus exilliba
ta virgine nascendo
formam sumpseris.

Maria mater gracie
mater mie tu nos ab
hoste protege et hora mor
tis suscipe.

Gloria tibi domine
qui natus es de virgie
cum patre sancto spũ in
sempiterna secula. X.

ãn. Dignare me.

D dominum
cum tribularer
clamaui et exaudiuit
me.

Domine animam
meam alabijs miq̃s
et a lingua dolosa.

Quid detur tibi aut
quid apponatur tibi

ad linguam dolosam.
Sagitte potentis ac
cute cum carbonibus
desolatorijs.
Heu michi quia in co
latus meus prolonga
tus est hytauiaum hy
tantibus eedar multu.
mcola fiut anima ma.
Cum hijs qui oderit
parem eram parificans
aim loquebar illis im
pugnabant me gratis
Gloria patri et filio z
spiritu sancto.
Sicut erat in prima
pio et nunc et semper z
in secula seculorum.
Amen.

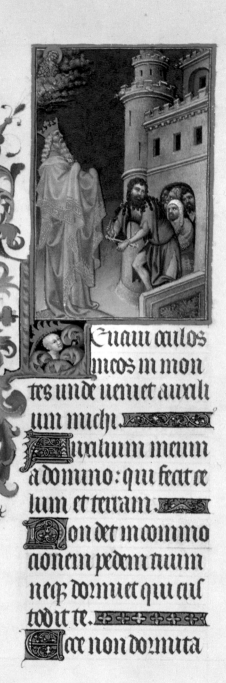

Leuaui oculos
meos in mon
tes unde ueniet auxili
um michi.
Auxilium meum
a domino: qui fecit ce
lum et terram.
Non det in commo
aonem pedem tuum
neqz dormiet qui cus
todit te.
Ecce non dormita

bit neq; dormiet qui ai
stodit israel.

Dominus custodit
te dominus protectio
tua super manum dex
teram tuam.

Per diem sol non u
rit te neq; luna per noc
tem.

Dominus custodit
te ab omni malo custo
diat animam tuam
dominus.

Dominus custodi
at introitum tuum z
exitum ex hoc nunc et
usq; in seculum.

Gloria patri et filio
et spiritui sancto.

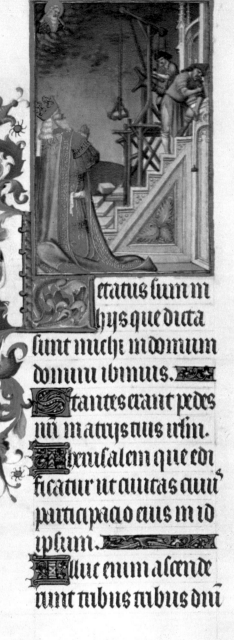

etatus sum in
hys que dicta
sunt michi in domum
domini ibimus.

Stantes erant pedes
nri in atrys tuis iersm.

Jerusalem que edi
ficatur ut ciuitas cuius
participatio eius in id
ipsum.

Illuc enim ascende
runt tribus tribus dni

47. Building in Jerusalem

Psalm CXXI, another gradual canticle, sings of the house of the Lord and construction within the city of Jerusalem: "We shall go unto the house of the Lord. Our feet were standing in thy courts, O Jerusalem. Jerusalem, which is built as a city, which is compact together." In the miniature introducing this psalm the Limbourgs have depicted a construction site. It is not clear whether the building under construction is religious or secular. The staircase, consisting of six visible steps and one which is probably hidden by King David's cloak, together with the buttresses, would seem to indicate a chapel, perhaps the Temple of Jerusalem whose construction was attributed to David. One of the workmen perhaps carves a stone while the other manipulates the rope and pulley which brings up the building materials.

[F. 49v]

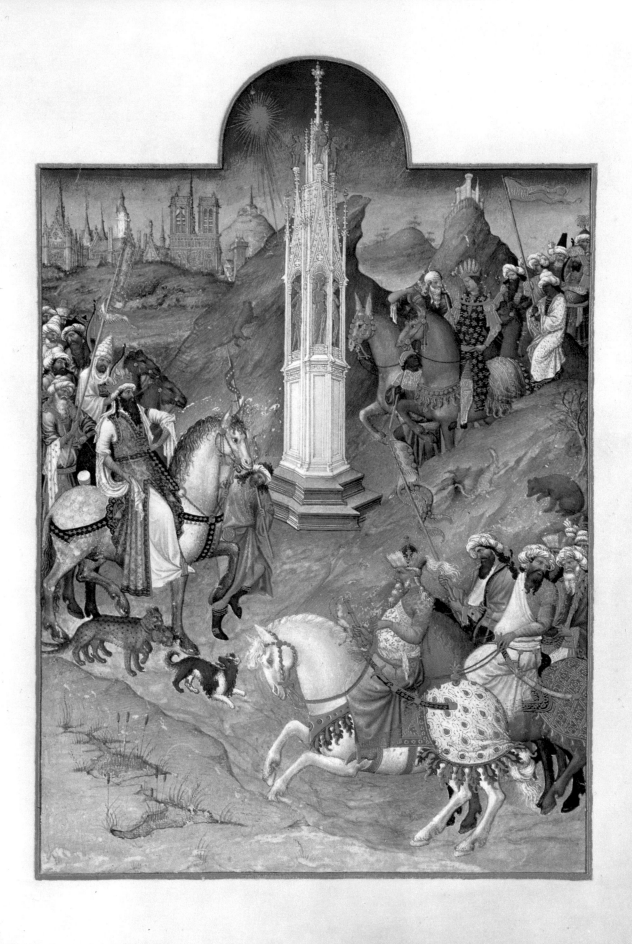

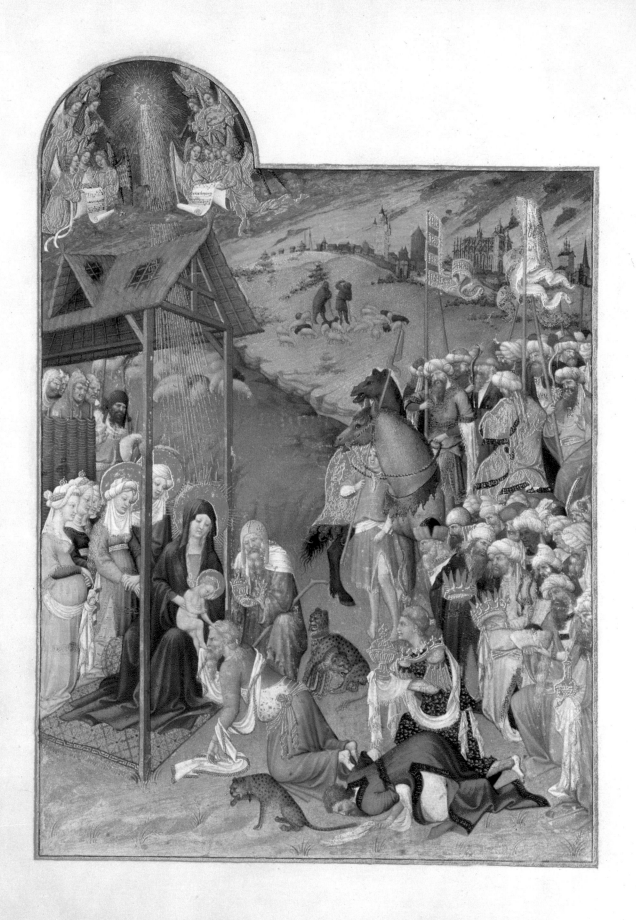

50. Prayer of David

The first miniature represents David kneeling, intoning Psalm CXXII, a song of confidence in the Lord God, who appears to him amid the clouds: "To thee have I lifted up my eyes, who dwellest in heaven. Behold as the eyes of servants are on the hands of their masters, as the eyes of the handmaid are on the hands of her mistress. . . ." Several figures, probably representing the servants and handmaid of the canticle, look out from behind a barred window set in the tower wall. In the background a landscape opens. Like nos. 51 and 52, this painting is attributed to Jean Colombe.

[F. 52v]

51. Prayer of David

In the second miniature David kneels in prayer before an altar. This painting introduces Psalm CXXIII, a hymn of thanksgiving for divine protection: "Blessed be the Lord, who hath not given us to be a prey to their teeth." The open door looks from the church onto a medieval street lined with narrow houses.

[F. 53r]

52. Prayer of David

Here the church is differentiated from that in the preceding miniature by its columns and pilasters and its absence of sculpture. David kneels, a book open before him, and chants Psalm CXXIV, a plea for help: "Do good, O Lord, to those that are good, and to the upright of heart." Because Jean Colombe made use of space reserved for an explanation of the subject, the painting on this page, as well as no. 50, is larger than those executed by the Limbourg brothers.

[F. 53v]

53. Psalm CXXV

David prays before an open chapel, while several figures emerge from a house behind him, apparently to join in his supplication. They represent the Israelites returned from their captivity, for this psalm was created upon the King's return from exile: " When the Lord brought back the captivity of Sion, we became like men comforted. " In the background is a landscape of distant grassy hills which appear blue.

[F. 55r]

54. Psalm CXXVI

" Unless the Lord build the house, they labour in vain that build it. " The artist interpreted literally the psalm's first verse by representing the construction of a large house, which David shows to his people. The building is almost completed; one workman carries a heavy stone upstairs on his back while two others finish covering the tiled roof.

[F. 55v]

55. Psalm CXXVII

Here Jean Colombe, who also illustrated nos. 53 and 54, has tried to show the blessings of the just who fear the Lord: " Thy children as olive plants, round about thy table. ... And mayest thou see thy children's children. ... " A patriarch, seated nobly on a throne, gathers his sons around him in his home.

[F. 56r]

Eus in ad
iutorium
meum in
tende ↦

Domine ad adiu
nandum me festina ·

Gloria pri . ymnus ·

Eni crator sps
mentes tuorum
uisita imple superna
gratia que tu creasti
pectora ↦

Memento salutis auc
tor quod nostri quondam
corporis ex illibata uir
gine nascendo forma
sumpseris ↦

Maria mater gratie mater
misericordie nos ab hoste p
tege t hora mortis suscipi ↦

Gloria tibi domine qui na
tus es de uirgine ↦

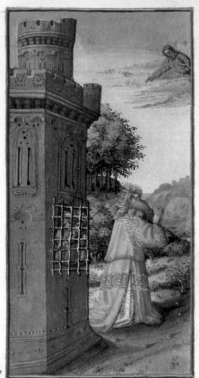

aunt · Post partum ps dd ·

Dte leuaui o
culos meos :
qui hitas in celis ↦

Ecce sicut oculi seruo
rum in manibus do
minorum suorum ·

Sicut oculi ancille
in manibus domine

sue ita oculi nri ad
dnm deu nostru do
nec misereatur nri.
Miserere nri dne
miserere nri quia
multu repleti sum?
despectione.
Quia multum
repleta est anima
nra opprobrium ha
bundantibz; et despe
tio superbis

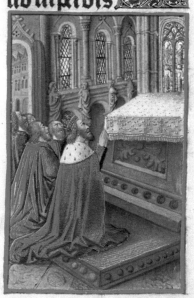

Nisi quia domi
nus erat in
nobis dicat nunc is
rael nisi quia domin?
erat in nobis.
Cum exurgerent
homines in nos forte
uiuos deglutissent
nos.
Cum irasceretur
furor corum in nos for
sitam aqua absor
buisset nos
Torrentem pertra
siuit anima nra for
sitan pertransisset a
nima nra aquam
intollerabilem
Benedictus domi
nus qui non dedit
nos in captione den
tibus eorum

nima nrā sicut
paſſer erepta est de la
queo nenancium.
Laqueus contritꝰ
est et nos liberati sum
Adintorium nr̄m
in nomine domini
qui fecit celū et terrā
Gloria patri

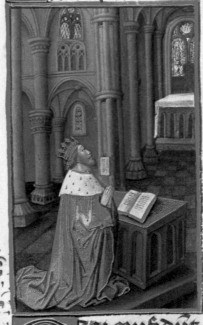

Qui confidit
in domino

sicut mons ſyon nō
cōmouebitur in eter
num qui hitat in
ꝑerusalem
Montes in circuitu
eius et dn̄s in cir
cuitu populi ſui ex
hoc nūc et uſq̃ ī ſclͫ.
Quia nō relinq̃t
dominus uirgam
peccatorū super ſorte
iuſtorū ut non ex
tendant iusti ad ini
quitatē man̄ꝰ ſuas.
Bene fac domine
bonis et rectis cozde.
Declinantes autē
in obligaciones ad
ducet dominus cū
operantibꝫ iniquita
tem pax super israel.
Gloria patri et filio

pio et nunc et semper
et in secula seculorum.
amen. ymnus
Veni creator spiritus mentes tu
orum visita imple su
perna gracia que tu cr
asti pectora.
Memento salutis
auctor quod nri quon
dam corpous erlibata
uirgine nascendo for
mam sumpseris.
Maria mater gracie
mater misericordie tu
nos ab hoste protege et
hora mortis suscipe
Gloria tibi domine
qui natus es de uirgie
cum pre sancto spiritu
in sempiterna secula.
Amen.

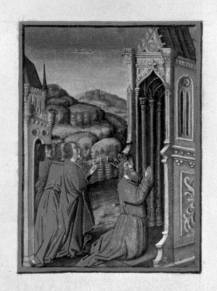

Ant. Sicut lilium. ps. iii.
In conuertendo
dominus capti
uitatem syon fa
sumus sicut consolati
Tunc repletum est
gaudio os nrm et lin
gua nra in exultacione.
Tunc dicent inter ge

tes magnificauit dns
facere cum eis.
Magnificauit dns
facere nobis cum fri n
sumus letantes.
Conuertere domine
captiuitatem nram si
cut torrens in austro.
Qui seminant in
lacrimis in exultacio
ne mettent.
Euntes ibant et fle
bant mittentes semina
sua.
Enientes autem
nenient cum exultaci
one portantes mani
pulos suos.
Gloria pri et filio.

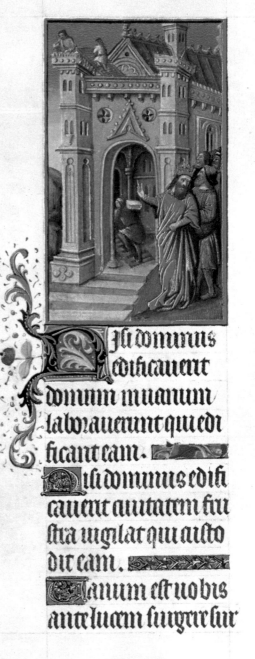

Isi dominus
edificauerit
domum inuanum
laborauerunt qui edi
ficant eam.
Nisi dominus edifi
cauerit ciuitatem fru
stra uigilat qui custo
dit eam.
Uanum est uobis
ante lucem surgere sur

gitte post quod sedentis qui
manducatis panem
dolons.

Dum dederit dilectis
suis sompnium ecce he
reditas domini filij m
ces fructus uentris.

Sicut sagitte m ma
nu potentis ita filij ex
cusorum.

Beatus uir qui im
pleuit desiderium suu
ex ipsis non confunde
tur cum loquetur m
mucis suis m porta

Gloria pri et filio et
spiritu sancto.

Sicut erat m prima
pio et nunc et semp et.

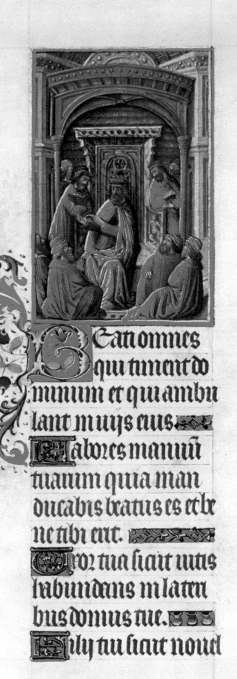

Bati omnes
qui timent do
minium et qui ambu
lant m uijs eius.

Labores manuu
tuarum quia man
ducabis beatus es et be
ne tibi erit.

Vxor tua sicut uitis
habundans m lateri
bus domus tue.

Filij tui sicut nouel

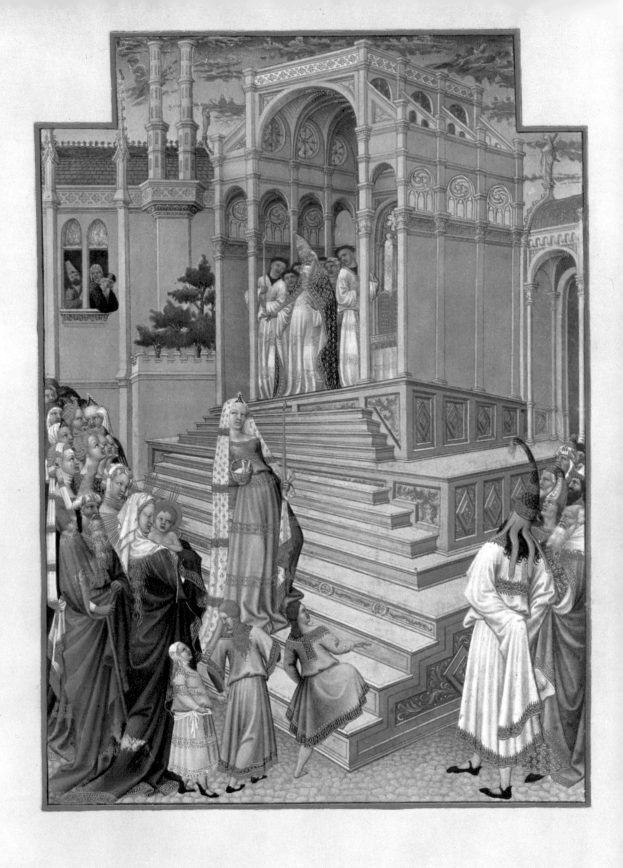

56. The Purification of the Virgin

The Gospel of Luke states that after the Virgin's days of purification (forty, in accordance with the law of Moses) were accomplished, Mary brought her child to Jerusalem to present Him in the Temple of the Lord, where she made an offering of two turtle doves.

The Limbourgs represented this scene at the beginning of none. Their composition is strikingly similar to Taddeo Gaddi's fresco of the mid-fourteenth century, *The Presentation of the Virgin,* in Santa Croce, Florence. Certain details, such as the children at the bottom of the stairs, are identical. Yet there are distinct differences, beginning with the subject matter. In the Florentine work, the central figure on the stairs is Mary the child; here, it is curiously no longer the Virgin but a young woman carrying the sacrificial doves, whose body sways in the characteristic fashion of contemporaneous French painting.

Does this mean that the Limbourgs were inspired by the fresco? Even if they had not seen the original or any of its Italian copies existing in Florence, Prato, and Padua, they might have come upon an Italian drawing in one of the princely collections or upon one of the numerous sketches or plans that circulated freely in the workshops as a result of the extensive international travels of artists at that time. It is therefore impossible to know exactly what directly or indirectly influenced the brothers.

The Virgin stands at the foot of the stairs, holding the Christ Child, who is covered by His mother's blue mantle. Behind her stands Joseph, wearing an oriental hat and robes. To emphasize local color, the artists have adorned the figures on the right with picturesque costumes—robes embroidered with arabesques and high, peaked headgear. The High Priest at the head of the stairs wears a golden tiara. The architectural setting is sumptuous: the staircase is of different colored marbles, and the Temple vaults are painted red. Figures staring from the windows of a neighboring house add anecdotal animation to the scene.

[F. 54v]

57. The Flight into Egypt

The Flight into Egypt, placed at the beginning of the Vespers for the Virgin, is the only illustration for the Hours of the Virgin that the Limbourg brothers did not have time to execute. Jean Colombe has devoted two miniatures to the subject: one large illumination, in the usual format, above a smaller illumination placed like a predella, both within a rather heavy architectural frame. Each miniature illustrates an anecdote popular in the Middle Ages. The first comes from the apocryphal *Gospel of Mary's Birth and the Savior's Childhood*. This text states that on the third day of their flight, the Virgin stopped to rest beneath a tree bearing fruit which caught her fancy. But the tree was tall, and, realizing that the fruit was beyond Joseph's reach, the Infant Jesus said, " Tree, bow your branches and feed my mother with your fruit. " The tree leaned, and the family was able to pick and eat its fruit.

Jean Colombe has treated the scene with his usual vigor, placing it in a setting of bluish mountains and rocks that in no way resembles a desert. Jesus, already a tall boy, seems to be talking to the tree as it bends within reach of Joseph, who typifies the heavy-bearded figures we see so often in Jean Colombe's miniatures. The Virgin, with her arched brow and long blonde hair, maintains an air of charming modesty in the swaying hipshot stance fashionable at the time of the artist. On the right, startled villagers observe the scene, while on the left two girls are seated, one apparently arousing the amazement of the other by showing her some fruit she was able to pick.

The scene below illustrates another anecdote related to the Flight into Egypt. While fleeing Herod's men, the Virgin and Child met a peasant sowing wheat. Jesus reached into the bag of seed and threw onto the path a handful, which immediately sprang into wheat as high and as ripe as if it were a year old. When Herod's soldiers arrived and asked the peasant if he had seen a woman carrying a child, he answered, " Yes, when I sowed this wheat, " whereupon they gave up the pursuit.

Also of interest on this page is the initial that decorates the text separating the two miniatures. Within it, the figure of the Christ Child is simply modeled with light touches of gold.

[F. 57r]

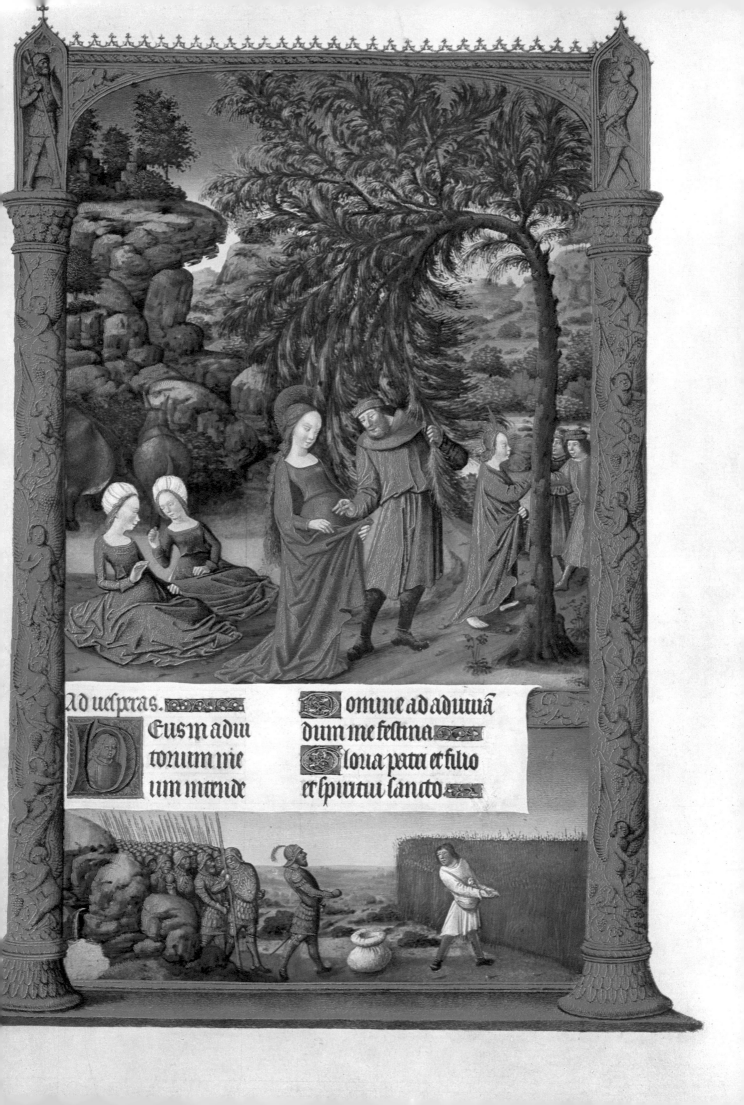

Ad uespras. Domine ad adiutoriu̅
Deus in adiu dum me festina.
torium me Gloria patri et filio
um intende et spiritui sancto.

mo ipo deus spiritu
sancto turuis honor
nunus. Amen. versus
Post partum virgo inuio
lata permansisti. Respon.
Dei genitrix intercede p
nobis. A. Sancta maria.

Magnificat aia
mea dnm.

Et exultauit spus
meus in deo salutari
meo.
Quia respexit humili
tatem ancille sue: ecce
enim ex hoc beatam
me dicent omnes ge
neraciones.
Quia fecit michi
magna qui potens est
et sanctum nomen e.
Et misericordia eius
a progenie in progeni
es timentibus eum.
Fecit potenciam in
brachio suo: dispersit
superbos mente cordis
sui.
Deposuit potentes
de sede: et exaltauit hu
miles.
Esurientes imple

58. The Visitation

According to Saint Luke, after the Annunciation the Virgin Mary left Galilee to go into a city of Judah, where she visited Zachary and Elizabeth, her cousin (see also no. 33). The latter, inspired by the Holy Ghost, welcomed her with the words, " Blessed art thou among women, and blessed is the fruit of thy womb. And whence is this to me, that the mother of my Lord should come to me?" (Luke 1: 42-43) In answer the Virgin intoned the *Magnificat,* which is transcribed below the miniature and continues onto the next page.

This scene takes place inside the house of Elizabeth and Zachary. Both women stand before a high chimney and a bench upon which lies an open book; Elizabeth grasps Mary's wrist. Pots, a pair of bellows, and a round wicker-covered bottle stand on or hang from the fireplace, in which we see two andirons. The window's wooden shutters are open, clearly revealing a red-roofed fortress.

Although the Limbourgs had already treated this subject, Jean Colombe has repeated it at the head of the Magnificat. The initial letter with its rabbit and the border foliage date from the time of the Limbourgs.

[F. 59v]

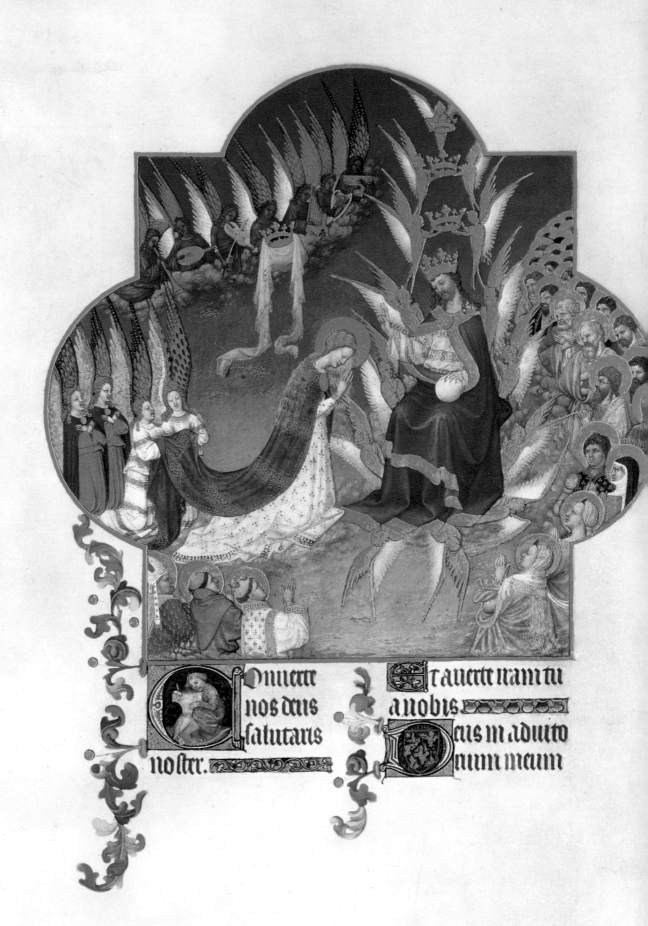

59. The Coronation of the Virgin

The cycle devoted to Mary ends with this magnificent Coronation of the Virgin, which illustrates the last hour of the day, compline. The Limbourgs have done justice to the theme, which had inspired medieval artists from the thirteenth century on. Against the blue background of the sky spreads a golden arabesque of angels' wings and saints' halos, in the middle of which the Virgin's purple mantle contrasts with Christ's deep blue robe.

Mary is not placed on the Lord's right, as she was on the portals of numerous cathedrals, but is shown kneeling with bowed head before her Son, awaiting His benediction. This is a new conception of the scene, which later in the fifteenth century was to be repeated and made well known by Fra Angelico. In the French pictorial tradition, she is crowned not by her Son but by an angel. Christ wears a crown, and five angels above Him hold three crowns which perhaps symbolize the Trinity.

Angels' wings flare behind and above the Virgin, recalling Dante's description of the scene in Canto XXXI of *Paradiso:* " . . . with outstretched wings, I saw more than a thousand Angels making festival, each one distinct in glow and art. " Several attending angels hold her train, and in the sky others play different instruments: trumpet, lute, viol, portable organ, harp, and dulcimer. On the right is a procession of saints, among whom Peter and Paul are recognizable, the first by his beard and wiry hair, the second by his baldness. The pure-faced Saint Clare, in nun's habit, stands above a virgin with a bare neck, perhaps Saint Catherine, whose life was depicted by the Limbourgs in the *Belles Heures*. The group is completed by a queen who wears a crown on her arm like a bracelet. Three other saints stand in the left foreground: Stephen, Francis, and a bishop, difficult to identify because he lacks specific characteristics, but who could be Saint Denis since he wears the purple attributed to martyrs.

[F. 60v]

60. Psalm XII

David begs the Lord not to forget him, nor to hide His face from him: "lest at any time my enemy say: I have prevailed against him. They that trouble me will rejoice when I am moved." The artist has represented the people of Israel at the left, threatened by the attack of enemy horsemen.

[F. 61r]

61. Psalm XLII

Jean Colombe has shown David kneeling in prayer before God, who appears to him above an altar. Groups symbolizing the oppressed, for whom David is praying, are imprisoned in two towers behind barred windows.

[F. 61v]

62. Psalm CXXVIII

In his prayers David reminds the Lord that although he has been persecuted by his enemies from the time of his youth, he has not been vanquished. The group of men on the left represent David's enemies who plot against him and are doomed to failure.

[F. 62r]

63. Psalm CXXX

This miniature illustrates David's canticle of confidence and humility: "If I was not humbly minded, but exalted my soul: As a child that is weaned is towards his mother, so reward in my soul." We can see that the artist's imagination seems to have failed him for several of these psalms, for he contented himself with depicting the King of Israel kneeling before his Creator in various settings: here, in front of the open door of a Gothic chapel.

[F. 62v]

64. The Presentation in the Temple

Simeon, a pious and just man of Jerusalem, knew that he would not die until he had seen the Lord's Christ. Encouraged by the Holy Ghost, he went to the temple on the day the Virgin came to sacrifice a pair of turtledoves or two young pigeons on the occasion of her firstborn. Simeon, on the right, prepares to receive the Christ Child from the Virgin and to intone the *Nunc dimittis*: "Now thou dost dismiss thy servant, O Lord, according to thy word in peace. ..." (Luke II: 29)

All the miniatures described on this page are by Jean Colombe.

[F. 63r]

intende. Domine ad adiuuan
dum me festina. Gloria pri et filio et
spiritu sancto. Sicut erat in princi
pio et nunc et semper.
an̄. Sancta dei genitrix.

Usquequo dn̄e p.
obliuisceris me

m finem usquequo a
uertis faciem tuam a
me. Quam diu ponam
consilia in anima me
a dolorem in corde me
o per diem. Usquequo exaltabi
tur inimicus meus su
per me respice et exaudi
me domine deus meus.
Illumina oculos
meos ne unquam ob
dormiam in morte neq̄n
do dicat inimicus me
preualui aduersus eu.
Qui tribulant me
exultabunt si motus
fuero autem in miseri
cordia tua speraui.
Exultabit cor meu
in salutari tuo canta

bo domino qui bona
tribuit michi et psal
lam nomini domini
altissimi.
Gloria patri et filio.

gente non sancta ab
homine iniquo et do
loso erue me.
Quia tu es deus for
titudo mea quare me
repulisti et quare tristis
incedo dum affligit me
inimicus.
Emitte lucem tuam
et ueritatem tuam ipsa
me deduxerunt et addu
xerunt in montem san
ctum tuum et in taberna
cula tua.
Et introibo ad alta
re dei ad deum qui leti
ficat iuuentutem meam.
Confitebor tibi in
cythara deus deus me
quare tristis es anima
mea et conturbas con
turbas me.

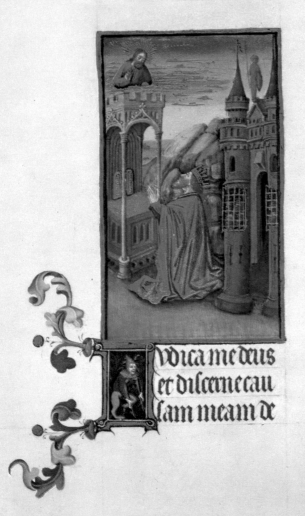

Iudica me deus
et discerne cau
sam meam de

Spera in deo quoni
am adhuc confitebor
illi salutare uultus mei
et deus meus.

Gloria patri et filio.

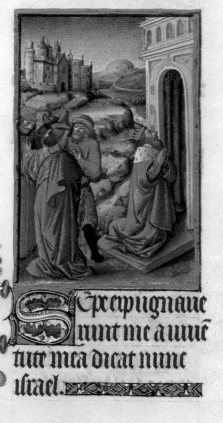

Spe expugnaue
runt me a iuuen
tute mea dicat nunc
israel.

Sepe expugnauerunt
me a iuuentute mea
et enim non potuerunt
michi.

Supra dorsum me
um fabricauerunt pec
catores prolongauerunt
iniquitatem suam.

Dominus iustus
concidet ceruices pecca
torum confundantur
et conuertantur retror
sum omnes qui oderunt
syon.

Fiant sicut fenum
tectorum quod priusque
euellatur exaruit.

De quo non imple
uit manum suam qui
metret et sinum suum
qui manipulos colli
get.

Et non dixerunt qui
preteribant benedictio
domini super nos bene
diximus nobis in no
mine domini.
Gloria patri et filio.

sunt oculi mei.
Neck ambulaui in
magnis neck in mira
bilibus super me.
Si non humiliter
seniebam sed exaltaui
animam meam.
Sicut ablatatus est
super matre sua: ita retri
butio in anima mea.
Speret israel in domino
ex hoc nunc et usque in se
culum.
Gloria patri et filio
et spiritui sancto. ant.
Sancta dei genitrix vir
go semp maria intercede p
nobis ad dominum deum nostrum.
Virgo dei genitrix.
genitur quem
totus non capit orbis
in tua se clausit viscera

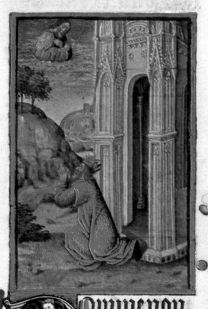

Domine non
est exaltatum
cor meum neque elati

factus homo.

Vera fides geniti pur
gauit crimina mundi
et tibi uirginitas inuio
lata manet.

Te matrem pietatis
opem te clamitat orbis
subuenias famulis o
benedicta tuis.

Gloria magna pri
compar tibi gloria na
te cum sancto spiritu glo
na magna patri. Amen.

Sicut capitulum.

Cynamomium
et balsamum aromati
zans odorem dedi quasi
mirra electa dedi suaui
tatem odoris. Deo gras.

Ecce ancilla domini. R.

Fiat michi secundum u
bum tuum. Antiphona.

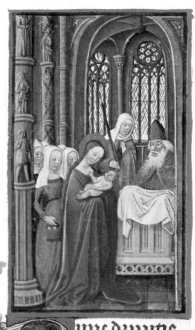

Nunc dimittis
seruum tuum
domine: secundum
uerbum tuum in pace.

Quia uiderunt oculi
mei: salutare tuum.

Quod parasti ante

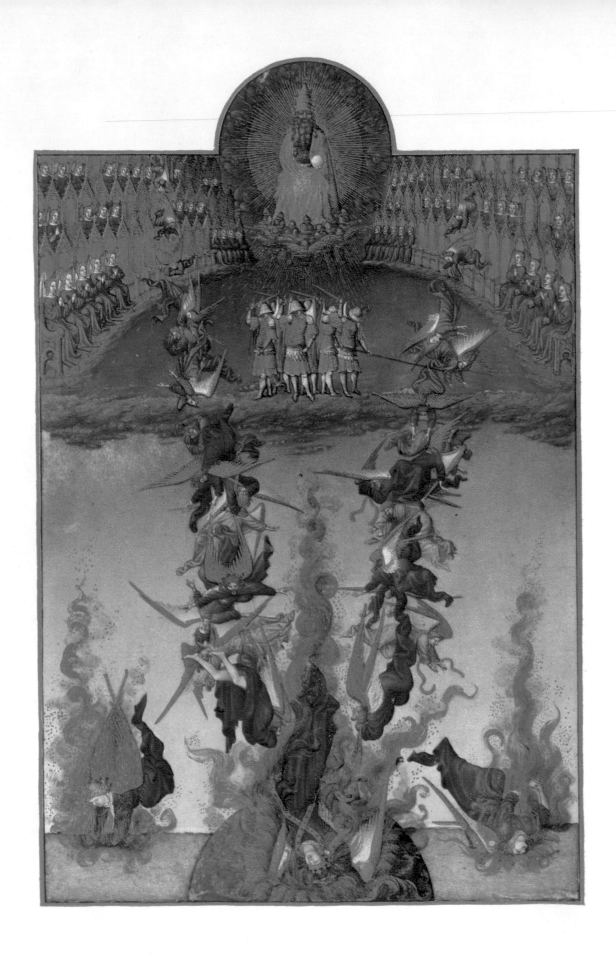

65. The Fall of the Rebel Angels

This is one of the Limbourgs' most original and beautiful miniatures. The extraordinary movement of the rebel angels falling from the sky and the chatoyant harmony of blues and golds, almost the only colors used, reveal the artists' genius. Not originally planned for the *Très Riches Heures,* it is an inset page executed separately either at the suggestion of the Duc de Berry or upon a sudden inspiration of one or more of the brothers. It was placed at the beginning of David's Penitential Psalms, probably because the angels' revolt was the first sin from which stemmed all other sins because of Lucifer's wish for revenge.

God, fiery faced, holds a globe and sits enthroned in the firmament with shining seraphim at His feet. Rows of gold stalls in semicircular tiers resembling a theater represent the seats, many of which are vacant, of the heavenly powers: one thought of the Almighty was enough to send the rebel angels hurtling down.

The fall itself is a marvelous innovation: the double row of intertwining gold wings and blue robes, headed by the handsome Lucifer crowned in gold, ends with the angel's conflagration upon touching the earth. One recalls the words of Isaiah: "How art thou fallen from heaven, O Lucifer, who didst rise in the morning?" (Isaiah XIV: 12) High between the two rows of falling angels, we see the heavenly host in gold coast of mail and silver helmets. Firmly planted at the feet of the Lord, they stand surveying the execution and ready to obey Him.

[F. 64v]

66. Psalm VI

In Psalm VI, whose text appears on this page, David appeals to the goodness of the Lord, who in the miniature appears half-length amid clouds. David has set his crown in front of himself and has left his throne to prostrate himself with joined hands before God: " Have mercy on me, O Lord, for I am weak: heal me, O Lord, for my bones are troubled. And my soul is troubled exceedingly. . . . "

This psalm seems to have been composed by the King of Israel at a moment when he felt abandoned by all: " My eye is troubled through indignation: I have grown old amongst all my enemies. " Certain figures in the crowd behind David look at him wickedly while others avert their eyes; these are the enemies to which the psalm refers, the men of Israel who forsook the King during Absalom's rebellion.

Jean Colombe executed the miniature, although the initial letter and its bearded figure, whose hair is held by a yellow ribbon tied on the side, were painted at the time of the Duc de Berry.

[F. 65r]

bata eſt ualde: ſed tu do
mine uſquequo.
Onuertere domine
et eripe animam mea
ſaluum me fac prop̃
miſericordiam tuam.
Quoniam non eſt
in morte qui memoz
ſit tui in inferno aut̃
quis confitebitur tibi.
Laboraui in gemi
tu meo lauabo per ſin
gulas noctes lectum
meum lacrimis meis
ſtratum meum rigabo.
Turbatus eſt a furo
re oculus meus: inuet
aui inter omnes inni
cos meos.
Iſcedite a me om̃s
qui operamini iniqui
tatem quoniam exau

Omine ne
in furore tu
o arguas me
neq̃ in ira tua corripi
as me.
Iſerere mei domine
quoniam infirmus
ſum ſana me domine
quonia conturbata ſt
omnia oſſa mea
t anima mea tur

diuit dominus uocem
fletus mei. Exaudiuit dominus
deprecacionem meam
dominus oracionem
meam suscepit. Erubescant et contur
bentur uehementer omis
inimici mei conuerta
tur et erubescant ualde
uelociter. Gloria patri et filio
et spiritui sancto. Siaut erat in princi
pio et nunc et semper
et in secula seculorum.
Amen.

Beati quorum
remisse sunt in
quitates et quorum tec
ta sunt peccata. Beatus uir cui non
imputauit dominus
peccatum nec est in spi
ritu eius dolus. Quoniam tacui inue
trauerunt ossa mea
dum clamarem tota
die.

67. David and Nathan

This miniature introduces Psalm XXXI, a prayer of repentance and pardon: " I have acknowledged my sin to thee, and my injustice I have not concealed. I said I will confess against myself my injustice to the Lord: and thou hast forgiven the wickedness of my sin. "

Jean Colombe chose to illustrate the event of the prophet Nathan rebuking David for having slain Uriah the Hittite in order to take his wife, Bathsheba (II Samuel XII). Because David repented, the Lord spared his life but punished him with the death of the son Bathsheba had borne him. David, overwhelmed with contrition, sits on a high-backed chair, while Nathan stands before him and reproaches him in the name of the Lord.

[F. 65v]

de.

Gloria patri et filio.

Domine ne in furore tuo arguas me neq; in ira tua corripias me.

Quoniam sagitte tue infixe sunt michi

et confirmasti super me manum tuam.

Non est sanitas in carne mea a facie ire tue non est pax ossibus meis a facie peccatorum meorum

Quoniam iniquitates mee supergresse sunt caput meum et onus graue grauata sunt super me.

Putruerunt et corrupte sunt cicatrices mee a facie insipientie mee.

Miser factus sum et curuatus sum usq; in finem tota die contristatus sum ingrediebar.

Quoniam lumbi mei impleti sunt illusionibus et non est sa

68. Psalm XXXVII

This psalm, an appeal of the sinner to his Lord, prefigures the commemoration of Christ's sacrifice: "Rebuke me not, O Lord, in thy indignation; nor chastise me in thy wrath. For thy arrows are fastened in me: and thy hand hath been strong upon me." The army, camped before a wide river separating it from the city, symbolizes the instrument of divine wrath: "But my enemies live, and are stronger than I: and they that hate me wrongfully are multiplied." Spears drawn, the cavalry stands ready to attack. A church and several large towers dominating the red tile roofs of small houses along the water perhaps represent Jean Colombe's conception of Jerusalem.

[F. 66v]

gna locuti sunt.

Quoniam ego in flagella paratus sum et dolor meus in conspectu meo semper.

Quoniam iniquitatem meam annunciabo et cogitabo pro peccato meo.

Inimici autem mei viuunt et confirmati sunt super me: et multiplicati sunt qui oderunt me inique.

Qui retribuunt mala pro bonis detrahebant michi quoniam sequebar bonitatem.

Ne derelinquas me domine deus meus ne discesseris a me.

Intende in adiuto

nium meum domine deus salutis mee.

Gloria pri.

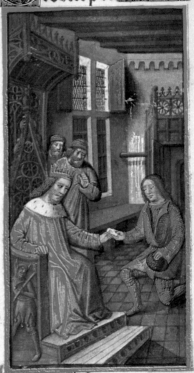

Miserere mei deus secundum magnam miam tuam.

Et secundum multitudinem miseracionum tuarum dele ini

69. David Entrusts a Letter to Uriah

Psalm L is a Penitential Psalm, composed by David after Nathan came to him following the King's adultery with Bathsheba. To illustrate this prayer, Jean Colombe chose the scene described in II Samuel XI when David completes his sin by sending Bathsheba's husband, Uriah, to Joab with the letter which seals his fate: "Set ye Urias [Uriah] in the front of the battle, where the fight is strongest: leave ye him, that he may be wounded and die." The scene is set within a fifteenth-century house; Uriah kneels bare-headed before David who hands him the fatal letter. Two servants stand behind the King of Israel.

[F. 67v]

tuas et impij ad te con
uertantur. Libera me de sangui
nibus deus deus salutis
mee: et exultabit ling
ua mea iusticiam tuam.
Domine labia mea
aperies: et os meum an
nunciabit laudem tu
am. Quoniam si nolu
isses sacrificium dedis
sem utiqʒ holocaustis
non delectaberis. Sacrificium deo spu
contribulatus cor con
tritum et humiliatu
deus non despicies. Benigne fac domi
ne in bona uolunta
te tua syon ut edificen
tur muri iherusalem.

Tunc acceptabis
sacrificium iusticie ob
lationes et holocausta
tunc imponent sup
altare tuum uitulos.
Gloria patri.

ne exaudi ora
nem mea: et cla
mor me' ad te ueniat.

70. An Attack on a City

Psalm CI, the fifth Penitential Psalm, expresses the lamentation of the afflicted: "Hear, O Lord, my prayer: and let my cry come to thee." The armed assault on a city by warriors whom we see forcing its gates symbolizes the insults received by the people of God and by their leader: "All the day long my enemies reproach-ed me: and they that praised me did swear against me." The battle takes place within Jerusalem; the enemy is shown at the doors of the fortress erected in the middle of the city. Like no. 68, this illumination by Jean Colombe precisely depicts weapons and troop movements at the end of the fifteenth century.

[F. 68v]

71. *De Profundis*

De Profundis, the sixth Penitential Psalm (Psalm CXXIX), is illustrated by a miniature in which David kneels with joined hands before an altar within a chapel; a red-hatted figure in the middleground is in a similar supplicant posture. On the left, a bearded man clasps a blonde woman who watches the King pray.

Jean Colombe executed the ornamental D and the center foliage as well as the miniature. The face in the initial letter recalls the young woman's face in the scene above.

[F. 70r]

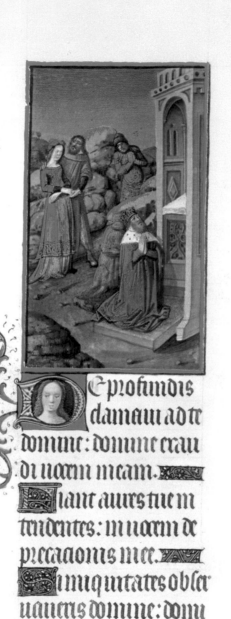

nuto tu domine ter
ram fundasti: et opera
manuum tuarum sūt
celi.

pi peribunt tu au
tem permanes: et oīs
sicut uestimentum ue
terascent.

Et sicut opertorium
mutabis eos et muta
buntur tu autem idem
ipe es et anni tui non de
ficient.

ilij seruorum tuo
rum habitabunt et se
men eorum in seculum
dirigetur.

loria pri et filio. et
spiritui sancto.

E profundis
clamaui ad te
domine: domine exau
di uocem meam.

iant aures tue in
tendentes: in uocem de
precacionis mee.

Si iniquitates obser
uaueris domine: domi
ne quis sustinebit.

uia apud te propi

ciacio est : et propter le
gem tuam sustinui te
domine.

Sustinuit anima
mea in verbo eius spe
ravit anima mea in
domino.

A custodia matuti
na usq; ad noctem spe
ret israel in domino.

Quia apud diim
misericordia et copio
sa apud eum redemp
cio.

Et ipse redimet isrl'
er omnibus iniquita
tibus eius.

Gloria patri et filio
et spiritu sancto.

Domine exau
di oracionem
meam: auribus perci
pe obsecracionem me
am in veritate tua ex
audi me in tua iusti
cia.

Et non intres in iu
dicium cum servo tuo
quia non iustificabi
in conspectu tuo omis

72. Psalm CXLII

Jean Colombe has shown David, again kneeling in prayer, reciting the seventh Penitential Psalm before a covered altar adorned with unusual statuettes. His armed enemies prowl around him: "For the enemy hath persecuted my soul: he hath brought down my life to the earth."

[F. 70v]

73-74. The Procession of Saint Gregory

This subject could not have been originally planned for the *Très Riches Heures* since only one text column, not space enough for a large miniature, remained free between the end of the Penitential Psalms and the beginning of the Litanies of the Saints. However, the Limbourgs ingeniously used this column to paint a large double-page miniature, which they placed at the beginning of the Litanies since the Procession of Saint Gregory was known as "The Great Litany," or "The Great Supplication."

The scene is based on *The Golden Legend*. At the time of Gregory's election to the papacy in 590, Rome was ravaged by the plague. The newly elected Pope, later known as Gregory the Great, ordered a procession around the city to entreat the heavens to end their affliction. While praying at the head of the procession, Gregory saw an angel appear on the top of the citadel and sheathe a bloodstained sword. He understood the plague was coming to an end; thereafter the citadel, formerly Hadrian's mausoleum, was called the Castel Sant'Angelo, or the Castle of the Holy Angel.

The artists have shown the procession passing before the city walls, led by priests, one of whom has just fallen victim to the plague, and by deacons bearing banners. Wearing the papal tiara, the Pope follows and implores Heaven with both arms. Behind him come the cardinals, beside whom lies a monk, also felled by the scourge. The procession ends with a crowd thronging through the city gates. Beyond the walls are the monuments of Rome as imagined by the Limbourgs, who in fact probably never saw them. Instead of the actual squat and massive Castel Sant'Angelo, they have depicted a slender building on which the angel appears sheathing his sword.

The Limbourgs did not complete this large miniature. The design and coloring of the sky, buildings, and figures, as well as the execution of the faces on the left-hand page undoubtedly reveal their mastery. However, the round, somewhat dazed, physiognomies on the facing page are in the style of Jean Colombe. As in no. 10, the fact that the faces were obviously painted last attests to the miniaturists' procedure of work.

[F. 71v-72r]

cabis me in equitate tua.
Educas de tribulacio
ne animam meam et
in misericordia tua dis
spides omnes inimi
cos meos.

Et pedes omnes q
tribulant animam
meam quoniam ego
seruus tuus sum.

Gloria patri et filio
et spiritu sancto.

Sicut erat in princi
pio et nunc et semper z
in secula seculorum. Amen.

Ne reminiscaris Ant.
dne delicta nostra vel parentum
nostrum neq; uindictam su
mas de peccatis nostris parce do
mine ppło tuo quem redemisti
sanguine tuo. ppio ne in eter
num irascaris nobis. Et.

75. The Man of Sorrows

In this fine miniature by Jean Colombe, a bloodstained Christ, showing the wounds on His breast and wrists and wearing the crown of thorns stands in His sarcophagus before the Cross of His Crucifixion. The theme of the Man of Sorrows seems to have appeared first in fourteenth-century manuscripts in which the dead Christ was held by one or more angels. Here, He stands unaided.

On the left kneels Jean Colombe's patron, Duc Charles I de Savoie, in a voluminous ermine-hooded cloak over a blue garment. He wears the collar of an order and a headband decorated with pearls and gems. His wife, the Duchesse Blanche de Montferrat, kneels on the other side. In the lower part two cherubs with spread wings hold the shields of Savoie and Montferrat.

A most skillfully executed landscape stretches behind Christ and the Cross. A lake dotted with rowboats winds between hills which recede in a succession of planes. On the left rises a powerful yet elegant castle, which might be Ripaille on the banks of Lake Leman near Thonon, a favorite place of sojourn of the dukes of Savoie. Paul Durrieu pointed out that the instructions of Charles I de Savoie to pay twenty-five écus to Jean Colombe, then completing the *Très Riches Heures,* were dated August 31, 1485 at the Château de Ripaille (*Les Très riches Heures de Jean de France, duc de Berry,* p. 111). At the end of the lake, we glimpse a town which could be Geneva.

Before Jean Colombe began his work, a scribe had written four double lines of text in two columns. But the illuminator was not satisfied with the space that had suited the Limbourg brothers seventy years before; his illustration breaks into every margin to such an extent that the binder was forced to cut the top of the frame around the Duc and Duchesse de Savoie.

The decorated initials representing a scowling bearded man and a young woman with half-closed eyes are also from the workshop of Jean Colombe.

[F. 75r]

Domine la biabit laudem tuam. bia mea a pnes. Deus madiuto rium meum ttos meum annu intende.

76. Pentecost

To begin the Hours of the Holy Ghost, Jean Colombe painted Pentecost, grouping in a circle beneath a shining white dove not only the twelve apostles but also the Virgin and other disciples, including two women. This representation was traditional, although the Acts of the Apostles states only, " they were all together in one place. " (Acts II: 1)

This is not one of the artist's best miniatures: the men have unpleasant faces thickened with beards and even the Virgin is ungraceful. Jean Porcher writes, " Burdened with commissions, about which he complained bad temperedly, Colombe was capable of the best and of the worst; he often let assistants finish works which he had only sketched rapidly on a bit of parchment. " Such was probably the case with this illustration, which is inferior to the Man of Sorrows (no. 75) or the Entomb-

ment (no. 118). He seems to have taken more interest in the setting, in the somewhat heavy gold frame and the architectural decoration of the hall. Obviously attracted by details of the new architecture of the early Italian Renaissance, this brother of the sculptor Michel Colombe imagined statues, medallions, and bas-reliefs which are infinitely more interesting than the poses or expressions of the figures.

Wishing to use the whole page to give an architectural dimension to his framework, Jean Colombe erased the first lines of a verse from Psalm L, inscribed at the bottom of the space reserved for the miniature, and rewrote it in capital letters at the base of the frame under the medallions: " *Domine, labia mea aperies et os meum.* " " O Lord, thou wilt open my lips: and my tongue shall declare thy praise. " Here the lines apply to the descent of the Holy Ghost.

[F. 79r]

77. Job Mocked by His Friends

For the Office of the Dead, which occupies an important position in the *Très Riches Heures,* Jean Colombe executed five large miniatures (nos. 77, 80, 82, 85, 88). Representing nearly a quarter of his contribution to the manuscript, they are indicative of the nature of his illustrations therein. The scene of Job mocked by his friends heads the cycle. Lessons taken from the Book of Job were placed in matins for the dead to symbolize the bitterness and misery of existence, the weariness of life, the anguish before death and judgment, and at the same time the confidence one must have in God the Redeemer.

We see Job on the dung heap before his ruined home. His body is covered with sores and his ribs show through his skin, but his miserable appearance does not deter his friends, of whom he begs pity, from jeering at him. They remind him of the words with which he used to comfort the weak and unhappy: *"Ubi est timor tuus, fortitudo tua, patientia tua, et perfectio viarum tuarum?"* ("Where is thy fear, thy fortitude, thy patience, and the perfection of thy ways?" [Job IV: 6])

Jean Colombe has executed this miniature with particular care, rendering the expressions and gestures of the figures with such an effort at realism that Job's suffering and his friends' disparaging quibbling are almost exaggerated. The scene is framed by a pleasant landscape; in contrast to Job's ravaged house is a magnificent château, perhaps a favorite home of the Duc and Duchesse de Savoie, the artist's patrons at the time. The painting's architectural framework, of the type favored by Jean Colombe, is rather curious with its fragments of pink and turquoise marble columns, jewel-studded pillars and strange statuettes, probably in silver, which represent gesticulating corpses. Two stages of a burial have been painted in the base of the frame: on the right a funeral procession is escorted by the weepers who first appeared at the beginning of the fifteenth century with the burial of Philippe le Hardi, Duc de Bourgogne, and on the left a burial in a church vault is shown.

[F. 82r]

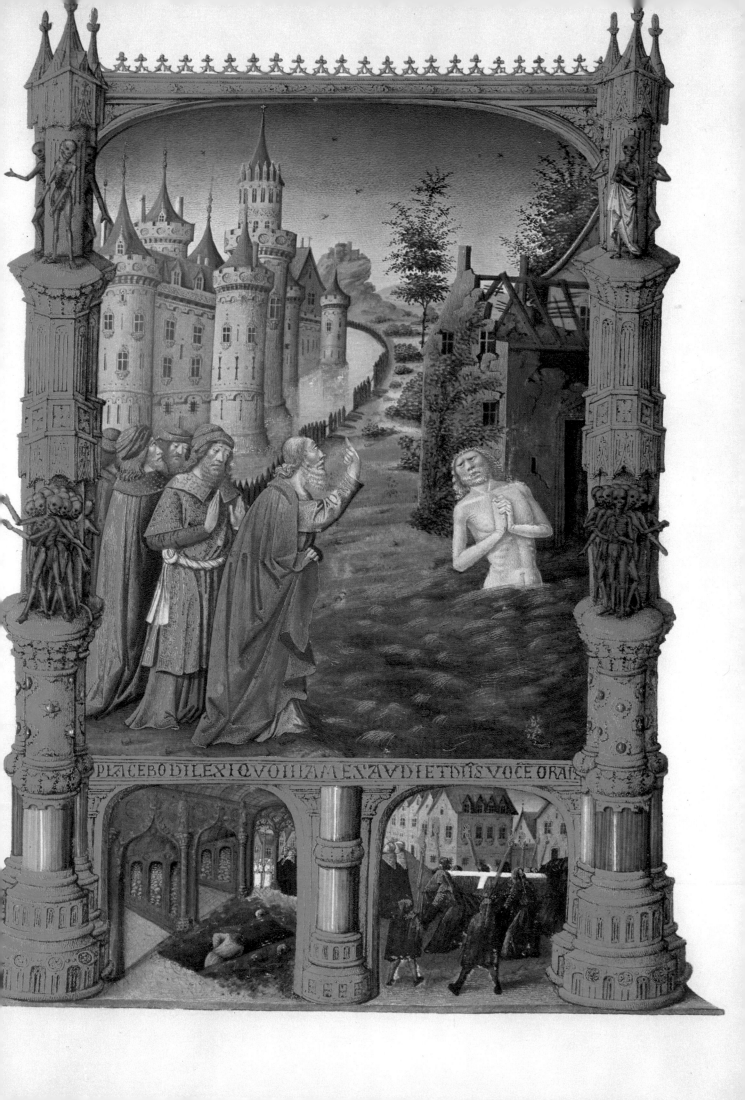

PLACEBO DILEXI QVONIAM EXAVDIET DNS VOCE ORAI

78. Psalm CXXXVII

A priest wearing a long surplice genuflects before a figure who stands, holding his hat and slightly bowing his head to receive the sprinkling of holy water. Two attendants accompany this man, who is perhaps a member of the Duc de Savoie's household. The scene is set in a large chapel with side aisles and triforium; the choir is screened by a jubé decorated in bas-relief. There seems to be no definite connection between Jean Colombe's illustration and David's psalm of thanksgiving: " I will praise thee, O Lord, with my whole heart. ... I will worship towards thy holy temple, and I will give glory to thy name for thy mercy, and for thy truth. ... "

[F. 84r]

Si iniquitates obserua
ueris domine domine quis
sustinebit. antiphona.
Extra manuum

Confitebor tibi p̄.
domine in toto
corde meo: quoniam
audisti uerba oris mei.
In conspectu angelo

rum psallam tibi ad
rabo ad templum sanc
tuum et confitebor no
mini tuo
Super misericordia
tua et ueritate tua: qm̄
magnificasti super ōe
nomen sanctum tuū.
In quacumq̄ die
inuocauero te exaudi
me multiplicabis in
anima mea uirtutem
Confiteantur tibi
domine omnes reges
quia audierint omā
uerba oris tui.
Et cantent in uijs
domini: quoniam ma
gna est gloria domini
Quoniam excelsus
dominus et humilia
respicit: et alta a longe

79. Psalm CXLV

Kneeling before an altar, David intones a song of hope for the afflicted: "Praise the Lord, O my soul, in my life I will praise the Lord: I will sing to my God as long as I shall be. Put not your trust in princes: in the children of men, in whom there is no salvation."

The scene takes place in the choir of a church. High windows light the blue transept vault supported by massive pillars with attached colonettes. The transept opens onto what could be a sacristy; part of the ambulatory is also visible. The altar hanging is embroidered in gold.

[F. 85r]

sturentes imple
uit bonis: et diuites di
misit manes ✦✦✦✦✦
uscepit israel pue
rum suum: recordatus
est misericordie sue.
icut locutus est ad
ad patres nros abraha
et semini eius in secula.
equiem eterna. A~
iu lazarum resuscita
sti a monumento fetidum
tu eis domine dona requie
et locum indulgentie. Pat~
nr̄. Et ne nos ind. Vsus.
n memoria eterna
erunt iusti. Responsor.
b audicione mala
non timebunt iustus.
porta inferi. Kri.
ue domine aias eor
redo inde bona diu.

n terra uiuentium.

auda anima
mea dominu
laudabo deum meum
in uita mea: psallam
deo meo qñ diu fuero.
olite confidere in
principibus: nec in fi
lijs hominum in quib

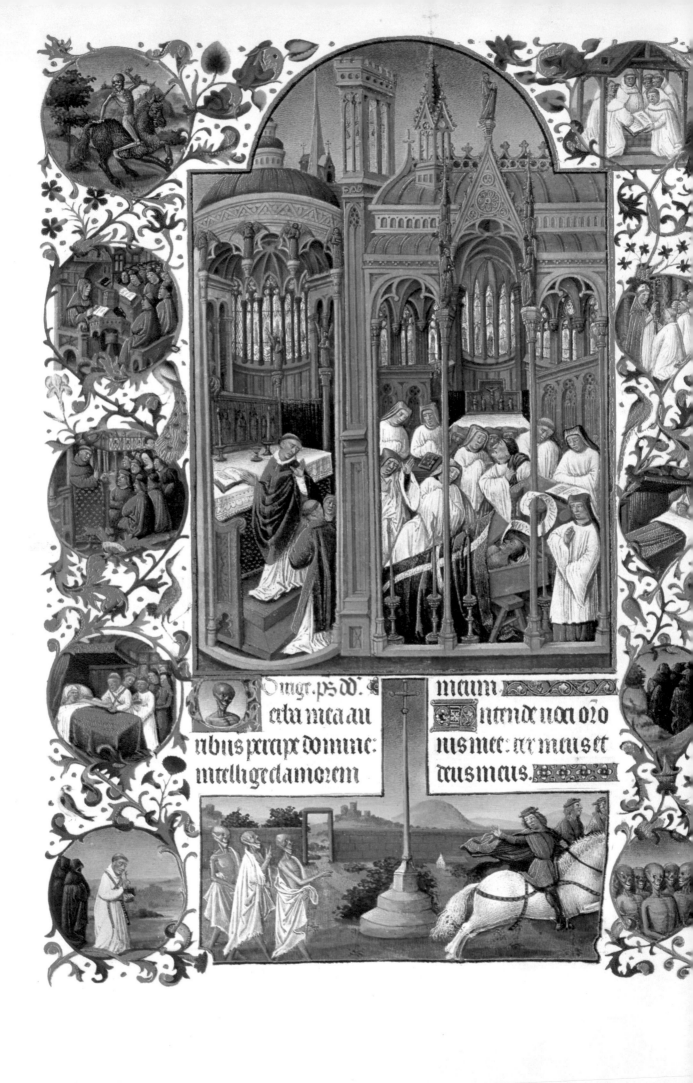

80. The Funeral of Raymond Diocrès

This illustration for the Office of the Dead expresses the aspects of death that were so prevalent in medieval art: its suddenness, its anguish, its bereavement, and its terrible judgment. The miniature depicts the tragic event that caused Saint Bruno to retire into solitude. According to the tradition of the Carthusian monks, at the funeral of Raymond Diocrès, a canon of Notre-Dame in Paris famous for his piety and preaching, the dead man rose up in his coffin to say, *"J'ai été appelé au juste jugement de Dieu, j'ai été jugé au juste jugement de Dieu, j'ai été condamné au juste jugement de Dieu."* "I have been called by the just judgment of God, I have been judged by the just judgment of God, and I have been condemned by the just judgment of God."

The shape of the miniature's frame, the church architecture, parts of the foliage, and especially the birds, are in the style of the Limbourgs, who had already treated this subject in the *Belles Heures*. They probably designed the miniature and made a first sketch, in part still visible, which was later completed by Jean Colombe, who also added the *bas-de-page* and the scenes in the left and right margins.

The *bas-de-page* represents the *dit des trois morts et des trois vifs* (the story of the three dead and the three living), an edifying thirteenth-century legend that provided material for several narratives and also inspired artists, especially in the fifteenth century. Three young horsemen of noble birth see in a cemetery three corpses who address them. "I was Pope," says one; "I was a cardinal," says the second; "I was an apostolic notary," says the third. And they add, "You will be like us: power, honor, riches are naught." The three terrified horsemen gallop away, but upon seeing a cross they realize they have received a warning from heaven.

Almost all of the small marginal subjects relate to the life of Raymond Diocrès and Saint Bruno. At the upper left is an interesting and unusual picture of Death mounting a unicorn. The decorative foliage resembles border work the Limbourgs painted on other pages of the *Très Riches Heures*.

[F. 86v]

81. Psalm VII

In this miniature by Jean Colombe the supplicant David is confronted by a lion, referred to at the beginning of the psalm: " O Lord my God, in thee have I put my trust: save me from all them that persecute me, and deliver me. Lest at any time he seize upon my soul like a lion, while there is no one to redeem me, nor to save. "

In the serenity of wooded hills dominated by baronial palaces, the Psalmist invokes the Lord. The river winding between the hillocks is enlivened by a rowboat.

[F. 88r]

urbatus est a furore
oculus meus inueteraui
inter omnes inimicos
meos. Discedite a me omnes
qui operamini iniqui
tatem exaudiuit dns
uocem fletus mei. Exaudiuit dominus
deprecacionem meam
dominus orationem me
am suscepit. Erubescant et con
turbentur uehementer
omnes inimici mei. Con
uertantur et erubescant
ualde uelociter. Requiem eternam
dona eis domine. Et lux perpetua luce
at eis. antiphona.
Conuerte domine et eri

pe animam meam quin no
est in morte qui memor sit
tui. ant. sequando. ps.

Omine deus
meus in te spe
raui: saluum me fac
ex omnibus persequen
tibus me et libera me.

DOMINVSREGITMEETNICHILMICHIDEERITINLOCO

82. The Horseman of Death

Placed at the beginning of the second nocturn for the Office of the Dead, Jean Colombe's miniature represents the fourth rider of the apocalypse: "And behold a pale horse, and he that sat upon him, his name was Death, and hell followed him. And power was given to him over the four parts of the earth, to kill with sword, with famine, and with death, and with the beasts of the earth." (Apocalypse VI: 8)

The rider, clad in red and brandishing a sword, rides a light-colored horse with red trappings, which leaps over the tombs in a graveyard. He is accompanied by a procession of corpses, still wearing their shrouds and armed with lances, axes, scythes, and sticks. The sight of this extraordinary group sends havoc among a passing group of soldiers, who beg for mercy. A striking effect could have been created here if it were not for the monotony of the skulls, assembled along a line which cuts the miniature diagonally, separating the terrified soldiers from the horseman of Death.

In the background a cheerful landscape and a quiet town, in which a few soldiers have taken refuge, contrast with this frightening scene. Jean Colombe seems to have intended here an illustration of Psalm XXII, whose first verse, beginning this second nocturn, is inscribed in the lower part of the miniature's frame: " Dominus regit me. ..." "The Lord ruleth me: and I shall want nothing." The psalm expresses the peace of the soul who believes in God: "For though I should walk in the midst of the shadow of death, I will fear no evil, for thou art with me. Thy rod and thy staff, they have comforted me." In this pleasant scene, we see at the extreme left the facade of a church, then a dovecote, several houses, and at the right the entrance towers of a château with a drawbridge and a moat filled with water. Tall trees and bluish mountains rise beyond, evoking the "place of pasture" of which the psalmist sings.

[F. 90v]

seruttas tuas edoce me
Dinge me in veritate tua et doce me: qui
a tu es deus saluator
meus et te sustinui to
ta die.

Reminiscere mise
rationum tuarum
domine: et misericor
diarum tuarum q̃ a
seculo sunt.

Delicta iuuentutis
mee et ignorancias
meas ne memineris.

Secundum miam
tuam memento mei
tu: propter bonitate
tuam domine.

Dulcis et rectus do
minus: propter hoc
legem dabit delinque
tibus in via.

Ad te domine
leuaui animã
meam: deus meus in
te confido non erubesca.

Neq; irrideant me
inimici mei: etenim
uniuersi qui sustinet
te non confundentur.

Confundantur v̄
omnes iniqua agen
tes superuacue.

Vias tuas domine
demonstra michi: et

83. Psalm XXIV

" To thee, O Lord, have I lifted up my soul. In thee, O my God, I put my trust; let me not be ashamed. " The kneeling tonsured figure, dressed in a long red and gold cassock, illustrates the first verse of this psalm by holding up his soul, represented by the common medieval symbol of a small naked figure. The church is decorated with unusual gold statues on pedestals. A golden angel perches on a gilded colonette near the altar. This miniature is by Jean Colombe.

[F. 91v]

meam et erue me: non
erubescam quoniam
speraui in te.

Innocentes et recti
adheserunt michi: q̃
a sustinui te.

Libera deus israel
ex omnibz tribulaci
onibus suis

Requiem eternã
dona eis domine.

Et lux perpetua lu
ceat eis. antiptona.

Delicta iuuentutis
mee et ignorancias me
as ne memineris domi
ne. antiptona

Dirige.

Dominus illu
minacio me
a: et salus mea quẽ
timebo.

Dominus uite mee:
a quo trepidabo.

Dum appropriant
super me nocentes ut
edant carnes meas.

Qui tribulant me
inimici mei: ipsi infir

84. Psalm XXVI

Jean Colombe was lacking in imagination when he illustrated this psalm for he has again shown David kneeling to invoke God, as suggested by the lines of the hymn which celebrates the intrepid confidence of the faithful in the Lord: " One thing I have asked of the Lord, this I will seek after; that I may dwell in the house of the Lord all the days of my life. ... Hear, O Lord, my voice, with which I have cried to thee. ... "

Colombe became a master of this kind of landscape: a body of water flecked with boats, a blue background fading into the distance, and the round towers of a city or fortification.

[F. 92v]

85. David's Victory

Jean Colombe's miniature illustrates Psalm XXIX, which begins the third nocturn for the dead: *"Exaltabo te, Domine. ..."* "I will extol thee, O Lord, for thou hast upheld me: and hast made my enemies to rejoice over me." David composed this hymn of thanksgiving after his victory over the Jebusites and the capture of their citadel, which became the site of Jerusalem. For the Office of the Dead, the Church has interpreted the psalm symbolically, applying the second and third verses to the deceased: "O Lord my God, I have cried to thee, and thou hast healed me. Thou hast brought forth, O Lord, my soul from hell: thou hast saved me from them that go down into the pit."

This is one of Colombe's better miniatures, in which he has treated the difficult subject of a melee, successfully rendering the different movements of the opposed horsemen, the fallen horses and men, one of whom is pierced with a lance, and the opening on the left made by golden riders through the black mass of the enemy. Only in the battle's background did he lapse into his overworked formula of aligning similar heads on the same level. The contrast of gold and black combatants seems to symbolize the meaning given Psalm XXIX by the Church. The gray-black tone of the enemy is that usually employed by miniaturists (the Limbourgs as well as Jean Colombe) to represent the devil, who, in the religious language of the day, was by definition the Enemy.

Behind this symbolic but realistic battle is one of Jean Colombe's most beautiful landscapes, whose varied planes recede in the distance. Here, as in other miniatures, the setting was probably inspired by some winding lake in Savoie, such as the Lac du Bourget.

In order to use the whole page, the artist erased the few lines of text at the bottom making an amusing error when he rewrote in a scroll on the base, *"Exultabo,"* or "I will rejoice," instead of *"Exaltabo te"*—"I will extol thee."

[F. 95r]

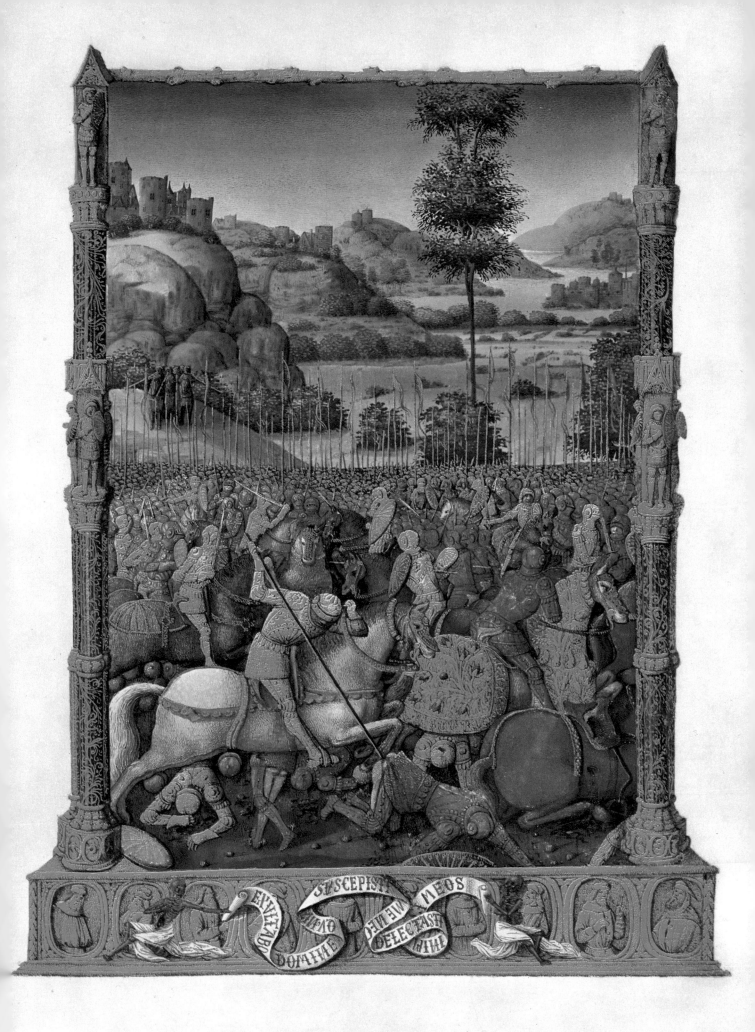

86. Psalm XXXIX

" With expectation I have waited for the Lord, and he was attentive to me. And he heard my prayers, and brought me out of the pit of misery and the mire of dregs. " In Jean Colombe's nocturnal, almost hellish landscape David thanks the Lord for having spared him the tortures depicted. The flames and smoke rising from rocks are not mentioned by the Psalmist, but the " pit of misery " and " mire of dregs " from which human heads emerge at the right, prefigure the tortures of hell awaiting impenitent sinners. The tones of this miniature and of the initial and foliage in the middle column differ from other illustrations by Jean Colombe. A large bird with a curved beak stands in the center.

[F. 96r]

sti sanctum meum et
circundedisti me letia
a

Et cantet tibi glo
ria mea: et non com
pungar domine ds
meus in eternum co
fitebor.

Requiem eternā
dona eis domine

Et lux perpetua lu
ceat eis. antiphona

Domine abstraxisti
ab inferis animam meā.
antiphona

Complaceat

Expectans ex
pectaui domi
num: et intendit m.
Et exaudiuit preces
meas et eduxit me de
lacu miserie et de luto
fecis.
Et statuit supra
petram pedes meos:
et direxit gressus meos.
Et immisit in os

diutoz meus et
protectoz meus tu es:
deus meus ne tardaius.
Requiem eternam
dona eis domine.
Et lux perpetua lu
ceat eis. ā. Complaceat
tibi ut euias me domine ad
adiuuandum me respice.
Situit.

uemadmodu
desiderat ceruus
ad fontes aquarum:
ita desiderat anima me
a ad te deus meus.
Situit anima me
a ad deum fontem uiu
um quando ueniā et
apparabo ante faciem
dei. uerunt michi la
crime mee panes die ac
nocte: dum dicitur mi
chi cotidie ubi est deus
tuus. Hec recordatus sum
et effudi in me animā
meam: quoniam trā
sibo in locum taberna
culi ad mirabilis usq;
ad domum dei. In uoce exultacioni

87. Psalm XLI

Although the miniature heads a psalm " for the Sons of Core, " the artist showed David here, facing the sky and bending on one knee before a heavily antlered stag that drinks from a clear stream. We see the trees of a forest from which the animal has emerged. This painting, whose space is almost entirely filled by the pleasant green, flowered landscape and stream, is in sharp contrast to the preceding one.

The drinking stag symbolizes the soul longing for the presence of God: " As the hart panteth after the fountains of water; so my soul panteth after thee, O God. " David's pink coat, yellow belt, and his crown as well as his beard and silver hair recall the Limbourgs' representations of him in several miniatures at the beginning of the manuscript, although this miniature is in fact by Jean Colombe.

[F. 97v]

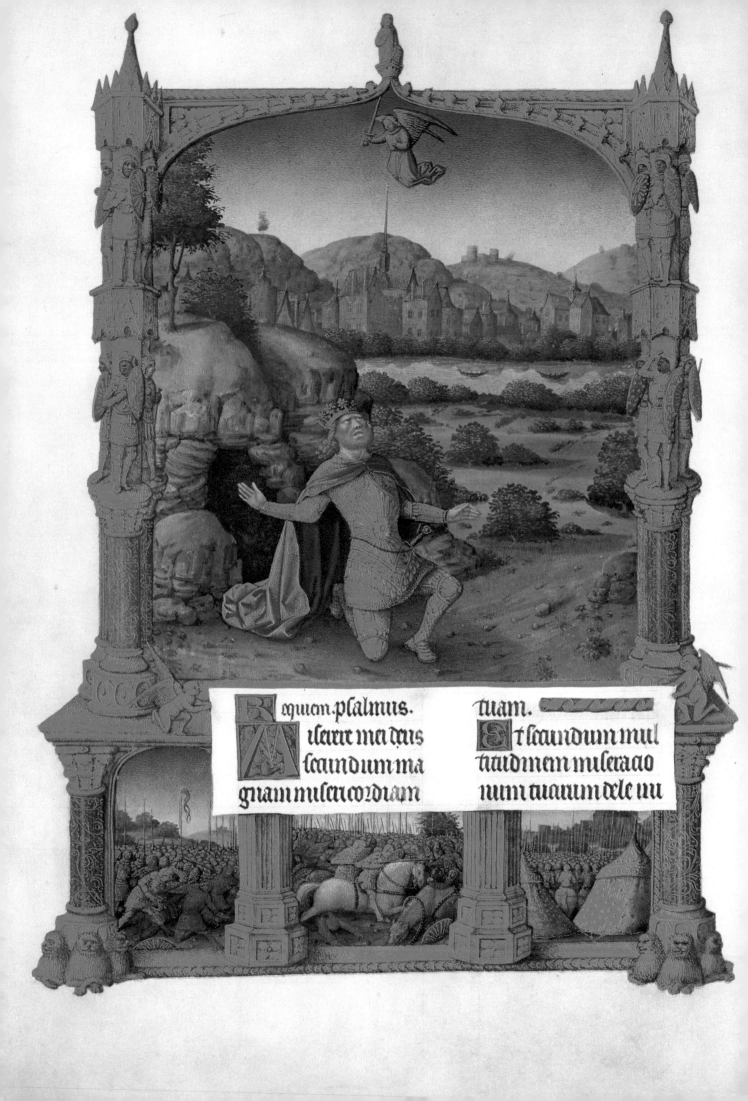

88. The Penance of David

Jean Colombe's miniature illustrates Lauds in the Office of the Dead, which begins with David's psalm of repentance: *"Miserere mei, Deus:"* "Have mercy on me, O God" (Psalm L). After seducing Uriah's wife, Bathsheba, David sent her husband to his death and married her. When the prophet Nathan reproached him for his sin and announced his punishment, the King repented; he begged humbly for God's mercy and submitted himself to a long penance, which is depicted here (II Samuel XI-XII). In the sky the Lord's angel appears, brandishing the avenging sword. David kneels before him with his arms extended in prayer and supplication: "Wash me yet from my iniquity, and cleanse me from my sin. ... For I know my iniquity, and my sin is always before me."

David, whose gesture is somewhat theatrical, is no longer the tall old man with a flowing beard represented by the Limbourgs. He is typical of the men painted by Jean Colombe, who are characterized by heavy eyelids and jaw and a low forehead, giving them a hard and often dazed look. His penance consisted of a fast amid rocks far from the city, which we see here beyond the water and against a mountainous background. It is a lovely landscape suggested to the artist by the Savoie.

Under the large miniature is a battle scene in which cavalry and infantry victoriously charge an enemy. It is probably meant to represent the battle waged by Joab, the leader of David's troops, against the Ammonites, Israel's neighbors across the Jordan River (II Samuel X). Divided into three sections, it forms the predella of a large frame with statuettes and colored columns, similar to the one enclosing Job Mocked by His Friends (no. 77). However, the small statues of warriors armed with lances and shields are less macabre than the gesticulating skeletons around Job. Jean Colombe has kept the original lines of text at the bottom of the page, placing them in a kind of large scroll held by two kneeling cherubim.

[F. 100v]

as tuas et impy ad te
convertantur.
Libera me de sang
uinibus deus deus salu
tis mee: et exultabit
lingua mea iustitiam
tuam.
Domine labia mea
apries et os meum an
nunciabit laudem tu
am.
Quoniam voluis
les sacrificium dedisse
utiqz; holocaustis non
delectaberis.
Sacrificium deo spi
ritus contribulatis cor.
contritum et humilia
tum deus non despicies.
Benigne fac domine
in bona voluntate tu
a syon ut edificentur

muri iherusalem.
Tunc acceptabis sa
crificium iustitie obla
aones et holocausta tuc
imponent super altare
tuum vitulos.
Requiem eternam.
Et lux perpetua luc.
Requiem eternam an.
dona eis domine et lux perpe
a luceat eis. an. Exaudi domine.

Te decet hympnus

89. Psalm LXIV

Wearing a voluminous golden cloak with an ermine cope, David sings a hymn of thanksgiving: " A hymn, O God, becometh thee in Sion: and a vow shall be paid to thee in Jerusalem. " Jean Colombe has painstakingly represented the interior of the religious building, very different of course from those in which David actually prayed. Particularly interesting are the detailed altar, baptismal font, stained-glass windows, and the woodwork of the pulpit.

[F. 101v]

dona eis domine. Et lux perpetua luce at eis. antiphona. Et suscepit dextera tua domine. ῶ. Aporta inferi.

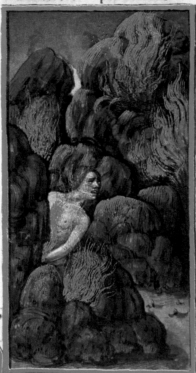

Ego dixi in di midio dierum meorum: uadam ad portas inferi

Quesiui residuum annorum meorum dixi non videbo dominum deum in terra uiuentium. Non aspiciam homi nem ultra: et habitato rem quietis. Generatio mea ab lata est et conuoluta est a me quasi tabernacu lum pastorum. Precisa est uelut est a texente uita mea: dum adhuc ordirer succidit me. de mane usq; ad uesperam fini es me. Sperabam usque ad mane quasi leo sic contriuit omnia ossa mea

90. Hezekiah's Canticle

Through the intervention of the prophet Isaiah, Hezekiah, King of Judah, was cured of a serious illness. He celebrated his recovery with a canticle: "I said: In the midst of my days I shall go to the gates of hell: I sought for the residue of my years." (Isaiah XXXVIII: 10)

Here Jean Colombe has represented the "gates of hell." The naked Hezekiah, his face haggard and frightened, sees the abyss from which he has escaped and thanks God for having spared him this torture: "O Lord, save me, and we will sing our psalms all the days of our life in the house of the Lord." (Isaiah XXXVIII: 20)

[F. 103v]

91. Hell

We return to the Limbourg brothers with this extraordinary miniature, an inset page added to the Office of the Dead, for which it was not originally planned. This extremely personal work, in which the chief artist gave free rein to his inspiration and creative imagination, appears to reverse the composition and coloring of the Fall of the Rebel Angels (no. 65). In the latter we see heaven, the kingdom of the Lord, here we see hell, the realm of Satan; there blue and glittering gold predominate, here grayish black and flaming red stand out; there the rebel angels are hurled by God from the heights of heaven, here the damned are spewed up from the bowels of the earth by Leviathan's burning breath. One major distinction differentiates the two subjects: the fall of the angels was rarely depicted by medieval artists, while hell was commonly represented throughout France on church portals in scenes of the Last Judgment.

The devil in the center of the miniature belongs to the tradition based on the Old Testament description of the leviathan: "Out of his nostrils goeth smoke, like that of a pot heated and boiling. His breath kindleth coals, and a flame cometh forth out of his mouth." (Job XLI: 12-13) He is shown lying on a grill, squeezing a tangled couple in each fist and trampling on other human beings tormented by snakes. On either side demons work enormous bellows which fan the flames that consume the damned beneath him. In the foreground, other demons torture more condemned souls, among which are several clerics as usual, but exceptionally few women. In the background, conical mountains serve as boilers "où damnés sont boullus," ("where the damned are boiled") as the poet Villon was to write fifty years later. Between these mountains a pallid sky is darkened by the pillar of smoke and fire coming from Leviathan's nostrils, in the midst of which jumbled bodies are vomited by the monster.

Thirteenth-century painters and sculptors had interpreted this theme to the point of exhaustion, so it is not surprising that the rest of the scene contains nothing new. The miniature's originality and ominous beauty lie in the spurt of fire bearing bodies in so many unexpected positions, within the red and black atmosphere of an infernal forge.

[F. 108r]

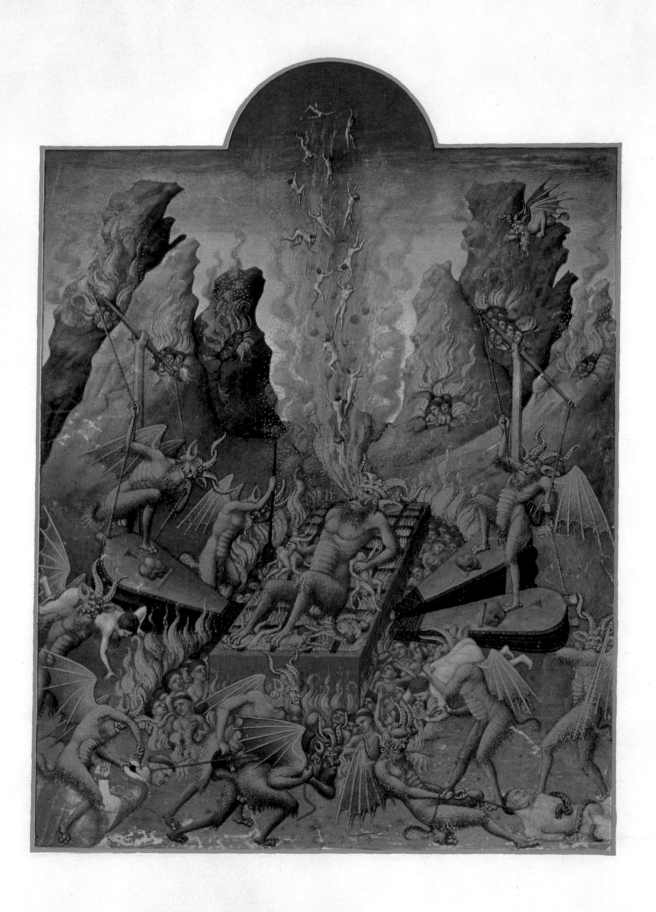

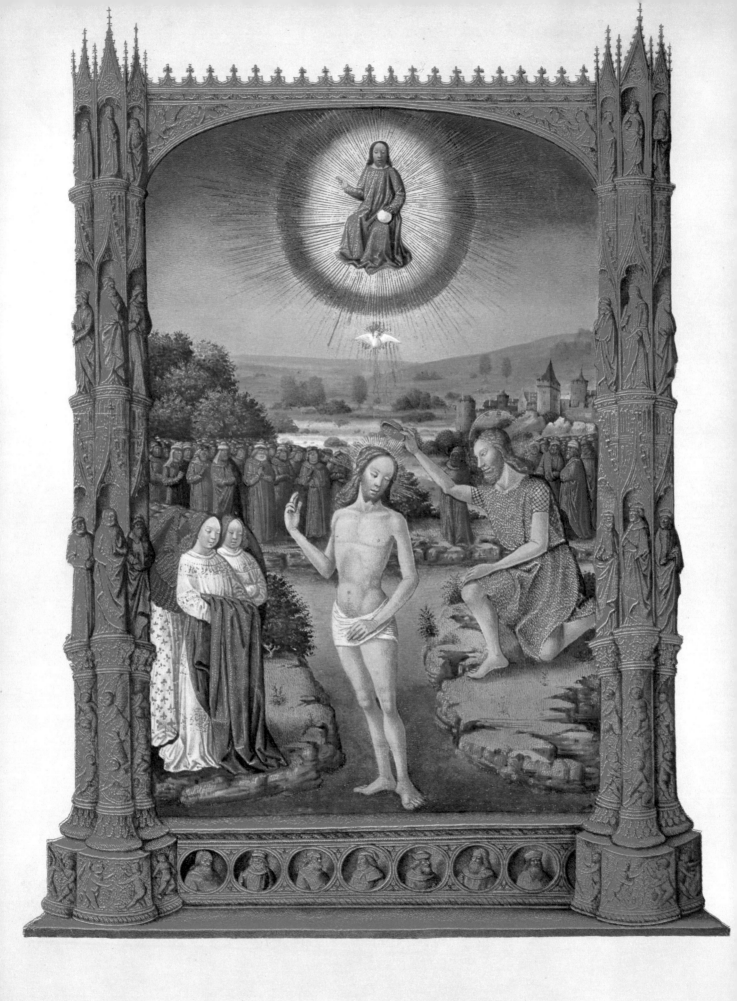

92. The Baptism of Christ

In the *Très Riches Heures* a series of little week day offices follows the Office of the Dead. Each day is devoted to a particular cult: Sunday to the Trinity, Monday to the dead, Tuesday to the Holy Ghost, Wednesday to the saints, Thursday to the Holy Sacrament, Friday to the Cross, and Saturday to the Virgin. This entire section was without miniatures at the time of the death of the Limbourg brothers and the Duc de Berry; it was completely illuminated seventy years later by Jean Colombe.

For the Sunday Office of the Trinity, the artist painted the Baptism of Christ in an attempt to represent the words of the first Gospel: " And Jesus being baptized, forthwith came out of the water: and lo the heavens were opened to him. ... And behold a voice from heaven, saying: This is my beloved Son, in whom I am well pleased. " (Matthew III: 16-17)

Jean Colombe has executed this scene with as much meditative simplicity as he could.

Although Christ's slightly inclined body and the gesture of His right arm still betray a certain mannerism, the artist was no doubt trying to express the emotion with which Christ heard the words from above. He stands with only His feet touching the waters of the River Jordan, while John the Baptist pours baptismal water from a shell onto His forehead. To the right, holding Christ's garments, are two angels of a type which were inspired by Byzantine mosaics and had already appeared in thirteenth-century psalters. The heavens have opened to reveal God within a circle of light and fire; a dove descends toward Christ to unite Him with His Father and thus completes the image of the Trinity.

In the middleground, a crowd attracted to the desert by John's preaching witnesses the event with astonishment and admiration. In the background is a town and one of the pleasant landscapes which Jean Colombe varied so admirably and which give his compositions special charm.

[F. 109v]

93–99. Seven Pages of Text

In the manuscript the seven following pages come immediately after the Baptism of Christ, the verso of which was to remain untouched according to the still legible words of the layout artist, *"nichil hic,"* underneath which a rubric announces a little Sunday Office of the Trinity, which continues to the last page, containing a Monday Office of the Dead.

While the calligraphy is the work of one scribe, and the decoration of capital letters and line endings is by one artist, the initial letters from which foliage breaks into the margin have two attributions: the first four pages belong to the period of Jean Colombe, and the last three to the time of the Limbourgs. We recognize the Duc de Berry's escutcheon in no. 99 (folio 113r) and his emblems, the wounded swan and the bear, in no. 98 (folio 112v).

[F. 110r–113r]

Omine
labia me
a aperies.
Et os meum annu
tiabit laudem tuam.
Deus in adiuto
rium meum
intende.
Domine ad adiu
uandum me festina.
Gloria patri et filio
et spiritui sancto.
Sicut erat in prin
cipio et nunc et semp
et in secula seculorum.
amen. alleluya alla.
Tua uniuscuiusque
uult animam
firmiter saluare.
Tres personas ardue
re ipsas honorare.
Tenetur et iugiter

precibus orare.
Unum deum dice
solum adorare. Vt sius
Te iure laudant te ado
rant te glorificant omnes
creature o beata trinitas.
Domine exaudi orone
meam.
Et clamor meus ad te
ueniat.
Oremus. Oracio.
Omnipotens
sempiterne ds
te suppliciter depreca
mur ut sanctam tri
nitatem in hoc mun
do ita nos facias firmi
ter fideliterque credere ne
raciter et simpliciter co
fiteri ut in aliquo pos
simus eam perfecte co
gnoscere et letanter fa

ac ad faciem intueri.
Qui uiuis et regnas
in unitate spiritus sancti
deus per omnia secula
seculorum. Amen.

Benedicamus do-
mino.

Deo gracias. Ad. j.

Deus in adiuto-
rium meum
intende.

Domine ad adiu-
uandum me festina.

Gloria patri et filio
et spiritui sancto

Sicut erat in princi-
pio et nunc et semper
et in secula seculorum.
Amen. ymnus

Trinitatem ardiun
summum gra-
torem

Sanctum eius filium
nostrum redemptorem.

Spiritum paracli-
tum gracie datorem.

Unum tamen di-
camus deum creatorem.

Te iure laudant te ylus
adorant te glorificant om-
nes creature o beata trinitas.

Domine exaudi oracione-
m meam.

Et clamor meus ad te
ueniat.

Oremus. Oracio.

Omnipotens sem-
piterne deus te
suppliciter deprecamur
ut sanctam trinitate-
m in luce mundo ita nos
facias firmiter fideliter-
q; credere ueneracter et si-
pliciter confiteri ut in

aliquo poſſumus eam
perfecte cognoſcere et le
tanter facie ad faciem
intueri. Qui uiuis et re
gnas cum deo patre in u
nitate ſpiritus ſancti
deus per omnia ſecula
ſeculorum. Amen.
Benedicamus dño
Deo gracias. Ad .iij.
Eus in adiu
torium meum
intende
Domine ad adiu
uandum me feſtina
Gloria pri et filio et
ſpiritui ſancto
Sicut erat in prin
cipio et nunc et ſemper
et in ſecula ſeculorum
Amen. ymnus
O ſe patrem arduum

eam hunc generauit.
Lumen de lumine
lumen reſultauit.
Procedentem ſpiritum
uterque ſpirauit.
Nullus bonum genuit
ipſum uel arauit. verſus.
Te iure laudant te ado
rant te glorificant omnes
creature o beata trinitas.
Domine exaudi oraſone
meam.
Et clamor meus ad te
ueniat.
Oremus. Oracio.
Omnipotens ſe
piterne deus te
ſuppliciter deprecamur
ut ſanctam trinitatem
in hoc mundo ita nos
facias firmiter fideliter
que credere ueraciter et ſi

pliciter confiteri ut in
aliquo possimus eam
perfecte cognoscere et leta
ter facie ad faciem in tu
eri. Q iii uiuis et regis
deus per omnia secula
seculorum. Amen. Ad vi.
eus in adiuto
rium meum
intende.
omine ad adiuuan
dum me festina
loria patri et filio
et spiritui sancto.
icut erat in prin
pio et nunc et semper et
in secula seculorum. A.
Or ad patrem v.
pertinet super
baptizatum
ua so(n)auit filius
humane uocatum.

ature susceptio co
lumbe uolatum.
redimus et specie
paraclito ditum. v.
E uire laudant te ado
rant te glorificant omnes
creatur. o beata trinitas.
omine exaudi o(rati)one
meam.
Et clamor meus ad te
ueniat.
remus. Oracio.
mnipotens se
piterne deus te
suppliciter deprecamur
ut sanctam trinitate
in hoc mundo ita nos
facias firmiter fideliter(que)
ardere ueraciter et sim
pliciter confiteri ut in
aliquo possimus eam
perfecte cognoscere et leta

ter facie ad faciem intui
eri. Qui viuis et regnis
deus per omnia secula
seculorum. Amen. Deus ad nonam
ad adiutorium
meum intende.
Domine ad adiu
uandum me festina
Gloria pri et filio et
spiritui sancto.
Sicut erat in prin
apio et nunc et semp
et in secula seculorum.
Amen. ymnus.
Iste pater potencia
acta deuotatur
filio pruden
cia omnis declaratur.
Gloria paraclito in
niuersa datur.
Qui cum patre na

toq; cum glorificatur.
Te iure laudant te v.
adorant te glorificant omnis
creatura o beata trinitas.
Domine exaudi orone
meam.
Et clamor meus ad te
ueniat. Oremus. Oracio.
Omnipotens
sempiterne
deus te supplicater dep
camur ut sanctam
trinitatem in hoc mu
do ita nos facias firmi
ter fideliterq; ardere ue
raciter et simpliciter
confiteri ut in aliquo
possimus eam perfecte
cognoscere et letanter fa
cie ad faciem intueri.
Qui uiuis et regnas
deus per omnia secula

101. The Apostles Going Forth to Preach

Since Jean Colombe had already represented Pentecost in the *Très Riches Heures* (no. 76), he illustrated Tuesday, the day of the Holy Ghost, with a picture of the apostles, inspired by the Holy Ghost, going forth to preach the Gospel. The subject is not new; earlier artists had shown the apostles shod and setting out for their journeys to different parts of the world. The innovation here is their leave-taking of the Virgin Mary, who traditionally accompanied them spiritually. This scene probably reflects the influence of the staging of contemporaneous religious theater, such as the *Conversion saint Pol* in which the apostles take advantage of their farewell to Mary to ask her for advice:

> *Mais alons ainçois, je vous prie,*
> *Savoir de la Vierge Marie*
> *S'elle nous voudra rien commander.*

Approaching Mary here are a curly-bearded Peter and Matthew. The heavy physiognomy of the first is typical of many of Jean Colombe's figures, while the expression of the second is softened by a flowing white beard and a thinner face. Touched by their behavior, the Virgin greets them with a gesture of both hands; behind her stand the rapt Holy Women, also mentioned in Acts.

The other apostles have already started out, not in the traditional groups of three but in pairs, so that we actually see only eight apostles, not twelve. John is recognizable because he is beardless, but the others do not have any distinctive characteristics. Three groups leave in the different directions marked by the fork in the road. Traditionally, some, like John and Philip, went to Asia Minor and Galatia; others, as in the case of Jude and Simon, went to Mesopotamia and Egypt; while still others, like Andrew and James the Greater, went to Greece or distant Spain. Here, their routes are scattered with châteaus, lakes, and mountains. *The Golden Legend* states that the apostles were miraculously reunited at the Virgin's bedside at the time of her death.

[F. 122v]

103. The Holy Sacrament

The Thursday Office is devoted to the Holy Sacrament, or the institution of the Eucharist, in honor of which Pope Urban IV in 1264 designated the Thursday after Trinity Sunday a holy day. Jean Colombe has illustrated the service with two superimposed scenes. The large one represents the interior of a Gothic church, with lavishly decorated pillars, in which two groups of figures pay tribute to the veritable presence of Christ in the Eucharist. On the right, representing the Old Testament, are three men with oriental headdresses, probably Melchizedek (who offered bread and wine to Abraham), Moses (who received manna), and Elijah (who was fed by an angel). On the left, representing the New Testament, are several bareheaded men, probably the four Evangelists. All raise their heads to worship and appear to proclaim the grandeur of this sacrament, repeating the words of Thomas Aquinas in the *Pange lingua,* a hymn composed for the feast of the Holy Sacrament: "*Tantum ergo sacramentum veneremur cernui.*" "Let us kneel in veneration before such a great sacrament." In the choir at the back of the church, behind a jubé of fine openwork, two priests seem to join in the tribute.

The scene below depicts the story of Saint Antony of Padua and the mule, one of the many edifying anecdotes in circulation at the end of the Middle Ages proving the presence of Christ in the Eucharist. A heretic of Toulouse refused to believe in Christ's presence unless a mule knelt before the sacrament. After a few moments of prayer, Saint Antony presented a mule with the Eucharist in one hand and some oats in the other. To the amazement of the onlookers, the animal refused the grain and knelt before the Eucharist. Convinced by this experience, the heretic believed henceforth.

[F. 129v]

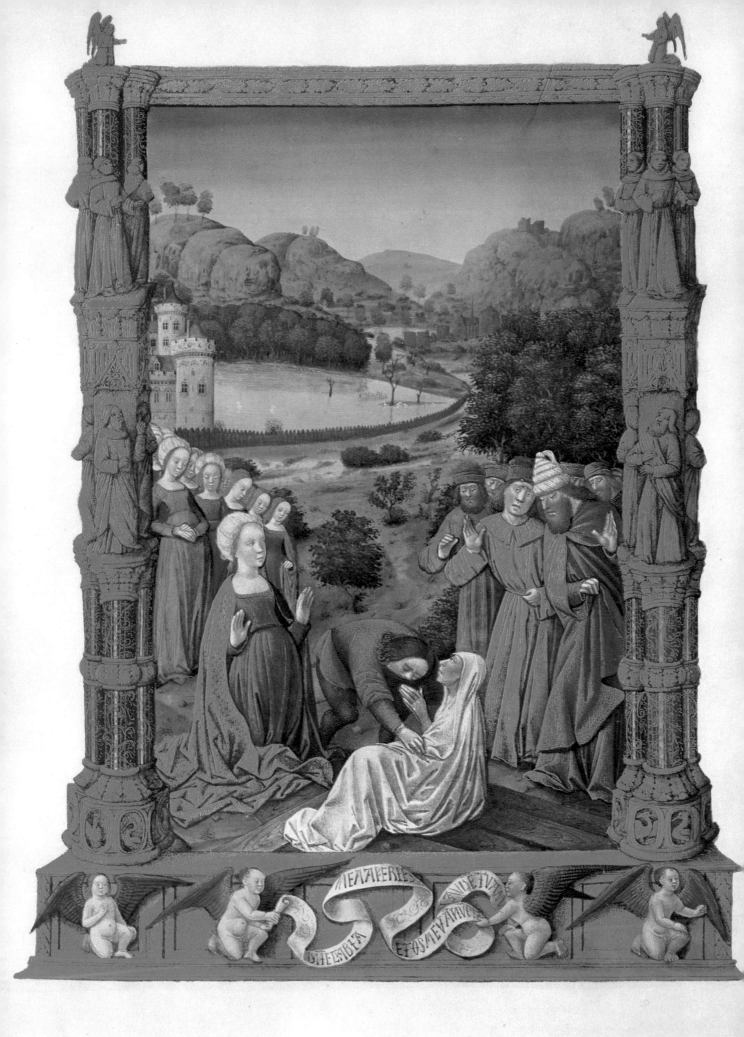

104. The Revealing of the True Cross

For the Friday Office, devoted to the Cross, Jean Colombe has represented the Revealing of the True Cross, as told in Jacopo da Voragine's *The Golden Legend*. Saint Helena, mother of Constantine, was generally considered responsible for the fourth-century excavations on Mount Calvary which led to the discovery of the Cross. Because there was doubt as to which of the three crosses had served for the crucifixion of Christ, the Bishop of Jerusalem ordered each one to be placed in turn beside a dying woman. When she touched the True Cross, she was miraculously cured.

In the miniature we see the woman, who had been lying prostrate on the Cross, sitting up. Kneeling before her, Saint Helena and the attendants are overcome with astonishment. Among the group on the right is a figure wearing a pointed cap, who probably represents the Jew who knew the secret of the crosses' location.

This pleasant scene painted in harmonious tones offers, as usual, a handsome landscape of mountains and lakes suggested to Jean Colombe by the Savoie region. It is surrounded by an architectural frame similar to those executed by the artist in his other miniatures. Below, cherubs hold a scroll on which are inscribed the first words of the service for the Revealing of the Cross; like the little angels in the miniature of The Man of Sorrows (no. 75), they call to mind Jean Fouquet's cherubs in the *Heures d'Etienne Chevalier* (c. 1455).

[F. 133v]

105. The Presentation of the Virgin

With the Presentation of the Virgin Jean Colombe has introduced the Saturday Office devoted to the Virgin. The subject is taken from the apocryphal *Gospel of the Nativity of the Virgin,* which describes Mary's life as an attendant in the Temple, where she was presented as a child. Here the young, tiny Mary is shown mounting the steps of the large Temple, attended by her parents, Anna and Joachim. Tonsured and surpliced priests, and Levites, who look very much like Catholic clergymen, await her at the door.

The artist did not imaginatively envision the Temple but simply painted the familiar cathedral in Bourges, the capital of Berry and his birthplace. He depicted the building's large center gable, known as *l'houstau,* with its stained glass and rose windows renovated a hundred years earlier by the Duc de Berry; the four attached buttresses, whose ornamentation was later modified; and three portals, corresponding to the nave and side aisles. But this is only the building's general appearance, for the two side towers and their portals are missing, the pointed portal arches have been made semicircular, and their number of statues has been reduced. The reddish mass of the church, shorn of its sides and towers, has a slightly crushing effect on the human scene it was meant to frame.

[F. 137r]

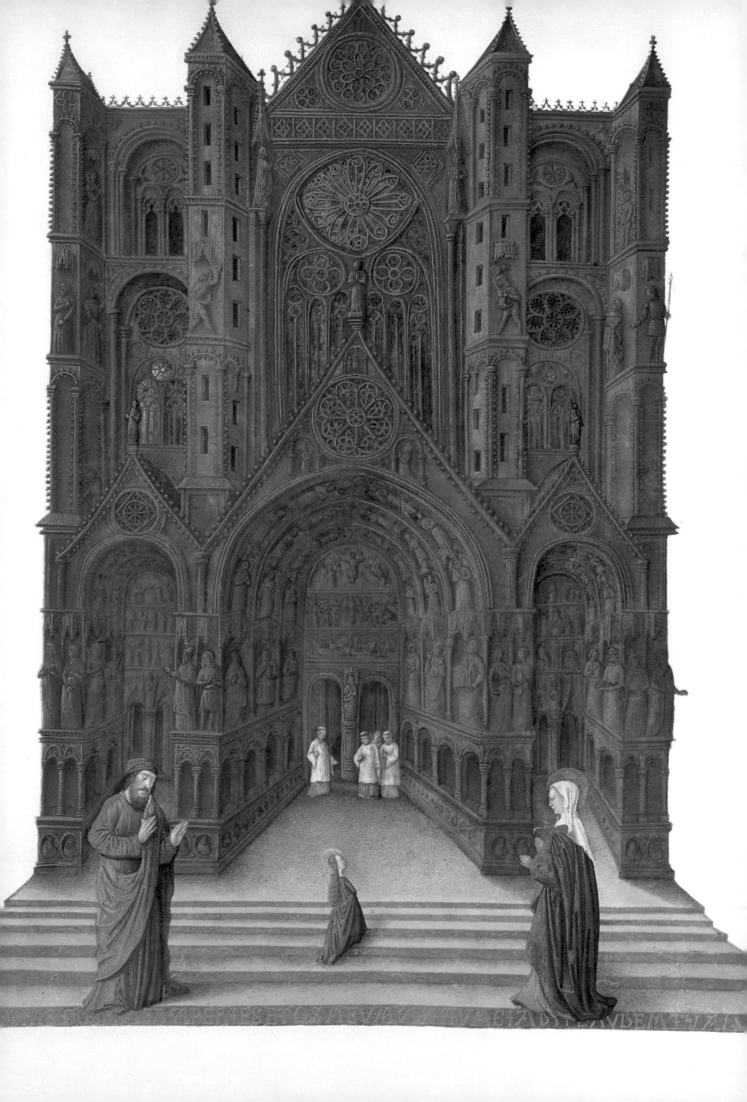

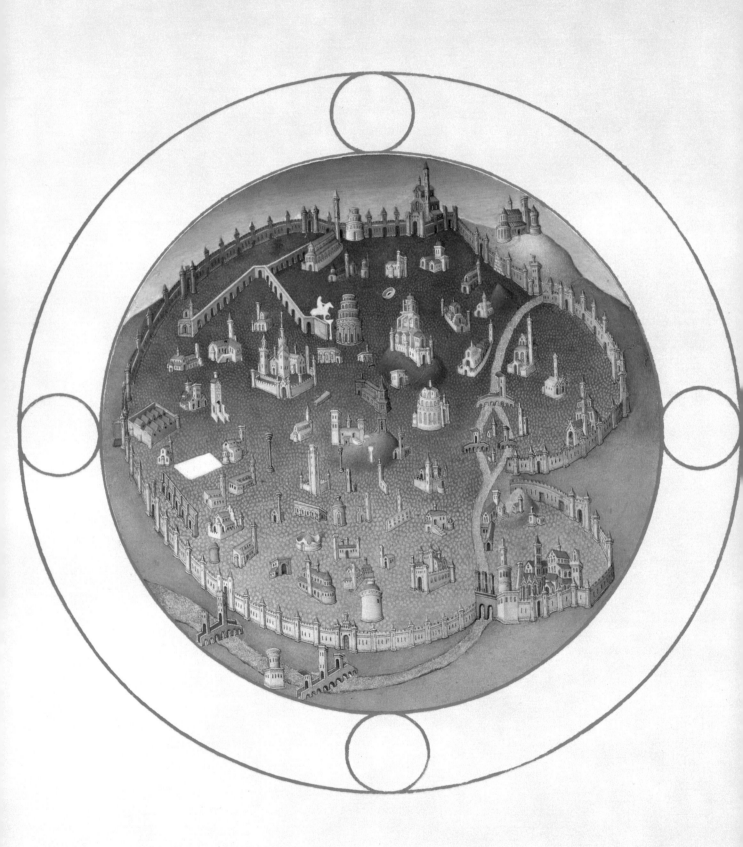

106. A Plan of Rome

This plan of Rome, an exceptional subject for a Book of Hours, is an inset page, painted by the Limbourgs and added to the manuscript as an afterthought. Its place, after the Little Offices and before the Hours of the Passion, is as difficult to explain as its presence. Perhaps it was originally at the head of an Office of Saint Peter and Saint Paul, which disappeared during the manuscript's re-collation in 1485.

It is, of course, tempting to see this strange miniature as a copy of Taddeo di Bartolo's fresco in the Palazzo Pubblico in Siena. But although the two paintings are certainly related, it is doubtful that the Duc de Berry's artists were inspired by the fresco. Since the Sienese work was painted between 1413 and 1414, at the same time the Limbourgs were at work on the *Très Riches Heures,* one of the brothers would have had to copy Taddeo di Bartolo's just-completed plan, bring it to Paris, and immediately include it in the Book of Hours. Furthermore, there are misunderstandings and interpretative errors in the miniature (the sites of the colossal statues on Monte Cavallo and the statue of Marcus Aurelius are left out; the Colosseum is misrepresented) which would not have occurred had the artist seen the fairly explicit fresco. We must conclude that the Limbourgs based their miniature on a much smaller document, perhaps a *mappemonde* (map of the world in two hemispheres)

owned by the Duc de Berry according to his inventories.

The most important monuments of Rome are easily recognizable in this figurative plan. At the upper right, outside the city wall, is San Paolo fuori le Mura which, since it was located south of the city, orients the plan. To the left of it, inside the walls, are San Giovanni in Laterano with its campanile, the Temple of Castor and Pollux in pink and the church of Sta. Croce in Gerusalemme in blue. The right arm of the aqueduct leads to the site of the equestrian statue of Marcus Aurelius (later moved to the Capitoline Hill) and to the Colosseum, represented as a storied tower. To the right of the Colosseum, a Gothic building with flying buttresses marks the Palatine Hill. Below it is the Arch of Titus, the chuch of Sta. Francesca Romana, and the Capitoline Hill with its campanile; above and to the left is the important pilgrimage church, Sta. Maria Maggiore, below which are the Column of Trajan, the Column of Antoninus Pius, and to their right a small round building, the Pantheon. At the bottom of the miniature, outside the city walls, are from left to right: the Ponte Milvio, the Castel Sant'Angelo with its bridge, and beyond the Tiber, a large group of buildings which includes St. Peter's and the Vatican, above which are the Isola Tiberina and the Trastevere.

[F. 141v]

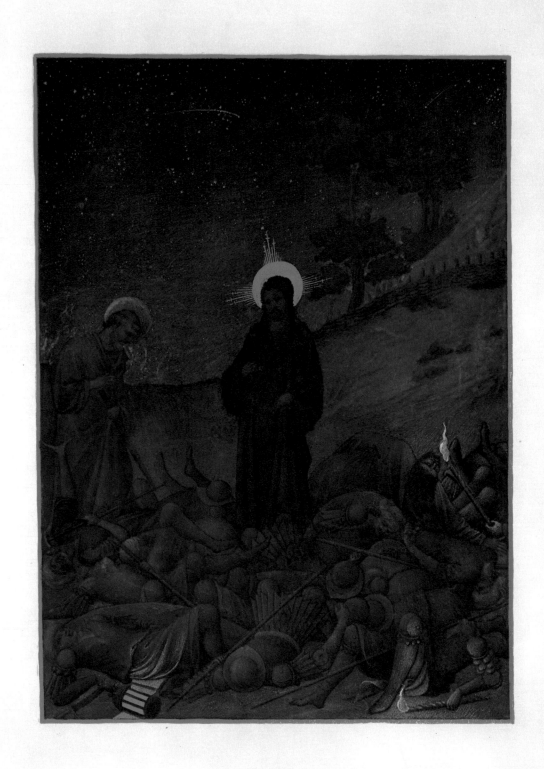

107. Christus in Gethsemane

In the *Très Riches Heures* the Hours of the Passion, painted by the Limbourgs, follow a series of short weekday services. The Passion cycle begins with matins and lauds illustrated by two facing scenes: Christ in Gethsemane and Christ Led to the Praetorium. The first is not only one of the three brothers' most extraordinary works, but the most beautiful night scene ever painted by a miniaturist. It is striking in the moving simplicity of its composition as well as in its nocturnal effect. The midnight-blue sky is studded with stars and streaked by three mysteriously symbolic shooting stars. On the grayish-brown earth of the Mount of Olives lie the shadowed bodies of the fallen soldiers, reflecting here and there the light of torches and lanterns. In the middle, even darker, is Christ, His halo shining brightly against the starry sky. Of the group, only Saint Peter remains standing, bowed before his Master and ready to draw his sword to defend Him.

The scene is based on the account of Saint John, the only Evangelist to describe the moment of Christ's arrest:

Jesus therefore, knowing all things that should come upon him, went forth, and said to them: Whom seek ye?

They answered him: Jesus of Nazareth. Jesus saith to them: I am he. And Judas also, who betrayed him, stood with them.

As soon therefore as he had said to them: I am he; they went backward, and fell to the ground.

(John xviii: 4–6)

Those who have come to arrest Jesus are shown lying on the ground with their lanterns, torches, and weapons, apparently struck more by the kindness of His face and the divine majesty radiating from Him than by His words. In this strangely poetic night scene, we are touched by something more than the elegance, charm, and brilliance of the other miniatures: a profoundly religious feeling, already expressed in different ways in the Garden of Eden (no. 20) and the Fall of the Rebel Angels (no. 65), emanates from the painting and gives it an extraordinary grandeur.

[F. 142v]

108. Christ Led to the Praetorium

The brilliant color of this miniature contrasts with Christ in Gethsemane on the facing page in the manuscript: the brightness of the early hours of the morning when Christ was led through Jerusalem opposes the nocturnal setting of the seizure on the Mount of Olives. The lively colors, picturesque figures, and similar expressions of Christ give this, the following three miniatures, and the Deposition (no. 117) a homogeneity unusual within the diversity of the *Très Riches Heures*. This luminous, colorful vision seems to indicate a definite Italian influence in each of these admirable paintings, which were probably among the Limbourgs' last works.

Here, a motley escort leads Christ to the praetorium to appear before the Roman governor; soldiers dressed in coats of mail mingle with bearded Jews wearing turbans and pointed caps. The procession, bristling with lances and banners, is led by a centurion who uses his mace to knock on the door of the praetorium. These figures all reappear in the following illustrations. Dominating the scene in the center, Christ walks with bound hands between a soldier and a servant of the high priest. Although treated like a criminal, His expression remains gravely resigned, and His halo sets Him off from the crowd.

The group winds down a street lined with picturesque houses of various hues with double- or pointed-arch windows and stepped gables more typical of a northern city such as Bruges than of a Mediterranean town. Above, a clear bright sky enhances the blue of the garments and ground, bringing out the subtle colors and accentuating the brilliancy of the silver in the helmets and armor, and the gold in the finery that has been donned for the coming ceremony.

[F. 143r]

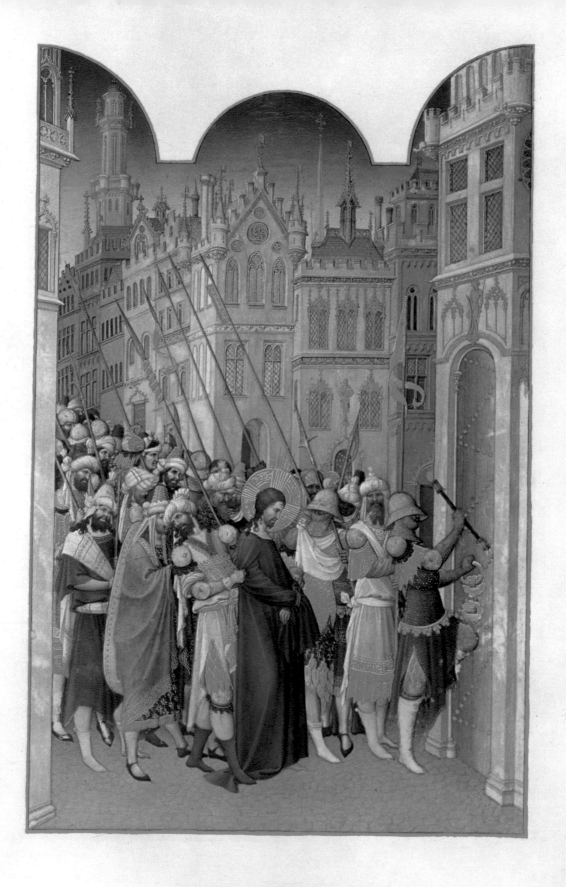

109. The Flagellation

The scene of the Flagellation illustrated primes. Jesus, stripped of His clothes which have been thrown on the ground, is tied to a pillar at the entrance of the praetorium, where He is beaten by several men with switches. The Gospels scarcely mention the Flagellation, but mystics gave much thought to it, and popular imagination added such details as the Limbourgs represented here: the switches have broken under the violence of the beating and litter the floor.

At the rear of the praetorium Pontius Pilate is enthroned, surrounded by men of Jerusalem who try to influence him. In a corner on the right, we see a beardless youth writing on parchment; this is obviously Saint John recording the details of the Passion which he described in his Gospel. The bearded, gray-haired figure looking through the door on the left is probably Saint Peter.

[F. 144r]

110. Christ Leaving the Praetorium

Christ Leaving the Praetorium and the Road to Calvary are represented in the manuscript on two facing pages between sext and nones: the first on the verso at the left, the second on the following recto. The Limbourgs executed both paintings in the bright luminous colors characteristic of this cycle. Picturesque details such as the banner and the children recall the Adoration of the Magi (no. 49) and the Purification of the Virgin (no. 56).

Pontius Pilate has delivered Christ to the mob to be crucified, and soldiers lead Him away. In the entrance of the praetorium is a naked man in chains, who represents one of the thieves to be crucified with Christ and who reappears in the Road to Calvary.

[F. 146v]

111. The Road to Calvary

This miniature is closely related to the three preceding ones not only in the similar colors and figures but also in the diagonal formed by the procession from left to right, which here completes the cycle with a direction and movement similar to that with which it began in Christ Led to the Praetorium (no. 108). It is by far the most tragic scene, for Christ no longer goes in resignation to His trial but to His death. Carrying the heavy Cross, He turns to look tenderly toward His mother who, supported by Saint John, follows Him on His painful way, despite the threats of a soldier.

The scene recalls Simone Martini's small panel of the same event (c. 1340; Louvre). But, with a personal touch, the Limbourgs expressed all the pathos of the moment in Christ's tender sad look.

[F. 147r]

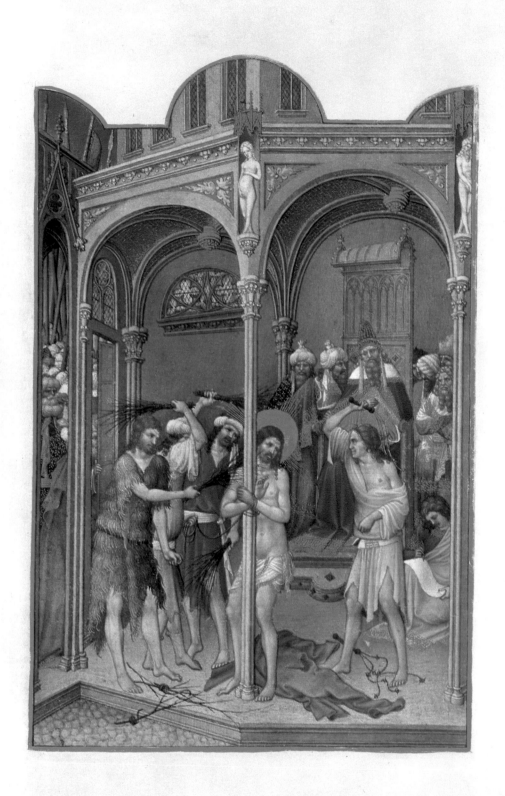

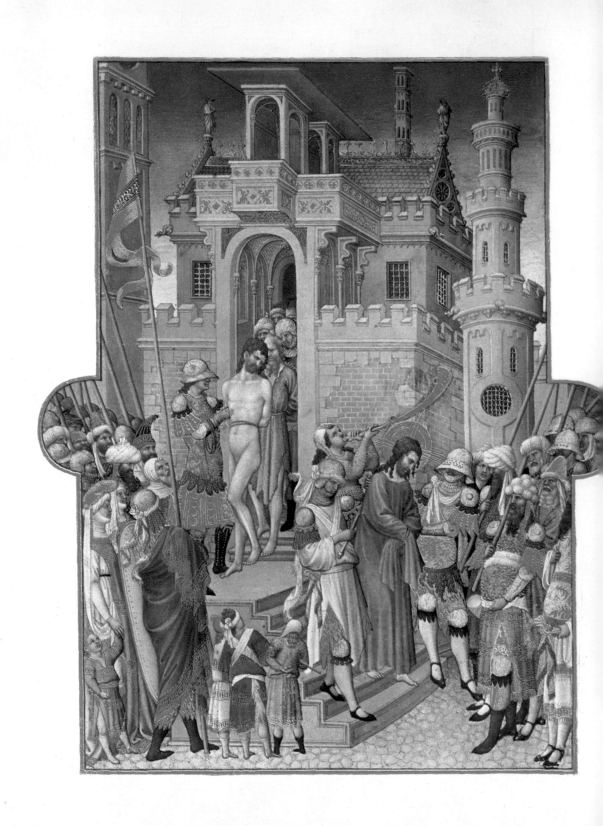

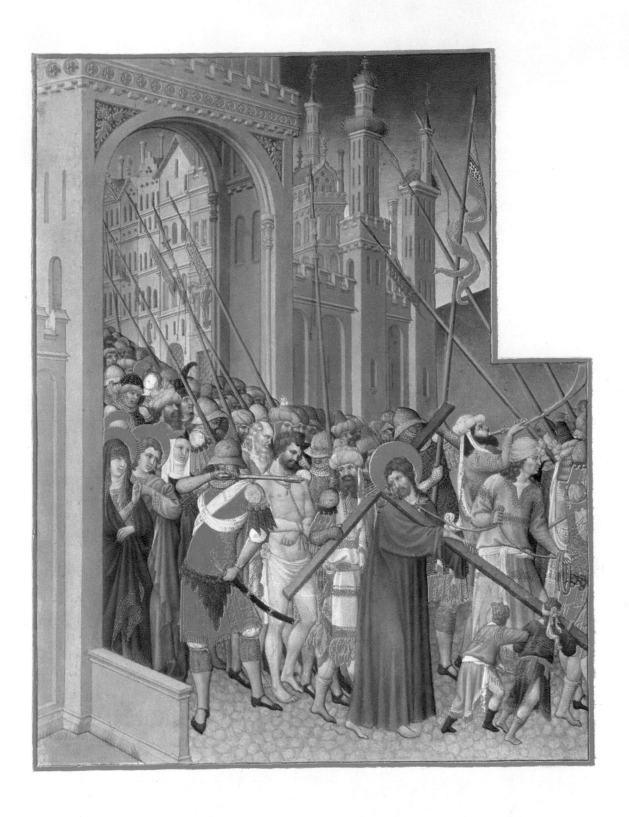

eus in ad
iutorium
meum in
tende.

omine ad adiu
uandum me festina.
loria patri et fili
o et spiritui sancto.
icut erat in prin
cipio et nunc et semp
et in secula seculorum.
men. ymnus.

ora qui ducta
teria fuisti
ad supplicia ipse ferui
do lumeris autem
pro nobis miseris.
ac nos sic te dili
gere sanctam que uita
ducere ut mereamur
regni celestis patrie.
aus honor ipo

nen dito et sine causa
prodito passo morte
pro populo in aspero
patibulo. amen. añ.

aia sunt.

eus laudem
meam ne ta
cueris quia os peccato
ris et os dolosi super

112. Judas Hangs Himself

In his remorse after his treachery, Judas Iscariot returned to the priests the thirty pieces of silver for which he had betrayed Jesus, and committed suicide. (Matthew XXVII: 3-5) This supplementary scene to the Passion was executed by Jean Colombe; the magnificent capital letters and marginal foliage were done at the time of the Duc de Berry.

Strangled by the noose around his neck, Judas dies with his features contorted in a hideous grimace. His cloak lies beneath him.

On the hill at the left, we see the outer buildings of Jerusalem. Several verses of the violent imprecatory Psalm CVIII, which follows this illustration, are applicable to Judas: "They have spoken against me with deceitful tongues; and they have compassed me about with words of hatred; and have fought against me without cause. Instead of making me a return of love, they detracted me. ... And he put on cursing, like a garment: and it went in like water into his entrails. ... "

[F. 147v]

113. Psalm XXI

Because it foretells the suffering and death of Christ, the most righteous among men, this psalm of David has been placed in the Hours of the Passion. It opens with the last words spoken by Jesus upon the Cross: " O God, my God ... why hast thou forsaken me?" Later verses prophesy the Crucifixion: " They have dug my hands and feet. They have numbered all my bones. And they have looked and stared upon me. They parted my garments amongst them; and upon my vesture they cast lots. "

Here, while David prays before a chapel, white-robed youths bend their heads before the executioner, in illustration of the lines, " Deliver, O God, my soul from the sword: my only one from the hand of the dog." The warrior with a sword wears an oriental hat made of three superimposed coils, which appeared in the Revealing of the True Cross (no. 104).

[F. 150r]

Eus in ad
iutorium
meum in
tende.

Domine ad adiu
nandum me festina.

Gloria patri et filio
et spiritui sancto.

Sicut erat in prin
cipio et nunc et semp
et in secula seculorum.
Amen. ynmus.

Crucem pro
nobis subit
et stans in illa siaye
ulxtus sacratis manib
datus fossis et predib3.

Honor et benedicti
o sit crucifixo filio qui
suo nos supplicio rede
mit ab exilio.

Laus honor xpo in

dito et sine causa pro
dito passo mortem p
populo in aspero pati
bulo. Amen. anthã.

Omnes videntes.

omine deus
meus respice
in me quare me dereli
quisti: longe a salute

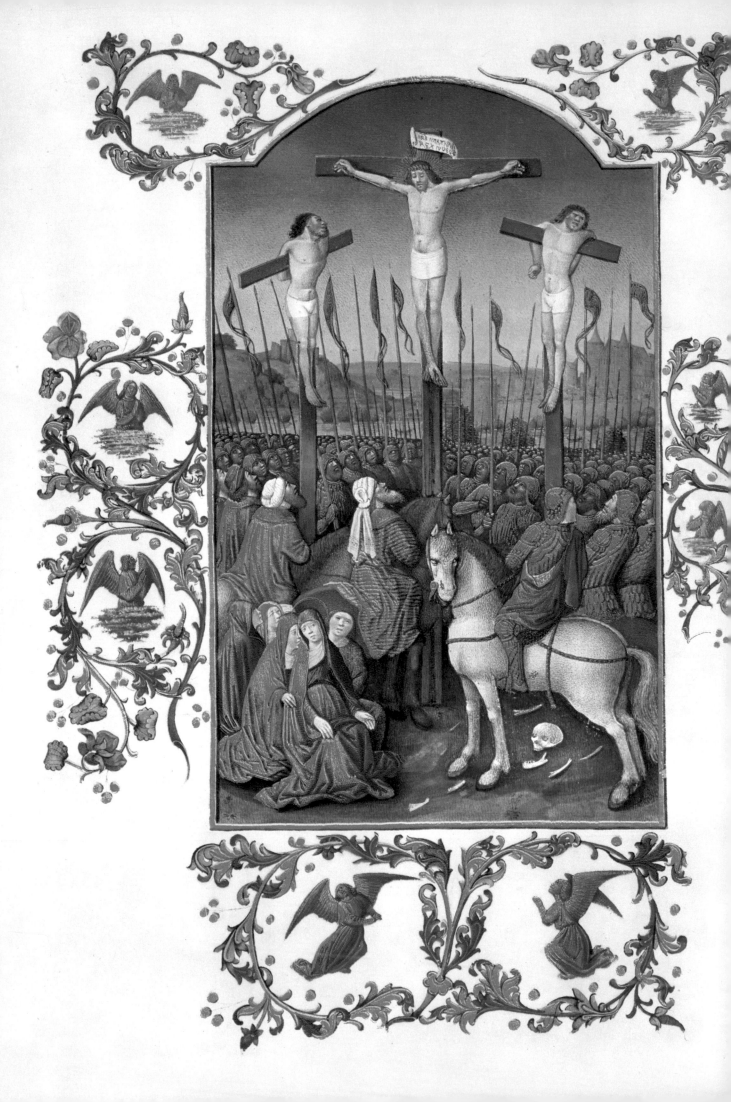

114. The Crucifixion

Again two miniatures of contrasting colors face each other: the Crucifixion and the Death of Christ, placed conventionally before the Office of Nones. The former was painted by Jean Colombe, although the setting suggests a sketch by the Limbourgs, which he obviously did not follow. In comparing this scene with the two following miniatures by the three brothers, we immediately notice the different placement of the crosses and the crucified figures. Notably, the thief on the left is no longer shown from the back in the extraordinary position that the Limbourgs gave him. It appears that from the original drawing only the arrangement of the crosses was maintained, an arrangement common in fifteenth-century paintings and due, Émile Mâle believes, to the influence of the settings of religious theater at that time (*L'art religieux de la fin du moyen âge en France,* p. 49, no. 1).

Had the Limbourgs executed this miniature, which represents the climax of the Hours of the Passion, it would have completed a perfect, uninterrupted cycle of major paintings. It is neither Colombe's strongest nor weakest contribution to the manuscript, but its reddish and blue colors and ordinary composition indeed break the unity of the cycle.

The three crosses dominate the crowd of citizens and soldiers whose banners and lances bristle around them. The onlookers, including several mounted figures in the foreground, press around the Cross. Christ is dying; the thief on the left looks toward Him while the other tries to avert his gaze. On the lower left, a group consisting of the fainting Virgin supported by Saint John and the three Holy Women, is less moving than the same group in the Death of Christ. Under the horse on the right are the skull and bones traditionally thought to be those of Adam, unearthed when the Cross was fixed in the ground.

[F. 152v]

115. The Death of Christ

Facing and contrasting to Jean Colombe's Crucifixion in the manuscript is the Limbourgs' Death of Christ. The gloom represented here in grayish black tones is not the black of night as in Christ in Gethsemane (no. 107) but a phenomena associated with the death of Christ: "Now from the sixth hour there was darkness over the whole earth, until the ninth hour. And about the ninth hour Jesus cried with a loud voice, saying Eli, Eli, lamma sabacthani?" (Matthew XXVII: 45-46)

After this last appeal to His Father, Christ's head fell forward onto His breast and He died, but a halo shining in the shadows continued to mark His divinity. In heaven, the Eternal Father shows by His blessing that He has not forsaken His Son. On either side of Jesus, the thieves expire on their crosses, and still farther to each side, in the upper corners of the miniature, the sun on the left and moon on the right are veiled by the mysterious eclipse.

At the foot of the Cross a crowd has gathered, in which several figures are recognizable. On the left, supported by Saint John, the Virgin swoons with suffering; above her, the centurion, struck by the wonders around him, raises his hand to his heart and exclaims, "Indeed this was the Son of God!" (Matthew XXVII: 54) Opposite them, a soldier holding a mace looks at the crucified Christ with surprise and seems to share the thoughts of his brother in arms. Although the scene lacks the simple beauty and technical perfection of Christ in Gethsemane, it is extremely touching.

In the margins, three small medallions depict the miracles that accompanied Christ's death. On the upper right, an astronomer searches the heavens for an explanation of the sudden darkness; below, the curtain of the Temple is torn in two; under the miniature, the resuscitated leave their tombs.

[F. 153r]

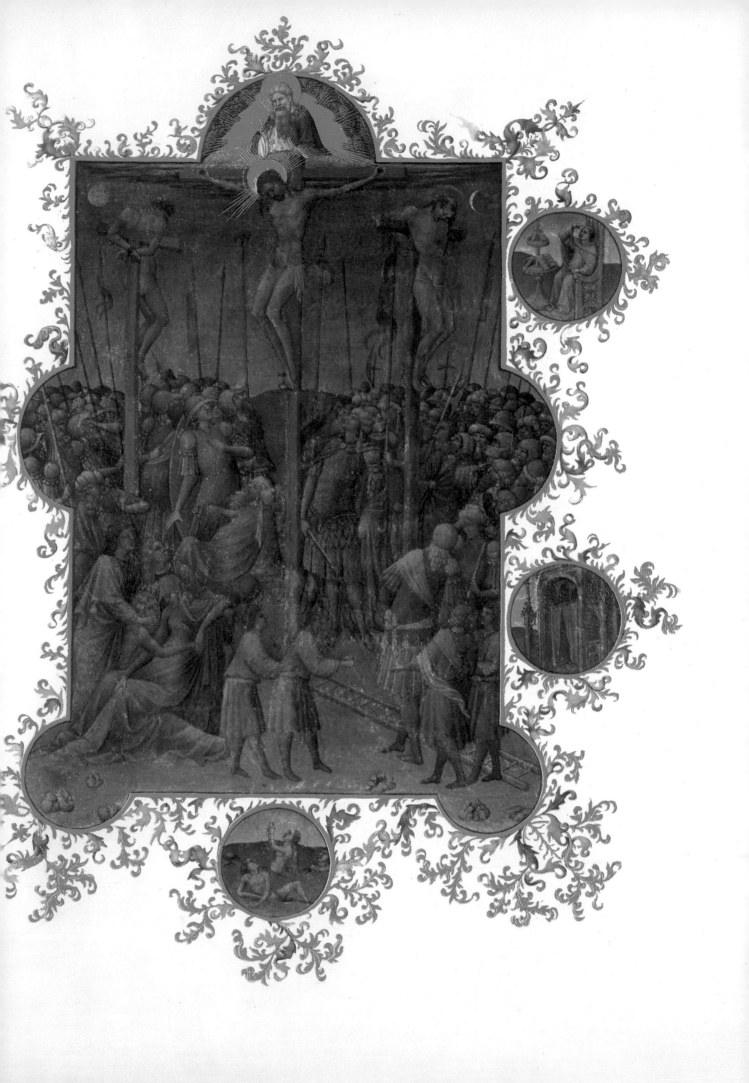

eus in ad
iutorium
meum in
tende.

Domine ad adiu
uandum me festina

Gloria patri et fi
lio et spiritui sancto.

Sicut erat in prin
apio et nunc et semp
et in secula seculorum
Amen. ymnus.

eata xpi passi
o sit nra libe
ratio ut per hanc nob
gaudia sint parata
celestia.

Gloria xpo domino
qui pendens in patibu
lo clamans emisit spi
ritum saluansq; mun
dum perditum

Laus honor xpo ue
dito et sine causa prodi
to passo mortem pro
populo in aspero pati
bulo. Amen. antiplo.

Laboraui.

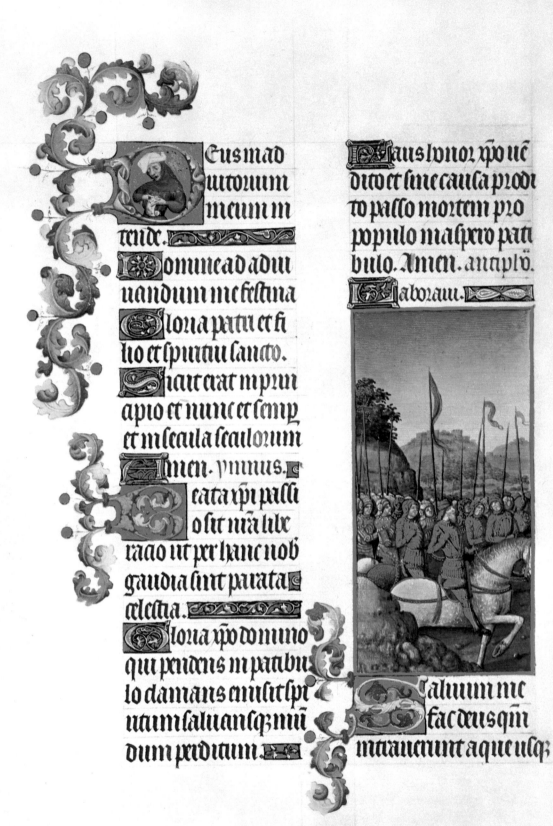

Saluum me
fac deus qm
intrauerunt aque usq;

116. Psalm LXVIII

Jean Colombe did not choose to illustrate the images suggested by the first lines of this psalm: "Save me, O God: for the waters come even unto my soul. I stick fast in the mire of the deep: and there is no sure standing." The cavalry with lances and banners which rides from left to right corresponds to a later verse: "They are multiplied above the hairs of my head, who hate me without cause. My enemies are grown strong who have wrongfully persecuted me. ..." Innumerable cuirassiers swarming behind the golden-armored horsemen emphasize the numbers and power of the enemy.

[F. 153v]

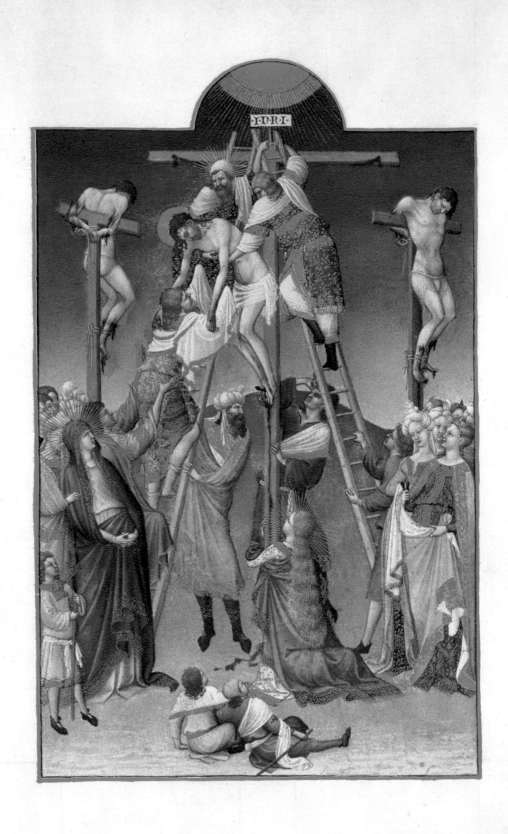

117. The Deposition

Again two miniatures face each other in the manuscript: the Deposition by the Limbourg brothers and the Entombment by Jean Colombe. The Deposition is perhaps the most beautiful of the colorful luminous cycle painted by the Limbourgs for the Hours of the Passion. The wide, clear sky against which the crosses rise gives the painting a special brilliancy that is heightened by the harmonious colors of the garments: the vermilion of the man on the ladder, the bright red of the kneeling Mary Magdalene, the pink of the turbaned Jew, and the dark blue of the Virgin.

While the thieves remain bound to their crosses in the same position as in the Death of Christ (no. 115), three men on ladders lower the dead Christ. With a few variations the group recalls Simone Martini's *Descent from the Cross* (now in the Antwerp Museum), part of the same polyptych (executed during the artist's later years, c. 1339-44) as the *Way to Calvary* (Louvre). Mary Magdalene, her long blonde hair spread over her robe, kneels at the foot of the Cross, which she embraces; the resemblance to Simone Martini's *Thrust of the Spear* (in the Antwerp Museum; also from the same polyptych) is even more striking here. At the left the Virgin stands looking at the body of her Son with noble resignation: beside her, Saint John extends his arms toward Christ. At the right, watching with emotion, are holy women of the same type as the young women behind Mary (who is not unlike the Virgin here) in the Adoration of the Magi (no. 49). In contrast to the gravity of the scene are the carefree, laughing children already seen in preceding miniatures by the Limbourgs (cf. nos. 110, 111) and similar also to those painted by Simone Martini.

[F. 156v]

118. The Entombment

In a twilight laden with dark clouds, Jean Colombe has successfully rendered the tragic grandeur of the Entombment of the Son of God. The three crosses on Calvary stand out against the orange reflections of the sun setting in a pale sky; the thieves have not yet been taken down, and ladders still lean against Christ's Cross.

The body of Jesus has been brought to the tomb offered by Joseph of Arimathea: while the Virgin lifts the body with a maternal attitude, Joseph of Arimathea and Nicodemus wrap it in a shroud. The jar of spices brought by Nicodemus has been placed beside the tomb; Mary Magdalene kneels to anoint Jesus' hand while Mary Cleophas, the mother of James, also kneels and contemplates His face. Other holy women pray at the head of the tomb. Saint John, silhouetted against the darkened Calvary which is in turn outlined by the sun's last rays, supports the Virgin as she leans over her Son; the distressed man on the right is probably Saint Peter, repenting his denial of Christ.

The composition was created with the dramatic nature of the scene in mind: the attitudes are noble and the faces illuminated by the waning light. However, Christ's body seems very stiff compared to that executed by the Limbourgs on the opposite page. Although the face of Mary is touching, the others are less expressive and sometimes even awkward, the chief fault of Jean Colombe and one evident in many of his miniatures. Yet the touching attitudes and striking effects of light make this one of his most beautiful works.

[F. 157r]

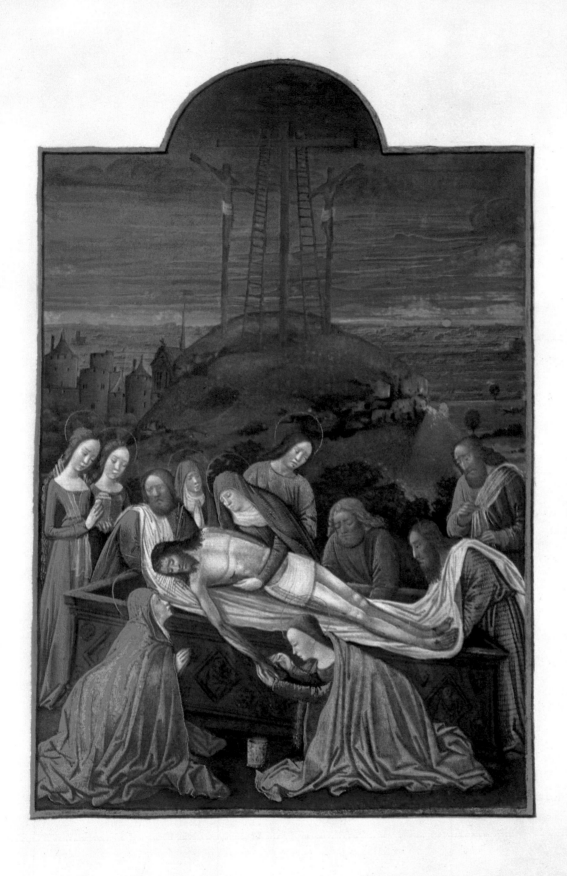

Eus mad
nitorium
meum in
tende. Domine ad adiu
nandum me festina
Gloria patri et fili
o et spiritui sancto.
sicut erat in prin
cipio et nunc et semp
et in secula seculorum.
Amen. antvi.
Clisit deus.

iserere mei
deus misere
re mei quoniam inte
confidit anima mea.
Et in umbra ala
rum tuarum sperabo
donec transeat iniqtas
Clamabo ad deum
altissimum deum qui
benefecit michi.
Misit de celo et libera
uit me dedit in obpro

119. Psalm LVI

David composed this poem when he was hiding in a cave to escape Saul's anger. Here Jean Colombe has replaced the cave with a graceful chapel and altar and has somewhat prematurely crowned David.

"Have mercy on me, O God, have mercy on me: for my soul trusteth in thee. And in the shadow of thy wings will I hope, until iniquity pass away." The wings of a blue angel hovering above the altar represent the Psalmist's refuge. As elsewhere in the manuscript, the gesticulating, conniving men on the left personify the enemies against whom David begs for the Lord's protection.

The capital letters on gold grounds and the border foliage are by the Duc de Berry's artists.

[F. 157v]

120. The Christmas Mass

Following the Hours of the Passion, a chronological series of masses devoted to the year's most important celebrations completes the manuscript. First comes the Christmas Mass, one of the three masses known as " the mass of the day. " The subject is indicated by the Nativity painted within the initial letter and by the lines following, which begin the Introit taken from Isaiah IX: 6: *" Puer natus est nobis. ..."* ("For a child is born to us, and a son is given to us ").

The mass here is noteworthy only for the picturesque details of the officiants and the congregation, and it must be classed among the less important works executed by Jean Colombe's assistants, including Pentecost (no. 76), the Funeral of Raymond Diocrès (no. 80), and the Holy Sacrament (no. 103). The thin columns of the choir, the slender golden statues between the stained-glass windows, and the vaults suggest that the Limbourgs designed the architecture. Jean Colombe then worked over it, as indicated by the small angel, typical of his style, painted on the keystone, and by the Savoie family's gules escutcheon with a silver cross.

At the altar the officiant stands reading the Gospel, aided by a deacon and a subdeacon; two priests kneel in the stalls. On the right, the head choir has gathered around a lectern to sing the office, while in the foreground two women, one wearing a hennin, the other a simpler headdress, follow the service in their books. Above them rises an organ whose show pipes are visible, and at the top of the choir three angels before the stained-glass windows join the Christmas celebration.

[F. 158r]

Ⓟ ter natus ſuper humanum caus et no
eſt nobis ec cabitur nomen eius ma
filius datus. gni conſilij, angelus. ps
eſt nobis cuius imperium Ⓒantate domino canti

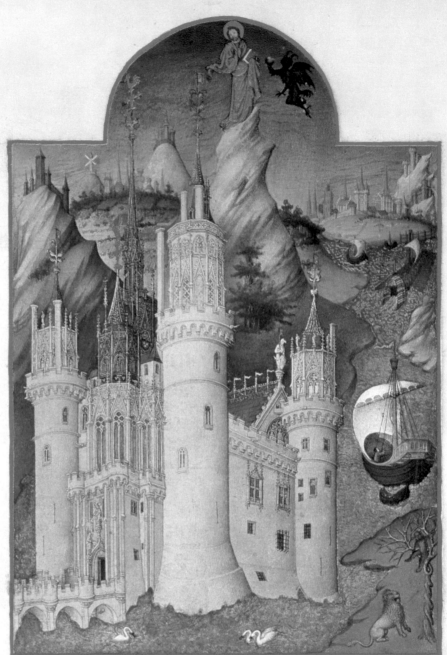

Dominica .i. quadrage nficabo eum longitudie
Inuocauit me sime. dicrum adinplebo eum.
et ego exaudiam eu **Q**ui hitat in ad **ps.**
eripiam eum et glo iutorio altissimi in pro

121. The Temptation of Christ

This miniature illustrates the text for the first Sunday in Lent, in which Matthew tells of the devil's tempting of Christ after His forty days and nights in the wilderness: " Again the devil took him up into a very high mountain, and shewed him all the kingdoms of the world, and the glory of them, And said to him: All these will I give thee, if falling down thou wilt adore me. " (Matthew IV: 8-9)

No doubt to please their patron, Paul de Limbourg and his brothers exaggerated the disproportion between the event and its setting. The temptation has been relegated to the background at the top of the miniature, while the Château de Mehun-sur-Yèvre, constructed by the Duc de Berry (who was extremely proud of it), dominates the foreground. In his *Chroniques* Jean Froissart called the château *"l'une des plus belles maisons du monde"* ("one of the most beautiful houses in the world"), and reported that the Duke enjoyed chats there about sculpture and painting with his *imagier* or draftsman, André Beauneveu, *"le meilleur en nulle terre"* ("the best in the world").

The brother specializing in architectural details has faithfully reproduced this magnif-icent château as proven by comparison with a drawing executed in 1737, when the castle still stood in its entirety. We recognize the slender towers, solidly implanted in the glacis bordering the water and crowned with delicate openwork rising above the battlements, and the elegant entrance buildings behind which we see the top of the chapel and its steeple.

All around the mountain upon which Christ stands rise the châteaus and cities symbolizing the riches offered by the devil if Christ will worship him; they apparently represent Poitiers, Bourges, Montlhéry, and the fortress of Nonette in Auvergne. The boats evoke more distant lands.

The Limbourgs imaginatively created this variegated landscape, even finding a place for the Duke's symbols: swans glide along the waters of the Yèvre surrounding the château and a bear has climbed into a tree to escape a lion. The latter is probably an allusion to some bellicose incident in the Duke's luxurious but often troubled life; only recently he had been beseiged by the Burgundians in Bourges, where he was forced to take refuge in the cloister of Notre-Dame to escape the onslaught of an enraged populace.

[F. 161v]

122. The Canaanite Woman

Jean Colombe has painted the story of the Canaanite woman as told by Matthew:

> And Jesus went from thence, and retired into the coast of Tyre and Sidon.
>
> And behold a woman of Canaan who came out of those coasts, crying out, said to him: Have mercy on me, O Lord, thou son of David: my daughter is grievously troubled by a devil.
>
> Who answered her not a word. And his disciples came and besought him, saying: Send her away, for she crieth after us:
>
> And he answering, said: I was not sent but to the sheep that are lost of the house of Israel.
>
> But she came and adored him, saying: Lord, help me.
>
> Who answering, said: It is not good to take the bread of the children, and to cast it to the dogs.
>
> But she said: Yea, Lord; for the whelps also eat of the crumbs that fall from the table of their masters.
>
> Then Jesus answering, said to her: O woman, great is thy faith: be it done to thee as thou wilt: and her daughter was cured from that hour.
> (Matthew xv: 21-28)

The artist faithfully recorded the details of the text in this double miniature representing Christ's two different attitudes. Above, He turns away from the Canaanite woman who implores Him despite the scorn of the apostles; in a house at the right we see a woman trying to comfort the recumbent girl who is tormented by a devil. In the small miniature below, the Canaanite kneels before Christ, who is touched by the perseverance of her faith and makes a gesture of consent; the apostles now seem to share their Master's feelings.

This is one of Jean Colombe's most beautiful miniatures, for its natural poses, well-rendered expressions, pleasant colors, picturesque setting which includes details of the village in the background (the half-timbered house, square garden, farm, well, dovecote, and church with its lean-to roof), and the sort of mountain landscape for which the artist was justly famous.

[F. 164r]

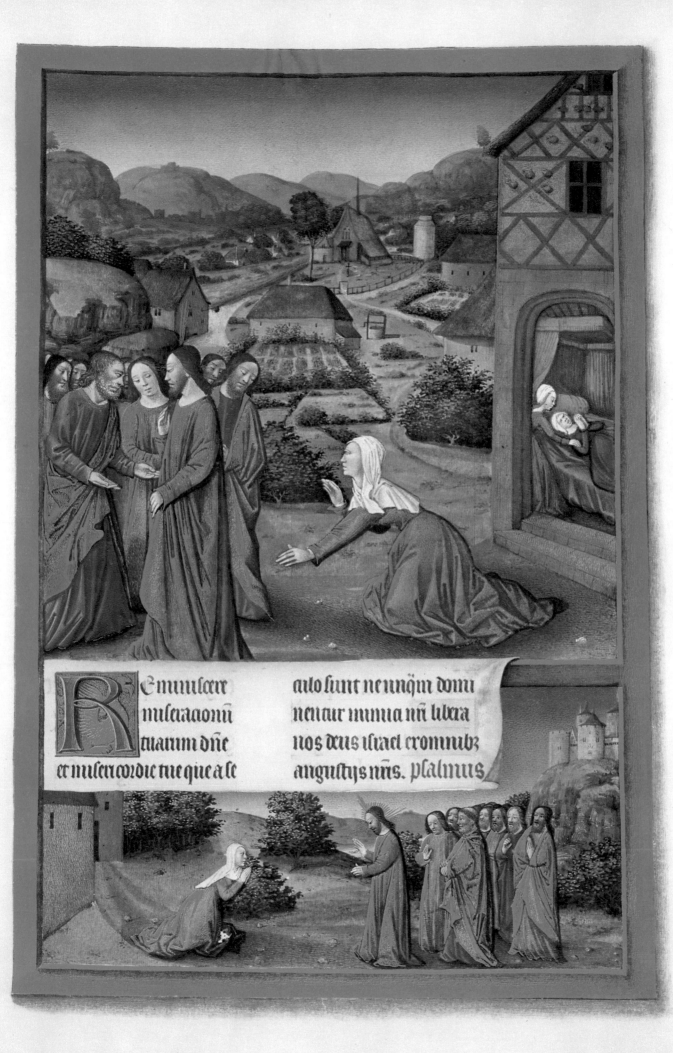

Emmiseere
miseraaonu
tuarum dñe
er misericordie tue que a se
aulo sunt ne unqm domi
nentur nimia nñi libera
nos deus israel er omnibz
angustijs nñs. psalmus

123. The Exorcism

This illustration for the third Sunday in Lent is the first in a cycle of four scenes that differs from the rest of the Limbourgs' production. The colors are warmer and deeper; the background for three of the scenes is an archaic floral design which does not occur in any of the other large miniatures, with the one exception of the Annunciation (no. 21). Christ's dark complexion and extreme gravity are slightly different from His appearance in the Hours of the Passion (nos. 107ff.). However, figures in the cycle, especially in the Raising of Lazarus (no. 125), are similar to those in the Adoration of the Magi (no. 49) and the Hours of the Passion, which would indicate the supervision and perhaps the participation of the master of the workshop (probably Paul de Limbourg), even if the cycle was executed by one of the younger brothers.

The first three Gospels do not tell much about the healing of the possessed. Luke, whose text was chosen for this Sunday, says only: " And he was casting out a devil, and the same was dumb: and when he had cast out the devil, the dumb spoke: and the multitudes were in admiration at it. ..." (Luke XI: 14) The Limbourgs have painted the scene in a chapel-like structure, whose slender pillars, blue vaults, and statuettes at either side of the roof recall the praetorium in the Flagellation (no. 109). Christ blesses the possessed youth who struggles in his mother's arms, while the demon leaves the boy's head in the form of a small black-winged dragon. Outside and within the chapel groups of figures wearing oriental robes and headdresses express their amazement at the miracle.

The sumptuous golden floral work on the blue background recalls the small miniature of Saint Luke in the extracts from the Gospels (no. 17) and several of the illustrations for the *Belles Heures*.

[F. 166r]

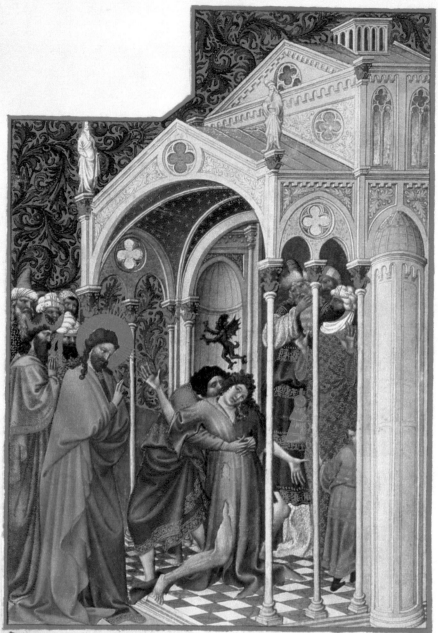

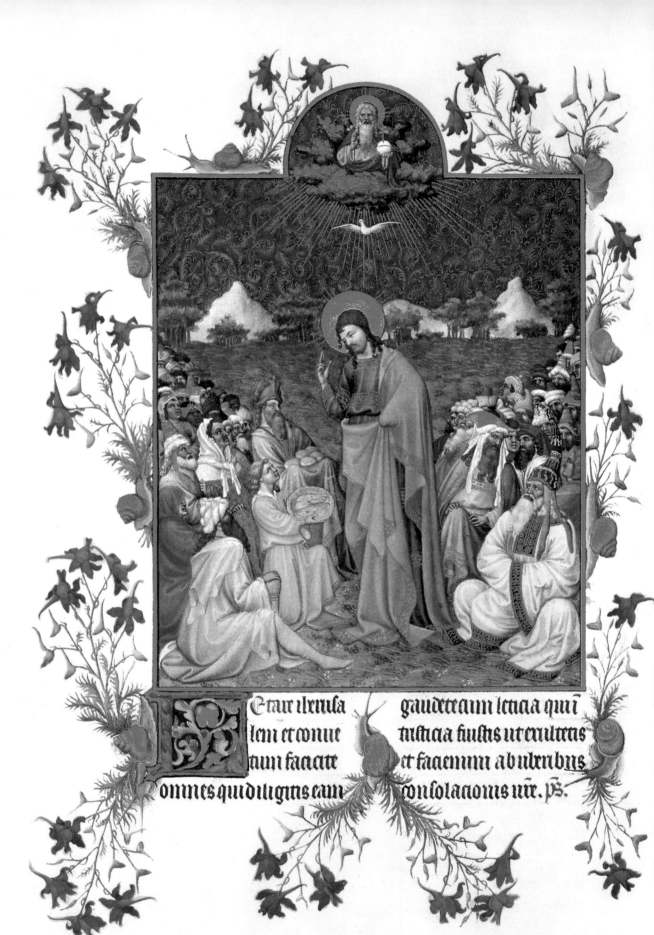

Etau ileruſa gaudete aim letuia quī
lem et conue triſticia fuiſtis ut eultetis
tum faciete et facenuui ab uberibus
omnes qui diligitis eam conſolationis uir. ⁊⁊.

124. The Feeding of the Multitude

This miniature illustrates the Gospel for the fourth Sunday in Lent, known as Laetare Sunday because the Introit begins with the words *"Laetare Jerusalem"* ("Rejoice Jerusalem"). Saint John tells the miracle of the loaves and the fishes, the first image of the Eucharist. Jesus went up into a mountain near the Sea of Tiberias, and when He saw the multitude following Him, He said to Philip:

"... Whence shall we buy bread, that these may eat?... One of his disciples, Andrew, the brother of Simon Peter, saith to him: there is a boy here that hath five barley loaves, and two fishes; but what are these among so many? Then Jesus said: Make the men sit down. Now there was much grass in the place. The men therefore sat down, in number about five thousand. And Jesus took the loaves: and when he had given thanks, he distributed to them that were set down. In like manner also of the fishes, as much as they would." (John VI: 5, 8-11)

We see the lad presenting the two fishes and Andrew the five barley loaves which Jesus sanctifies before distributing them. Blessing the scene from heaven is God the Father, united with Christ by the Holy Ghost in the form of a dove, which symbolizes the role of the Trinity in this miracle.

Like those before and after it, this miniature is painted in a somewhat antiquated style characterized by foliage on a blue background and the voluminous garments that envelop the figures. This archaism links the Feeding of the Multitude to scenes in the *Belles Heures* as well as to the Hours of the Passion cycle (nos. 107ff) and the Adoration of the Magi (no. 49) in the *Très Riches Heures*.

The Limbourgs have carefully painted extremely realistic columbine and snails in the margins. Differing from the floral ornamentation in the other miniatures, this decoration occupies almost the whole border, in a manner which relates the work to that of contemporaneous miniaturists and again marks its antiquation in comparison with other paintings in the manuscript.

[F. 168v]

125. The Raising of Lazarus

For the fifth Sunday in Lent, Passion Sunday, the Limbourgs have illustrated the touching chapter in which Saint John describes the resurrection of Lazarus. Christ's expression here is extremely serious; His tears at the sight of His friend's tomb were noticed by those present, causing them to exclaim: "Behold how he loved him." (John XI: 36)

"Martha therefore said to Jesus: Lord, if thou hadst been here, my brother had not died. ... Jesus said to her: I am the resurrection and the life: he that believeth in me, although he be dead, shall live: And every one that liveth, and believeth in me, shall not die for ever. ... Jesus therefore again groaning in himself, cometh to the sepulchre. Now it was a cave; and a stone was laid over it. Jesus said: Take away the stone. ... When he had said these things, he cried with a loud voice: Lazarus, come forth. And presently he that had been dead came forth, bound feet and hands with winding bands; and his face was bound about with a napkin." (John XI: 21, 25-26, 38-39, 43-44)

The artists have rendered the gesture with which Christ accompanied His command. Lazarus sits up and looks at Jesus, to whom Mary also turns in an attitude of faith. Between Mary and the Lord, Martha leans toward her brother. Some persons still weep, some look on in amazement, while others hold their noses in confirmation of Martha's fear, " *iam foetet:* " "Lord, by this time he stinketh, for he is now of four days." (John XI: 39)

The admirably painted and beautifully positioned body of Lazarus occupies the center of the scene. Like Adam in the Garden of Eden (no. 20), it seems to have been inspired by some classical statue, in this case a reclining river god. Mary wears the orange mantle of the Magdalene in the Deposition (no. 117), and the women beyond Christ resemble those behind the Virgin in the Adoration of the Magi (no. 49). Thus we see that, despite the variety of styles in different parts of the *Très Riches Heures,* the master of the workshop— probably Paul de Limbourg—achieved an overall unity which characterizes the work of all three brothers.

[F. 171r]

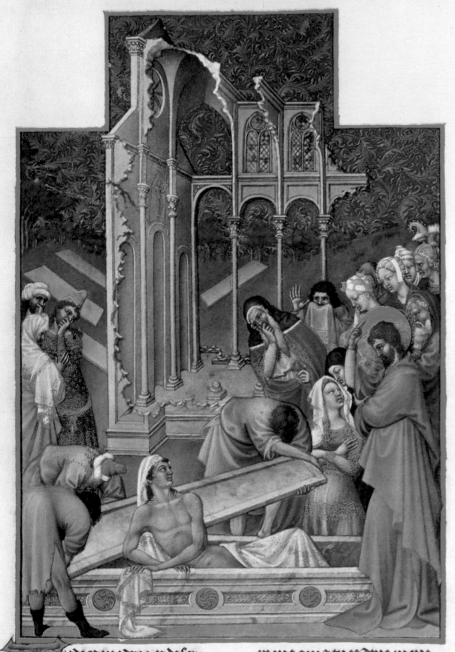

iudica me deus et discer pte me quia tu es deus meus
ne causam meam de et fortitudo mea. ꝓſ
gente non sancta ab Emitte lucem tuam et
homine iniquo et doloso eri ueritatem tuam ipsa me de

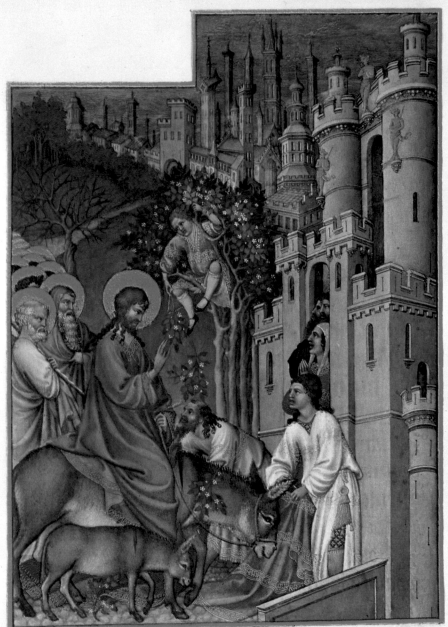

Domine ne lõ
ge facias au
rilium tuum
a me ad deffensionem meã

aspice libera me de ore leonis
et a cornibus vnicornium
humilitatem meam. ps.
Deus deus meus respice i

me quare

126. The Entry Into Jerusalem

The Lenten cycle ends with this miniature illustrating the Office of Palm Sunday ("flowered Easter," as it was called at the time). The Limbourgs have followed the text read on this occasion:

"...Go ye into the village that is over against you, and immediately you shall find an ass tied and a colt with her: loose them and bring them to me. ... And the disciples going, did as Jesus commanded them. And they brought the ass and the colt, and laid their garments upon them, and made him sit thereon. And a very great multitude spread their garments in the way: and others cut boughs from the trees, and strewed them in the way. ..." (Matthew XXI: 2, 6-8)

We see Jesus mounted on the ass, blessing those who spread their garments on the road; the colt follows. In a tree tossing down branches is Zacchaeus, mentioned in Nicodemus's apocryphal gospel and described by Luke as climbing a sycamore tree to see Jesus over the heads of the crowd in Jericho. Christ is followed by His disciples, led by Peter.

Although not painted against a foliage background, this illustration is stylistically perhaps the most archaic in the series, particularly in its perspective. City gates of the kind shown here recall those in the Limbourgs' earlier *Petites Heures* and *Belles Heures*. The bird's-eye view of the city walls rising to the left is usual for the time and was used in the *Belles Heures*. It is a strange view of Jerusalem, whose towers and belfries recall Sienese landscapes. The miniaturists did not include crowd effects such as the ones they rendered with such diversity in the Passion cycle (nos. 107 ff), although they would have been most appropriate here.

[F. 173v]

127. The Resurrection

To illustrate the Easter Mass, Jean Colombe freely interpreted that part of the Gospel of Matthew read during the Good Friday Office:

And in the end of the sabbath, when it began to dawn towards the first day of the week, came Mary Magdalene and the other Mary, to see the sepulchre.

And behold there was a great earthquake. For an angel of the Lord descended from heaven, and coming, rolled back the stone, and sat upon it.

And his countenance was as lightning, and his raiment as snow.

And for fear of him, the guards were struck with terror, and became as dead men.

(Matthew XXVIII: 1–4)

Jean Colombe has painted the guards strewn around the tomb which, interestingly enough, is sealed. The angel, with radiant wings and face, stands on the stone beside a figuration of Christ whose banner, symbolic of the Resurrection, confirms the nature of the representation. The angel seems to be on the point of speaking to the two Marys in the margin: "And the angel answering, said to the women: Fear not you: for I know that you seek Jesus who was crucified." (Matthew XXVIII: 5) Christ gestures, as if to dismiss the angel,

in an attitude similar to that toward Mary Magdalene in the lower border. The sun is about to rise; a faint light brightens the horizon, and the first rays of dawn begin to color the night sky, reflecting from the rocks on the left and from the edges of the tomb in the foreground, while the city remains enshadowed. As in the Entombment (no. 118), but to a lesser degree, Jean Colombe indulged in those effects of light that heighten the atmosphere of the scene and at which he excelled.

Amid the border foliation he has created little figures related to the subject of the miniature: two angels praying in the upper part, the two Marys carrying ointments on the right, and Christ appearing to Mary Magdalene below. In accordance with a new tradition, probably inspired by the *Mysteries,* Christ holds a spade instead of the usual oriflamme symbolic of His victory over death. This new iconography agrees with Saint John's account that Mary Magdalene at first supposed the resurrected Christ to be a gardener until He spoke to her, warning her not to touch Him *("noli me tangere"):* "Jesus saith to her: Do not touch me, for I am not yet ascended to my Father. But go to my brethren, and say to them: I ascend to my Father and to your Father, to my God and your God." (John XX: 17) This is also, in all probability, the meaning of His gesture of dismissal toward the angel at the tomb.

[F. 182v]

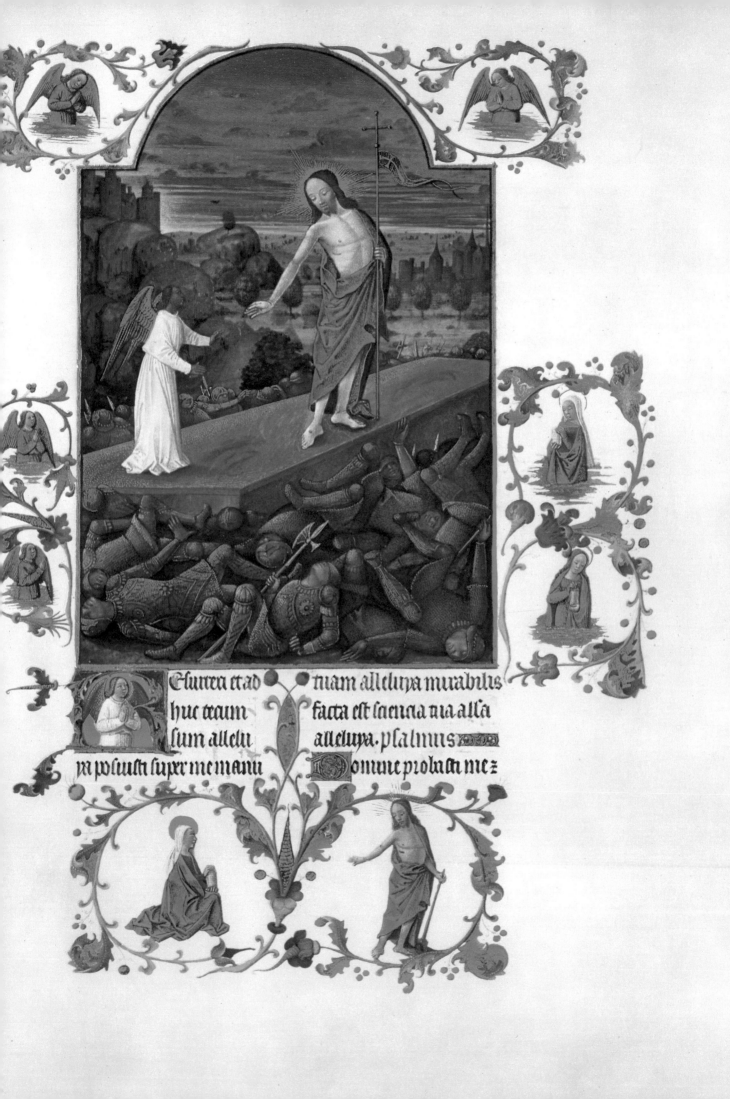

128. The Ascension

This illustration of the Office of the Ascension is by Jean Colombe. The text chosen for this mass is extremely brief: " And the Lord Jesus, after he had spoken to them, was taken up into heaven. ... " (Mark XVI: 19) However, the Epistle from the Acts of the Apostles is more explicit:

And when he had said these things, while they looked on, he was raised up: and a cloud received him out of their sight. And while they were beholding him going up to heaven, behold two men stood by them in white garments. Who also said: " Ye men of Galilee, why stand you looking up to heaven? This Jesus who is taken up from you into heaven, shall so come, as you have seen him going into heaven. " (Acts I: 9-11)

Jean Colombe has taken certain liberties with the text, while following some old iconographical traditions. On the right are the eleven apostles described by Mark (Judas has not yet been replaced), among whom John and Peter are clearly recognizable. But on the left, in addition to the Virgin, whom French artists always showed in this scene, are the Holy Women and other disciples. All kneel, as in Giotto's fresco in the Arena Chapel in Padua. Following an old and curious custom, Jean Colombe has shown the imprint of Christ's feet on the rock between the two groups.

The two men in white apparel who came to announce the Second Coming have not been included in the miniature. Jesus is accompanied in His ascension by a heavenly host who ignore the apostles. Unprotected by clouds, He rises in the sky. He does not extend His arms as usual in this event, but makes a gesture of benediction with His right hand and holds a thin, symbolic cross in His left.

[F. 184r]

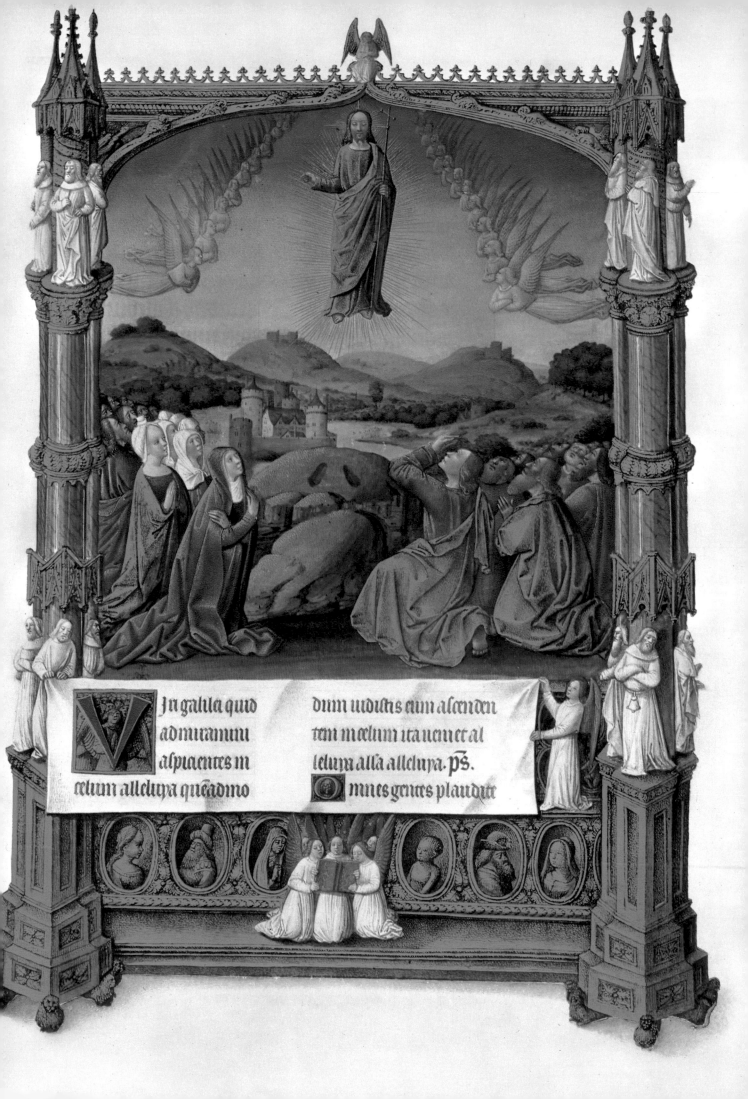

129. Pentecost

To illustrate the Office for Pentecost Mass, Jean Colombe has painted a miniature which re-creates in a smaller format the scene heading the Hours of the Holy Ghost (no. 76). It is centered around the Virgin who kneels before an open book. Unlike the larger miniature, there was not room enough here to show all the apostles, and the cenacle is different, but the dove, the golden rays of the Holy Ghost, and the Virgin's mantle are similar. The event takes place in the choir of a modest chapel, enclosed by wrought iron gates and a wooden partition. Despite the ornate decoration of the pillars, the architecture is in the Gothic style.

The ornamental letters and foliage also date from the second period of the manuscript's decoration.

[F. 186r]

Plena sunt celi et terra gloria
tua osanna in excelsis. Benedictus qui venit
in nomine domini osanna
in excelsis. Agnus dei qui tollis.
Agnus dei qui tollis.
Agnus dei qui tollis pec
cata mundi dona nobis pacem.
Psallite domino qui con
ascendit sup celos celorum
ad orientem alleluya. Presta postcom
nobis quesumus
omnipotens et miseri
cors deus ut que visibi
libus misterijs sume
da percepimus invisi
bili: consequamur ef
fectu. Per dominum.
In die sancto pentecost.
officium

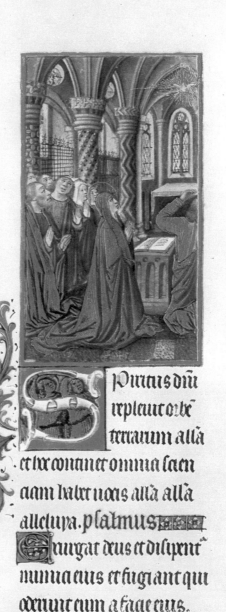

Spiritus domini
replevit orbe
terrarum alla
et hic continet omnia scien
ciam habet vocis alla alla
alleluya. psalmus
Exurgat deus et disipent
inimici eius et fugiant qui
oderunt eum a facie eius.
Spiritus domini reple.
Gloria patri et filio et spi.

130. Christ Blessing the World

Although Pope John XXII had extended the Feast of the Trinity to the universal church in 1334, Jean Colombe did not choose to illustrate the beginning of its office with a representation of the Three Persons. Instead, he showed Christ in a church with stained-glass windows representing large figures, blessing with His right hand and holding the globe with a cross in His left hand. His arched brow, flowing hair, and double pointed beard conform to the fashion of the day. The large B which marks the beginning of the introit of the Mass for the Trinity also dates from the time of Jean Colombe.

[F. 188r]

tua oſanna in ercelſis
Benedictus qui uenit in
nomine domini oſanna in
ercelſis
Agnus dei qui tollis pec
Agnus dei qui tollis pec
Agnus dei qui tollis pec
cata mundi dona nobis.
pacem. COMMUNIO.

Factus eſt repente de celo
ſonus aduenientis ſpū uele
mentis ubi erant ſedentes
alla et repleti ſunt omnes
ſpū ſco loquentes magnali
a dei alleluya alla. POSTCO.

Sancti ſpiritus
corda nra dñe
mundet infuſio: et ſui
roris intima aſperſio
ne fecundet. per eundem.
De ſancta trinitate intro
itus.

Benedicta
ſit ſancta tri
nitas atqz
indiuiſa unitas confitebi
mur ei quia fecit nobiſ cū
miſericordiam ſuam.
Benedicamus prem
et filium cum ſancto ſpū
laudemus et ſuperexaltem
eum in ſecula. pſalmus.
Benedicta ſit ſancta tri

unigenitus que dei filius scis
que spiritus quia fecit no
biscum miseriam suam. Sec.
anctifica que
sumus domine
deus noster per tuum nomi
nis invocationem
huius oblacionis ho
stiam et per eam nosmet
ipsos tibi perfice munus
eternum. Per do
Sanctus Sanctus scis.
dominus deus sabaoth. ple
ni sunt celi et terra gloria
tua osanna in excelsis. Bnd.
Agnus dei qui tollis.
Agnus dei qui tollis.
Agnus dei qui tollis. co.
Sudicamus deum celi z
coram omnibus viuentibus
confitebimur ei quia fecit
nobiscum miseriam suam.

Proficiat nobis
ad salutem cor
pus et anime domine
deus huius sacramen
ti susceptio et sempiter
ne sancte trinitatis ea
dem que indiuidue uni
tatis confessio. Per do.
In festo sacramenti. int.

Sbauit eos ex ad
ipe frumenti
alleluya et de

131. The Communion of the Apostles

Thomas Aquinas was almost entirely responsible for writing the Office of Corpus Christi, a feast officially instituted by Pope Urban IV. The introit was taken from Psalm LXXX, which prefigures the Eucharist: " And he fed them with the fat of wheat. ... "

Jean Colombe has shown Christ leaning forward from the waist to give communion to a kneeling apostle, probably Peter. Behind him, the younger beardless figure perhaps represents John. The others await their turn with joined hands. The hall in which the ceremony takes place is decorated with rather unusual sculpture. Within a capital letter, Christ presents the Eucharist above a chalice that is related to the same communion.

[F. 189v]

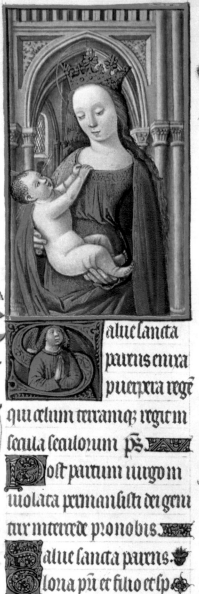

ṗ̇rieleiſon. iij.
ẛpeleiſon. iij.
ṗrieleiſon. iij.
loria merceiſis. oʒo.
oncede nos fa
mulos tuos q̃
ſumus domine deus
perpetua mentis et cor
poꝛus ſanitate gaudei
et glonoſa beate marie
ſemper uirginis inter
ceſſione a pꝛeſenti libe
rari triſticia et eterna
perfui leticia. peꝛ

aliue ſancta
parens enira
puerpera rege
qui cœlum terramᷓq̃ regit in
ſecula ſeculozum. pſ.

oſt partum uirgo in
uiolata permanſiſti dei genu
tur intercede pro nobis.

aliue ſancta parens.
lona pri et filio et ſp̃.
aliue ſancta parens.

lectio libri ſapie.
b inicio et ante
ſecula creata ſum: et
uſᷓq̃ ad futurum ſeculũ
non deſinam: et in hi
tacione ſancta coꝛam
ipo miniſtraui. Et ſic
in ſyon firmata ſum:

132. The Madonna and Child

Toward the end of the manuscript, Jean Colombe's talent seems to grow. This illustration at the head of the Office of the Holy Virgin is one of his best and most enjoyable miniatures. Standing against a typically French architectural background, Mary throws a side-long glance through half-closed eyes at the Infant in her arms who grasps her bodice, perhaps in an attempt to undo it. She wears a crown, and her bright blonde hair falls onto her blue mantle. Her high-arched brow is in the fashion of the time.

[F. 191v]

133. The Exaltation of the Cross

Khosrau's Persian soldiers had captured Jerusalem and taken the fragments of the True Cross discovered there by Saint Helena (see also no. 104). The Byzantine Emperor Heraclius succeeded in recapturing the Cross which he returned to Jerusalem, carrying it on his shoulders to Mount Calvary in 629, from which time the celebration of the Exaltation of the Cross assumed a particularly important place in the church liturgy.

The Duc d'Aumale, who gave the *Très Riches Heures* to the Musée Condé, and Paul Durrieu (*Les Très riches Heures de Jean de France, duc de Berry*, pp. 257-258) identified the two figures kneeling on the left in this miniature by the Limbourgs as the Emperor Constantine and his mother Helena, but they could also be Heraclius and his second wife, the Empress Martine, who accompanied her husband on his expeditions. On either side of the altar upon which the patriarchal cross is exhibited stand two men with flowing beards who hold long rods. One wears a very high-peaked hat and clasps a monstrance, the other seems to be counting bezants.

Encrusted with colored jewels, the cross rests on a green lizard whose tail entwines it; it is perhaps the *"croix au serpent"* ("snake cross") that belonged to the Duc de Berry. Three Negro monks wearing cloaks of the same color as their faces have come to adore it. Three golden statues crown the baldachino; in the center is Moses, and flanking him, according to Durrieu, two prophets *(idem)*.

The feast of the Exaltation of the Cross reminds us of, in addition to Constantine and Heraclius, that highly respected ancestor of the royal family to which the Duc de Berry belonged—Saint Louis, who, barefoot, carried relics of the Cross entrusted to him.

[F. 193r]

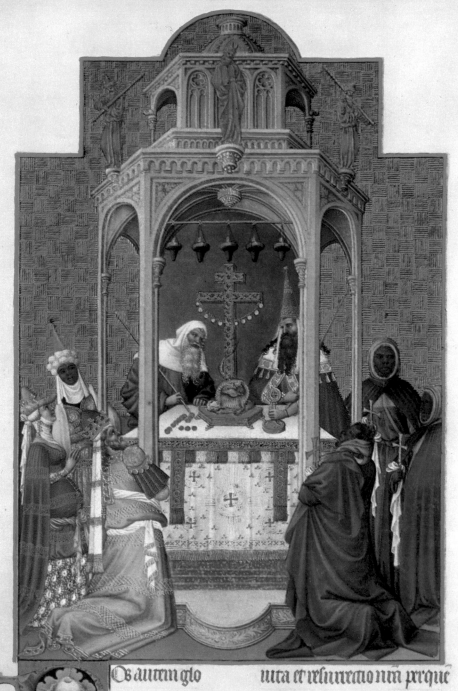

134. The Mass of Saint Michael

The cult of Saint Michael is an extremely ancient one; already in existence among the Hebrews, it grew among Christians due to the influence of the idea of apocalypse. In the twelfth chapter of The Apocalypse, it is Michael who appears to defend the woman and child against the "great red dragon." "And there was a great battle in heaven, Michael and his angels fought with the dragon, and the dragon fought and his angels: And they prevailed not, neither was their place found any more in heaven." (Apocalypse XII: 7-8)

In this miniature, belonging to the cycle of Offices of the Saints, the Limbourgs represented the war in heaven as a war between only Saint Michael and the beast. The bodies of the large reddish dragon and of Michael seem made of fire; the edges of Michael's wings are tipped with flames and he leaves clouds of smoke in the sky. The saint has just wounded the dragon, drawing blood and making the creature turn away its head in anger.

Characteristically, the Limbourgs set the battle in a well-known landscape. It takes place above Mont-Saint-Michel, a famous sanctu-ary and place of pilgrimage in the Middle Ages. Although the three brothers were among the first of many miniaturists to paint this site, one representation of it did precede theirs, that in the *Boucicaut Hours* (ms. 2, fol. 11v), whose unknown artist, perhaps Jacques Coene, exercised an undeniable influence on the art of the Limbourgs. However, the latter tried to reproduce more details of the mount than their predecessor: we recognize the large abbey with its choir, transept, and belfries; the abbatial buildings and heavy buttresses support-ing the walls; and the houses of the village crowded at its foot, surrounded by ramparts—the same picturesque view that is visible to this day. In the distance, we see the island of Tombelaine, which was fortified at that time.

A charming initial and medallions of angels, one of whom holds the arms of the Duc de Berry, complete the page. The Duke probably worshipped Saint Michael; his protégé, the Dauphin Charles (the future Charles VII) adopted this saint as his emblem in 1419, and Charles' son, Louis XI, created an order of knighthood in his honor which existed until the Revolution.

[F. 195r]

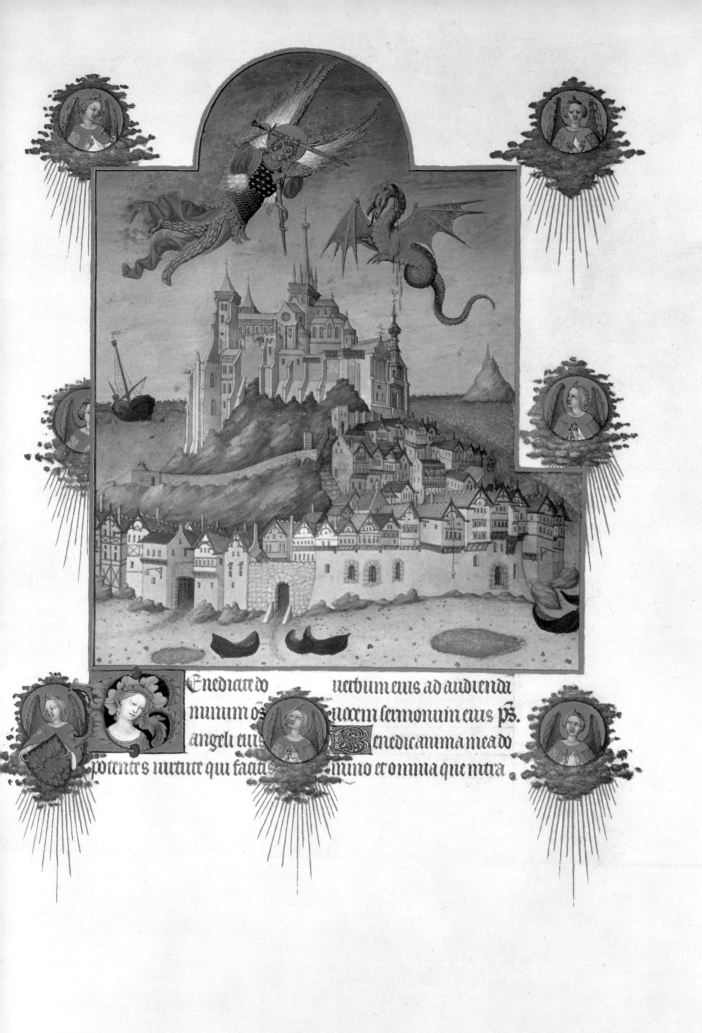

Enediarr do ucrbum cius ad audienda
nunuin os uocem sermonum cius pS.
angcli cius Benedicamma mca do
potentes uirtute qui facitis minio et omnia que intra

135. The Pope and His Cardinals

For All Saints' Day, Jean Colombe has presented us with the leaders of the Church Militant. Dressed in white and wearing his triple crowned tiara, the Pope makes a sign of benediction with the first two fingers of his right hand. Before him stand cardinals whose red robes appear almost orange; behind the pontifical throne, several figures represent less important members of the Church.

The enthroned Pope, surrounded by his cardinals who symbolize all the saints, was an understandable image in the court of Savoie by the end of the fifteenth century. It would have been less so at the time of the Limbourgs, seventy years earlier, when western Christendom was torn by the Great Schism.

The serene face within the ornamental letter is typical of Jean Colombe's representations of Christ.

[F. 197r]

136-137. Two Pages of Text

The two following pages of text are part of the Office for All Saints' Day. There is a striking difference between the marginal decoration executed by the Limbourgs on the left-hand page and that executed by Jean Colombe on the right-hand page.

[Fs. 198v-199r]

in excelsis.

Agnus dei qui tollis
Agnus dei qui tollis
Agnus dei qui tollis peccata
mundi dona nobis pacem.
Benedicite omnes co.
angeli domini domino ym
num dicite et superexalta eu
in secula. post communio.
Beati michaelis
archangeli inter
cessione suffulti suppli
ces te domine deprecamur
ut quod honore prose
quimur contingamus.
et mente. Per dominum
nostrum ihesum christum filium
tuum. Qui tecum vi
vit et regnat.
In festo omnium sancto
rum. Introitus.

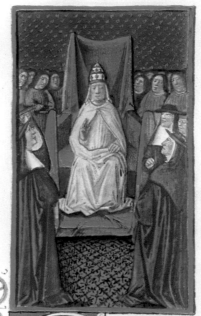

Gaudeamus
omnes in
domino die
festum celebrantes sub ho
nore omnium sanctorum
de quorum sollempnitate gau
dent angeli et collaudant
filium dei. PS.
Exultate adiutorio nostro
iubilate deo iacob.
Gaudeamus omnes

Dextera tua domine glo
rificata est in virtute dexta
manus tua confregit ini
micos. Alleluya. versus.

Iudicabunt sancti na
ciones et dominabuntur
populis et regnabit illo
rum deus in eternum. sed mathe
us. In illo tempore: vm
dens ihesus
turbas: ascendit
in montem. Et cum
sedisset: accesserunt ad
eum discipuli eius. Et
aperiens os suum: doce
bat eos dicens. Beati
pauperes spiritu: qui
ipsorum est regnum ce
lorum. Beati mittes.
quoniam ipsi posside
bunt terram. Beati
qui lugent: quoniam

ipsi consolabuntur.
Beati qui esuriunt et
sitiunt iusticiam: qm
ipsi saturabuntur. Bi
misericordes: quonia
ipsi miam consequen
tur. Beati mundo cor
de: quonia ipsi deum
videbunt. Beati paa
fici: qm filii dei vocabu
tur. Beati qui persecu
cionem paciuntur: pp
ter iusticiam: qm ipso
rum est regnum celox.
Beati estis cum male
dicunt vobis homies
et persecuti vos fuerit
et dicunt omne ma
lum adversus vos me
cientes: propter me.
Gaudete et exultate qm
merces vsa: copiosa e

mcelis.

Credo in unum. of

rabilis deus in sctis
suis deus israel ipse dabit uir
tutem et fortitudinem plebi
sue benedictus deus. Secreta

unera tibi one

nre denocionis
offerimus que et pro
cunctorum tibi grata
sunt honore sanctoru
et nobis salutaria te
miserante reddantur.
per dominum.

Sanctus scus. Scus
dominus deus sabaoth.
pleni sunt celi et terra glia
tua osanna in excelsis.

Benedictus qui uenit
in nomine domini osana
in excelsis.

Agnus dei qui tollis

precata mundi miser nob.

Agnus dei qui tollis pec
cata mundi miser nobis

Agnus dei qui tollis pec
cata mundi dona nobis
pacem. Communio.

Gaudete iusti in dno
alleluya. rectos decet collau
dacio alleluya. post con.

Da quesumus do
mine fidelibus
populis omnium sco
rum semper ueneraci
one letari: et eorum p
petua supplicacione
muniri. per dominu
nrm ihm xpm filium
qui tecum uiuit et reg
in unitate spiritus sci
deus per omnia secula
seculorum. Amen. pro
defunctis. Introitus

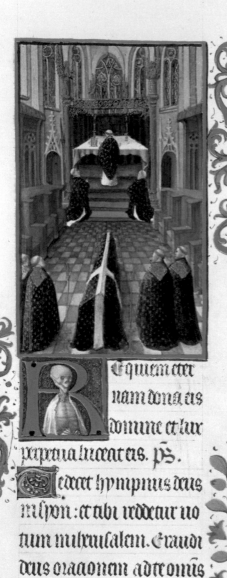

xleison. iij
yneleison. iij. oȝo.

nclina domine
aurem tuam
ad preces nȓas
quibus misericordiam
tuam supplices depreca
mur ut animam famu
li tui et animas famu
lozum famularumq̃
quas de hoc seculo mig̃
ir iussisti in pacis ac lu
as regione constituas
et sanctozum tuozum
iubeas esse consortes per
dominum. lectio libri
st machabeozum.

n diebus illis: uir
fortissimus iudas
collacione facta duode
cim dragmas argenti
misit iherosolimam

Equiem eter
nam dona eis
domine et lux
perpetua luceat eis. pS.

edet hympnus deus
insyon: et tibi reddetur uo
tum in iherusalem. Erauditi
deus orationem ad te omnis
caro ueniet.

equiem eternam do.

yneleison. iij

138. A Funeral Service

With Jean Colombe's illustration for the Office of the Dead, we find ourselves in the choir of a church in which a priest is officiating. Two kneeling clerics serve at mass while others stand near the bier covered by a black cloth adorned with a white cross. The skeleton in the initial letter completes the ensemble.

The general conception of the scene is far removed from the early-fifteenth-century representations of funeral services studied by Millard Meiss ("La mort et l'office des morts à l'époque du Maître Boucicaut et des Limbourgs," *Revue de l'Art*, 1968, nos. 1-2). Jean Colombe's painting gives a greater feeling of depth, and makes even the bier appear abnormally elongated; the scene's composition and details compare favorably with the work of the Limbourgs.

[F. 199v]

139. The Martyrdom of Saint Andrew

The *Très Riches Heures* ends with the Offices of Saint Andrew and of the Purification. As Saint Andrew was one of the Duke's heavenly patrons, a large miniature devoted to him had been planned during the prince's lifetime, only to be executed years later by Jean Colombe.

Brother of Simon Peter, Andrew is said to have preached in Palestine and then in Scythia, Thrace, and Achaia. In Patras in Greece, he converted the wife of the proconsul, Aegeus, with whom he had a number of profound discussions. Upon refusing to obey the proconsul's order to make a sacrifice to the pagan gods, Andrew was imprisoned and then bound to an X-shaped cross. *The Golden Legend* relates that he remained crucified for two days before a crowd of 20,000 people to whom he continued to preach during his suffering. He refused to be removed from the cross and expired on the third day in a blinding flash from heaven.

Men on horseback and on foot watch the saint's torture and listen to his words. In the background is a city meant to represent Patras, with its houses, ramparts, and churches. In the *bas-de-page* we see on the left Andrew's arrest and imprisonment, and on the right the saint's flagellation prior to his crucifixion. The frame of marble and gold columns is typical of Jean Colombe's work. This is the last miniature in the manuscript, which ends with two pages that were left blank despite the preparatory rulings.

[F. 201r]

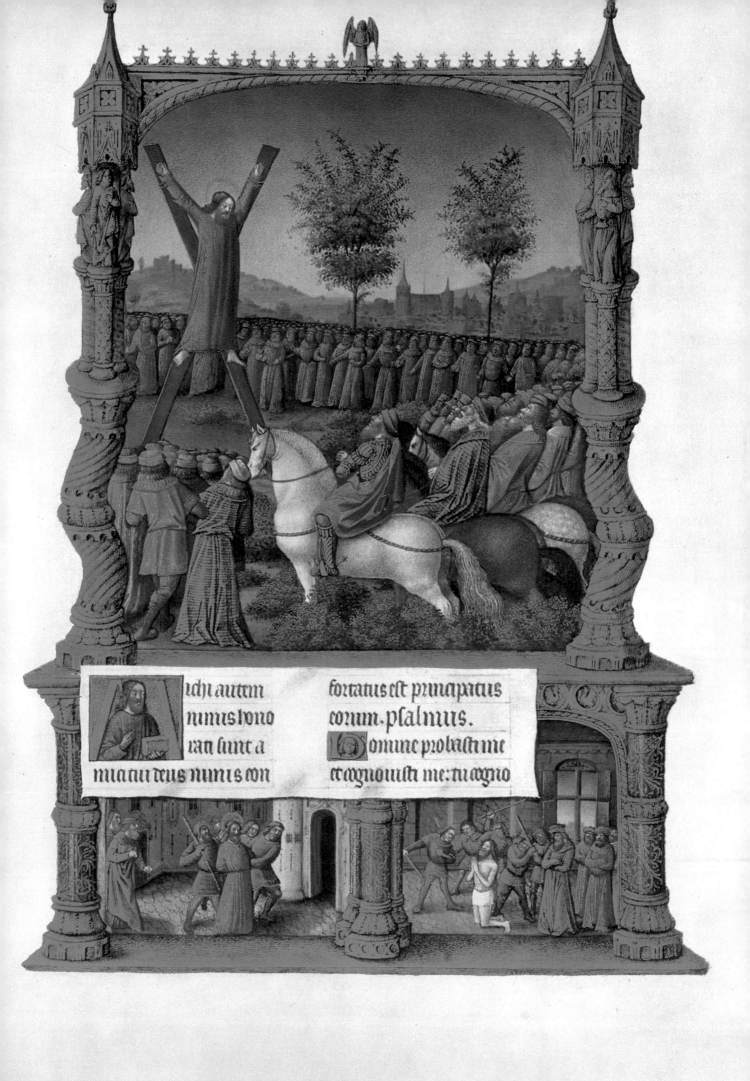

idn autem fortatis est principatus
nimis bono eorum. psalmus.
rati sunt a ꝺomine probasti me
miatui deus nimis con et cognouisti me: tu cogno